P9-DCQ-268

How to control & use
PHOTOGRAPHIC LIGHTING

David Brooks

Executive Editor: Carl Shipman
Editor: Theodore DiSante
Art Director: Don Burton
Book Design & Assembly: George Haigh
Typography: Cindy Coatsworth, Joanne Nociti, Patty Thompson
Photography: David Brooks, unless otherwise credited

Notice: The information contained in this book is true and complete to the best of our knowledge. All recommendations are made without any guarantees on the part of the author or HPBooks®. The author and publisher disclaim all liability incurred in connection with the use of this information.

Published by HPBooks®, P.O. Box 5367, Tucson, AZ 85703 602/888-2150
ISBN: 0-89586-059-7 Library of Congress Catalog Card No. 80-82382
© Fisher Publishing, Inc. Printed in U.S.A.

Contents

1 TWO CATEGORIES OF LIGHT 4

2 SEEING LIGHT
PHOTOGRAPHICALLY 13

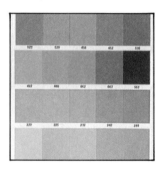

3 TOOLS FOR LIGHTING 42

4 LIGHTING FOR PEOPLE 68

5 LIGHTING FOR THINGS 124

INDEX TO MANUFACTURERS 156

INDEX . 157

Introduction

Just as light is essential to human sight, it is also the essence of photography. Light is the energy that puts an image onto photographic film. This simple parallel between human vision and the photographic process is a basic concept all photographers should understand. Today it is sometimes hidden from the beginning photographer in its most fundamental aspect by modern, automatic-exposure cameras.

Even though the function of the camera and film roughly simulates the action of the eye and brain, there are many differences between a subject perceived and that same subject photographed. The effects of light on both vision and the photographic process are very complex. Reducing a subject to the two dimensions of a photograph from three-dimensional reality, interpreting color as black and white, limiting the reality of space by the bounds of the picture format, and freezing the constant flow of time into an instant are photographic distortions of reality.

Many characteristics of a photographic image are due to the prevailing lighting conditions at the time of exposure. How successful you are in capturing an expected degree of likeness to the subject is primarily due to your skill in controlling light. This involves either manipulation of the light illuminating the subject or controlling how it affects the photographic process.

The first step is understanding how the qualities and characteristics of light affect not only vision and perception but also the photographic process. You then use this understanding to control the effect of light in two ways— *actively* or *passively.*

Active control involves manipulating the light source. One way is to modify or redirect light to change the effect of existing illumination. Another way is to introduce other light sources to illuminate the subject or to augment existing light.

Passive control of light refers to the way you use the camera and film to photograph the subject lit by either natural or artificial illumination. All the decisions you make in determining how the image is made, such as exposure, camera angle, choice of film and processing, are part of passive control. It is essential to all photography, whether or not you control light actively.

Unlike traditional books on lighting, which arbitrarily define styles of lighting and prescribe exact lighting setups, this book uses a less rigid approach. First, I suggest some concepts and definitions to help you form an understanding of the characteristics of light, vision, and the photographic process. Then the basic functions of light as it affects photography are described, with illustrations of tests you can do to acquire a practical, working understanding of lighting.

There are many tools designed to create artificial light for photography, to modify existing illumination, or to control the effects of an artificial source. In addition, there is a variety of measuring devices that can provide accurate, objective values of specific light qualities. These lighting tools are described in the second part of the book.

Following these sections, I discuss their applications to various photographic situations. You will find illustrations, diagrams and photos of typical setups, suggesting a basic approach and possible variations. Because there are differences in technique, I discuss photographing people and inanimate objects separately.

STEP VS. STOP

You'll notice in this book that the term *step* is used instead of *stop* or *f-stop* when exposure is discussed. This is standard ANSI usage because exposure depends on *both* shutter speed and lens aperture, not just lens aperture as *f-stop* and *stop* imply. If this bothers you, read *stop* or *f-stop* instead of *step.*

1
Two Categories of Light

Earlier, I described the control of light as being either active or passive. These controls involve two categories of light. Active control is the creation and manipulation of the light falling on the subject. This is *incident light*. Passive control refers to how you use camera and film to record an

BASIC PHOTOGRAPHIC CONCEPTS OF LIGHT		
Category	**Incident Light**	**Reflected Light**
Control	Active	Passive
Qualities	Intensity Color Source Size Direction Light Ratio	Brightness Subject Color

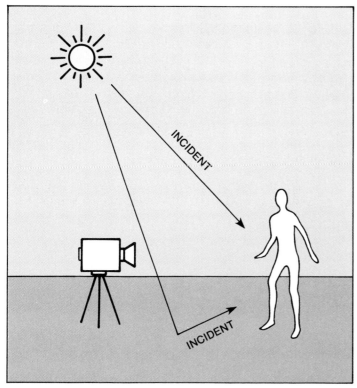

When you are outdoors in sunlight, the relationship between the direct source and the subject is obvious. Indirect sources, such as light reflected from the surroundings, are always less obvious sources of light.

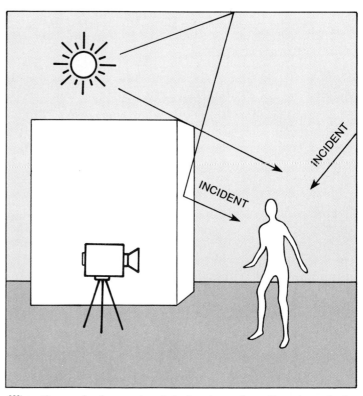

When the sun is obscured, only indirect rays from the sun are incident to the subject.

image using light reflected from the subject. This is *reflected light.*

From a photographic point of view, I'll use the term *incident light* to mean light falling on a subject as it is seen by the camera. The light may reach the subject directly or indirectly. Direct light travels from the source to the subject. Indirect light is direct light that has been affected by diffusion, filtration, or reflection.

As an example, let's consider a subject outdoors in the open on a clear day. Obviously, the sun is a direct source providing incident light to the subject. If the subject is on the beach, sunlight will also be reflected from the sand and this contributes indirectly to the incident light. If the subject moves into the shade of a building, then the sun is no longer a direct source. The incident light is now indirect sunlight from the sky and the reflected light from the surroundings.

As another example, imagine a flash unit attached to a camera and pointed directly at the subject. In this setup, light from the flash is directly incident to the subject. If the flash unit is turned up to point at the ceiling, light from the flash is no longer directly incident to the subject. The area of the ceiling reflecting light from the flash is the direct source. Obviously, the quality of light from direct illumination by the flash differs dramatically from the quality of light reflected from the ceiling.

To the camera, reflected light *is* the subject. It is the only reality that exists as far as camera and film are concerned. The reflected light we see and record on film is the result of interactions between the subject and the light incident to the subject. Therefore, the qualities and characteristics of reflected light from the subject are inseparable from the subject itself.

QUALITIES OF INCIDENT LIGHT

The qualities of incident light are basic. Being able to distinguish and specify each quality is essential to successful control.

Intensity—In this book, *intensity* refers to the amount of light produced by a source that illuminates a subject. Other words are also used to mean *intensity* the way I have defined it. *Bright, hot,* and *powerful* are three common ones. To avoid confusion I'll reserve the word *brightness* to describe a quality of reflected light.

The intensity of light can be expressed in units of *lux* or *footcandles,* as measured by some incident light meters. These units, though, are seldom directly applied to photography. Usually, incident light meters are used to read the light falling on the subject and give exposure-control settings for the camera. The meters are placed at subject position and pointed at the camera or source while the reading is made. They are described in more detail later.

Artificial light sources are sometimes rated by the amount of light they produce, but this rating is not often used for practical photographic application either. Instead, for tungsten sources most photographers prefer to use the wattage rating, which is a measure of power consumption. For flash, the maximum power stored in the capacitor is often used, expressed in units of watt-seconds. In both cases, the higher the number, the more intense the light source.

Color—This quality of incident light has special photographic significance. White light can be

TYPICAL INCIDENT LIGHT READINGS			
Source	EV Reading at ASA 100	Lux	Footcandles
Outdoor building lights	4	40	3.7
Candle light	4-5	40-80	3.7-7.4
Burning building	5-6	80-160	7.4-14.8
Household tungsten lamps	5-7	80-320	7.4-30
Stadium lights	8	640	60
Store lighting, fluorescent	8.5	960	90
City-center street lights	8-9	640-1280	60-120
Indoor sports or stage lighting	9-10	1280-2500	120-230

By metering some typical light sources, you can relate the measured intensities to your perception of the light.

divided into three primary colors—red, blue, and green. Light from different sources usually has different relative amounts of each color. For example, sunlight at different times of the day travels through different thicknesses of the earth's atmosphere to reach the surface. Due to scattering, the more air the sunlight travels through, the less blue remains in direct sunlight. When the sun is at a low angle, the balance between the colors shifts toward the red, or warm, end.

Differences in the balance between the red and blue ends of the spectrum or between any two colors can be measured and expressed as degrees Kelvin (K) on a scale of color temperature. The lower the color temperature, the redder or warmer the light. The higher the temperature, the bluer or cooler the light. On this scale an arbitrary standard for daylight was chosen—5500K. Standards for tungsten light are 3200K and 3400K.

Human perception compensates for changes in the color of light. Only at morning or evening or when we see two distinctly

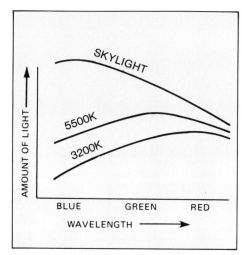

The relative amounts of red, blue, and green light in a continuous source are represented by color temperature. Low color temperatures have relatively more green and red light than blue light. High color temperatures produce relatively more blue light than red and green light.

different colors of light together are we visually aware of the differences. However, color film does not adapt. It records color as it is, not as we perceive it. The color sensitivity of color film is made to closely match the relative amounts of red, blue, and green light in the standard 5500K daylight or 3200K or 3400K tungsten light. When the color balance of incident light varies from that for which the film was designed, you should consider using a filter over the light source or in front of the camera lens to match the color of the light the film receives to the standard for which it is balanced.

Source Size—The size of the source relative to its distance from the subject affects a quality of incident light. When the source is small in relation to the distance from the subject, the light casts sharply defined shadows. This light is called *hard light*. The term *specular* is frequently used to refer to hard light from a small source,

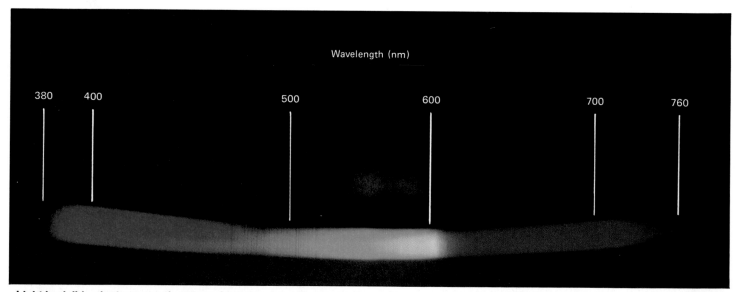

Light is visible electromagnetic energy. Light has wavelike properties and can be arranged according to wavelength in a diagram called the *spectrum*. In this photo, sunlight passing through a diffraction grating is separated into its spectral components. As wavelength gets larger, light changes color from blue to green to red.

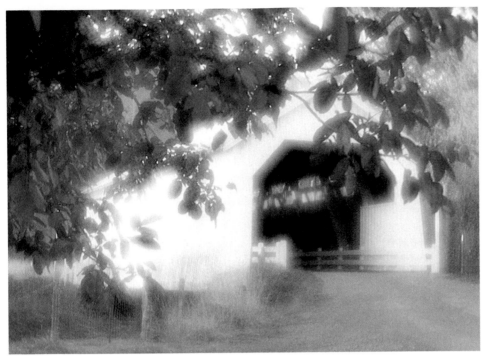

The front of this covered bridge is illuminated by the relatively cool light from blue sky. The side and interior of the bridge are illuminated by the warm sunlight of late afternoon.

but this should be avoided. Both specular light and its opposite, *diffuse* light, are easy to misunderstand when you apply them to incident light.

When the source is large in relation to the distance from the subject, the light casts shadows that are not sharply defined. This is described as *soft light*.

The sun is a large source, but in relation to its distance from any subject on earth, it is small. It is so far away that the light rays it produces are essentially parallel. When shining directly on a subject on a clear day, it always produces hard light and casts sharply defined shadows.

When the sky becomes overcast by a thin layer of clouds, the sun is no longer the direct source of incident light. Instead, the sky becomes the direct source. Because it is very large in relation to its distance from the subject, it

The photo at left was made in direct sunlight. Hard light from a relatively small, direct light source cast sharply defined shadows. The photo at right was made after the sky became overcast with a thin layer of clouds. Because the clouds act as a much larger light source, shadow areas are much lighter and less distinct.

provides soft light, which creates soft shadows.

In addition to becoming the direct source, an overcast of clouds scatters and diffuses the rays of sunlight. When a ray of light passes through a translucent substance such as a layer of clouds, it is scattered by the molecules that make up the substance and is scattered in every direction. In such a situation, the material diffusing the light increases the relative size of the source in relationship to the subject, and softer light on the subject results.

If, however, a small source a great distance from the subject is diffused at the source, the diffuser will scatter the light rays, but will not make the shadows cast by the subject any less sharply defined. The light will still be hard. Hardness and softness are not functions of diffusion, except indirectly.

Direction—The direction of light always refers to the angle between the lens axis and the position of the source. This is called the *angle of incidence.* Obviously, as you change camera position, the angle of incidence will also change, even if the location of the source doesn't.

Several terms are used to refer to the direction of light. *Front light* describes light that originates at or behind the camera position. It travels parallel to the lens axis, with an angle of incidence of zero. *Quarter*, or *three-quarter, light* has an angle midway between the lens axis and the subject plane, approx- imately 45°. *Cross* or *side light* comes from a source on one side of the subject. Its angle of inci- dence is 90°. *Back light* is light from a source behind the subject.

Shade is a result of light direc- tion. From the camera's view- point, front light completely illuminates the subject, creating no shadows. This, and the rare condition of light falling on the subject equally from all directions, are instances when shadows are not apparent on the subject. As the angle of incidence increases, an increasing part of each three- dimensional object in the subject plane will be in shade. A decreas- ing portion will receive direct light. All of these concepts are illus- trated and described in the next chapter.

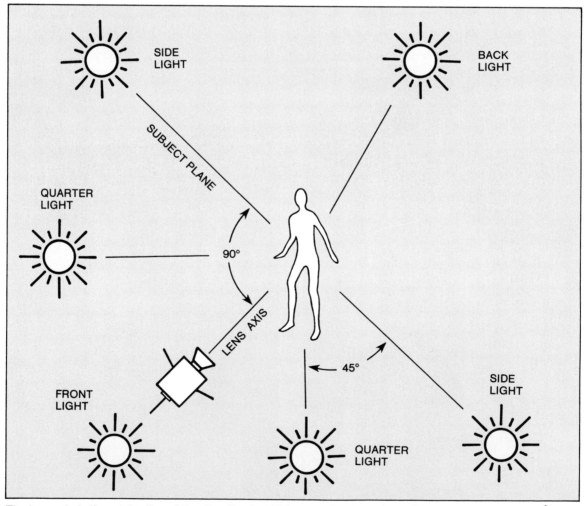

The lens axis is the center line of the direction in which you point the camera. It is always perpendicular to the subject plane. The angle of incidence of light is the angle between a ray from the source and the lens axis. As you move the camera, the angle of incidence of a fixed source changes.

Light Ratio—This compares the amount of incident light falling on a subject from the direct source to the amount of incident light illuminating the shaded portions of the subject. Only in a controlled studio environment with non-reflecting black surroundings can you create shadows receiving no illumination. In all practical situations, shadows receive illumination from secondary sources, such as light reflected from nearby surfaces.

You can measure this difference, sometimes referred to as *contrast*, with an incident light meter. From subject position you first measure the light falling on the portions of the subject lit by the main source. Next, measure the light falling on the portions of the subject in shade. The difference in exposure steps between light and shade is then expressed as a ratio. If there is no measurable difference between the main and shadow readings, the ratio is 1:1. If there is a one-step difference, the ratio is 1:2. And if there is a two-step difference, the ratio is 1:4. As the difference increases by one exposure step, the ratio is doubled.

Difference in Exposure Steps	Light Ratio
0	1:1
1/3	1:1.3
1/2	1:1.4
2/3	1:1.6
1	1:2
1-1/3	1:2.5
1-1/2	1:2.8
1-2/3	1:3.2
2	1:4
2-1/3	1:5
2-1/2	1:5.7
2-2/3	1:6.3
3	1:8
n	$1:2^n$

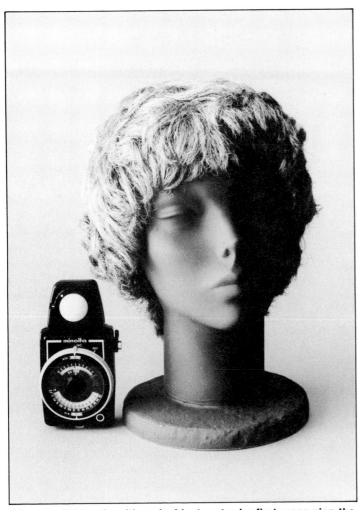

Measure light ratio with an incident meter by first measuring the direct light falling on the subject. Remember the reading or write it down.

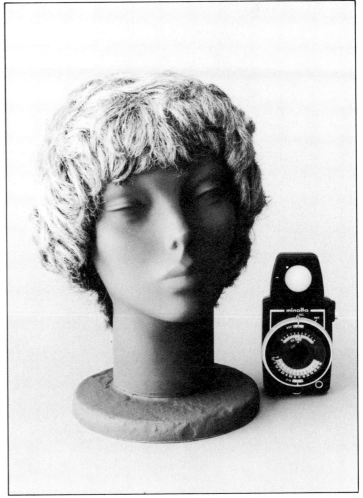

Move the light meter to read the light illuminating the shaded parts of the subject. Subtract this reading from the first reading. Refer to the accompanying table to find the corresponding light ratio.

QUALITIES OF REFLECTED LIGHT

Qualities of reflected light depend both on the qualities of incident light illuminating the subject and the characteristics of the subject reflecting the light. Passive control of lighting begins with measuring and analyzing the reflected light. Identifying those qualities that affect image formation is essential to passive control.

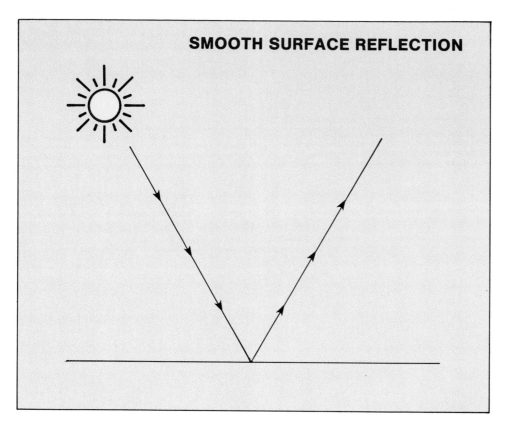

SMOOTH SURFACE REFLECTION

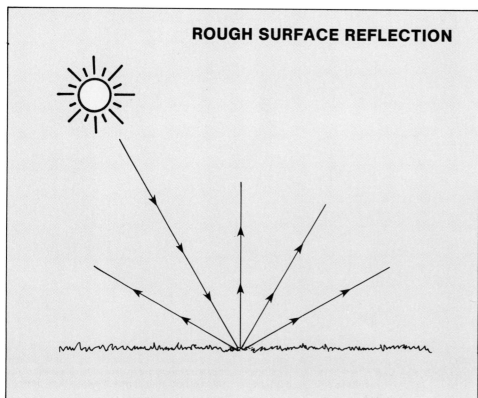

ROUGH SURFACE REFLECTION

Brightness—You can measure brightness objectively by metering. With a through-the-lens camera meter you can measure the reflected light from a subject as the camera sees it. Hand-held, reflected-light meters are available with different angles of view. Averaging types typically see a 30° angle, while spot types see a narrower angle, between 1° and 10°. These are described in more detail later.

Differences between reflected light values of a scene may be due to the amount of light falling on surfaces in the scene or to the way the surfaces reflect the light.

Smooth, shiny, mirror-like surfaces produce *specular* reflections; textured, rough, matte surfaces produce *diffuse* reflections. Surfaces that produce diffuse reflections break up and scatter incident light in many directions, while smooth surfaces reflect the rays intact.

The ratio between the incident light reflected from a surface and the amount incident to the surface is a measure of the surface's *reflectivity* or *reflectance*. Even mirrors and polished metal absorb and scatter some light and have a reflectivity of about 97%. "Pure" white surfaces have a reflectivity of about 90%, depending on whether the surface is smooth, rough, matte, or shiny. Darker materials have lower reflectivities.

Of the many factors that influence the amount of light reflected by particular areas of a subject, there are two that affect what is commonly called *subject contrast* or *subject brightness range*. The *light ratio* determines the difference between the amount of light available to be reflected from areas of the subject because some areas are in shade. The *subject reflectivity range* is the range of reflectance values in the subject.

Within the total subject brightness range there are likely to be areas of *local contrast* that are important to the photo. For instance, a scene with a high overall

10

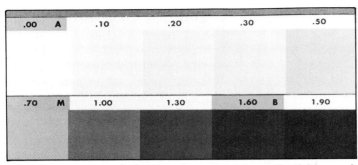

.00	A	.10	.20	.30	.50

.70	M	1.00	1.30	1.60	B	1.90

A standard gray scale has patches of varying reflectivities and represents a typical subject *reflectivity* range. It does not necessarily represent a typical subject *brightness* range because it does not include the effects of the light ratio.

Two gray scales, one in direct light and one in shade, simulate not only a full range of reflectance values in light and shade, but also the effects of the light ratio.

subject brightness range may contain shadow areas with subtly differentiated tones. Because the photographic process involves tonal compression in subjects with normal and high subject brightness ranges, you may be concerned about the tonal separation of these areas of low contrast. When the overall subject brightness range is low, there is the opposite problem of preserving gentle tonal gradations without distortion while the photographic process expands the range of subject tones.

In subjective visual terms, brightness does not necessarily refer to how much light illuminates the subject. For instance, if you were in an all-white room illuminated by indirect window light, the room would seem very bright. If you then stepped outside into a forest illuminated by sunlight on a clear day, the visual effect would be a feeling of darkness. This is because the forest surroundings have low reflectivity, even though the incident light level is several times greater than in the white room.

The photographic effect of your perception of brightness is usually called the subject *key*. A photographic image made up primarily of light tones has a *high key* while an image consisting of predominantly dark tones has a *low key*. The key of an image may or may not be a function of reflected light. It may result from manipulation of the photographic process at one or more stages of reproduction.

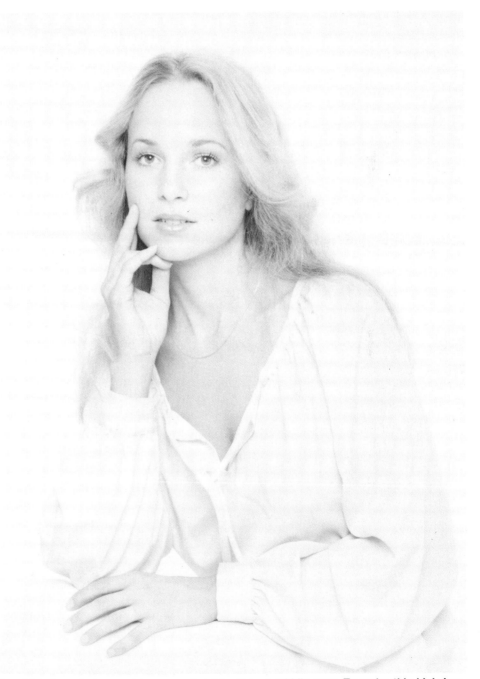

In a high-key photo, most tones are brighter than a middle gray. To make this high-key photo, I actively manipulated the lighting. This is described in more detail in Chapter 4, "Lighting for People."

Subject Color—Surfaces appear colored because they absorb some of the incident light and reflect the rest. The color we see is the color of the light reflected from the surface. This surface property is called *selective reflection*. Therefore, the color of reflected light depends on both the color of light incident to the subject and the selective reflection of the subject.

For example, a fire engine appears red in daylight because the paint on the vehicle absorbs blue and green light and reflects red light. If the same fire engine were in green light, it would appear black because there is no red light for it to reflect.

The color absorption components of reflective materials are called *pigments* and their colors are called *subtractive primaries*. With subtractive primaries there are again three divisions of color, but they are the *complements* of the red, green and blue additive primaries of light already mentioned. The three subtractive primaries are cyan, magenta and yellow.

When none of the colors is visible on a surface lit by white light, there is no appearance of color. This happens because none of the incident light is absorbed, so the surface appears white.

If cyan, magenta and yellow pigments are added together in equal amounts under white light, gray or black is produced. This is because cyan absorbs red light, magenta absorbs green light, and yellow absorbs blue light. The result merely reduces the amount of white light. If only magenta and yellow pigments are present, the surface appears red because yellow absorbs blue light and magenta absorbs green light. Only red light would be left, and it is the color you see.

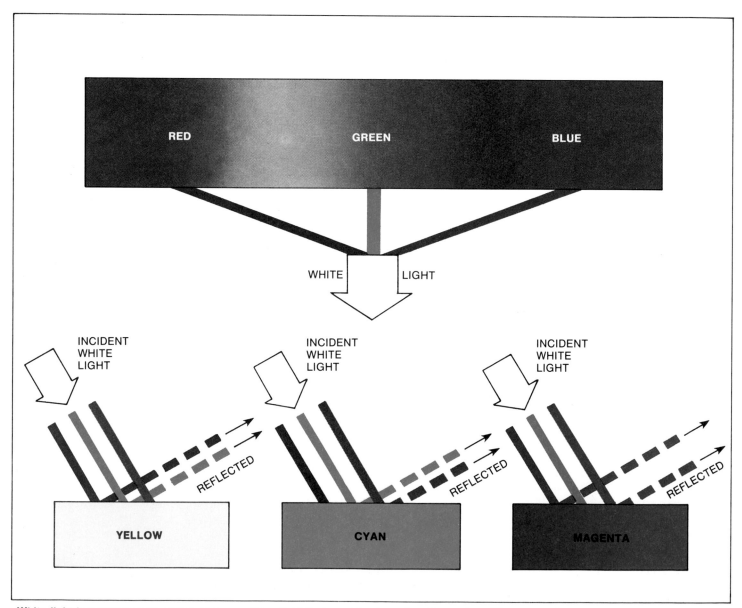

White light has components of red, green and blue light that combine to make other colors. When white light strikes a yellow surface, for example, the blue portion is absorbed and the red and green portions are reflected, making yellow. In reality, white light rarely contains equal amounts of the three additive primaries. Nor do colored materials absorb only one color of light. The different colors we see are due to mixed colors and light sources that contain unequal portions of the primary colors.

2
Seeing Light Photographically

Controlling light either actively or passively requires understanding how each quality of light affects the photographic process. This chapter shows how lighting theory relates to the practical control of light and its interrelated effects on image formation.

EXPOSURE: WHAT LIGHT IS TO FILM

When you insert a 35mm film cassette into the camera, the shiny surface of the film base is facing you. The other side of the film is coated with the *emulsion.* It is the image-forming, light-sensitive part of the film.

Film emulsion consists of very fine grains of silver-halide salts in a gelatinous material. These grains respond to light. During exposure to light no apparent change occurs. When you develop the film, chemicals in the developer convert the exposed grains into metallic silver, which is black and opaque. B&W film is then fixed, which dissolves the remaining unexposed and undeveloped grains. The exposed and developed grains of silver reduce the passage of light through the film, creating negative densities that correspond to the amount of exposure and development each area of the film received.

Film Characteristics—Different film emulsions have different degrees of sensitivity to light. This sensitivity is known by a number called *film speed.* The higher the number, the faster, or more sensitive to light, the film is.

A film with a particular film speed responds to exposure over a limited range of exposure levels. When the film is developed, varying amounts of negative density are produced, corresponding to the different amounts of exposure. The range of exposure levels to which the film is sensitive is called the film's *exposure range.* Different films have not only different film speeds but also different exposure ranges.

With some kinds of film, color reversal and color negative films for example, the exposure range is limited by a prescribed amount of development, which produces a certain density range. The exposure range of these films is set by the manufacturer of the film to produce an optimal density range when the subject brightness range is average, with approximately 5.5 to 7 exposure steps between the darkest detailed shadows and the brightest textured highlights.

If the subject brightness range is less than average, these films will exhibit only a portion of the density range of which they are capable. If the subject brightness range is greater than the film's exposure range, the film can record only a portion of the subject's tones.

However, b&w films designed for general photographic use have variable exposure ranges, which depend on the exposure and development the film receives. In reality, these films can respond to a subject brightness range many exposure steps greater than the average scene.

However, you may not get the full range on a print because there are two stages of reproduction in b&w photography. The range of usable densities in a negative is limited by the exposure range of the photographic paper.

This limit on b&w negative densities is a much smaller range than the film is capable of reproducing. By adjusting the rate of film development and the corresponding effective film speed, you can use a lesser or greater portion of the film's exposure range to produce a range of negative densities that match the paper's exposure range.

Exposure and Density—It's important to know what is meant by film speed and exposure relative to the average brightness range.

B&W film speed is determined by the amount of exposure necessary to produce a minimum negative density of 0.10 above the base-plus-fog density. This corresponds to the darkest shadows within the subject brightness range. An average subject brightness range is represented by a standard gray scale, which has a reflectivity range of 6.3 exposure steps. The average light level of this range is a midtone gray of 18% reflectance. To fit the subject brightness range to the film's exposure range, exposure is based on the average of the subject brightness range, the 18% midtone.

Rated film speeds are determined under laboratory conditions according to the principles just described and to international standards of measurement and development. This provides the numerical film speeds (ISO/ASA/DIN) assigned to film products by the manufacturer. Rated film speeds are valid in actual use only if the camera, light meter, and development all conform closely to standards; and if the film is exposed to an average subject brightness range. This is why all film manufacturers recommend that you use the rated speed as a base for practical tests to establish an effective film speed. The effective film speed, or exposure index (E.I.), is determined by you using the same camera, lens, light meter and development you will use in future applications.

With today's automatic cameras featuring built-in light meters, exposing film would be only a matter of composing and shooting if it were not for nonaverage subject brightness ranges and artistic considerations. Because a film's sensitivity is stated for a particular development time and because averaging reflected light meters

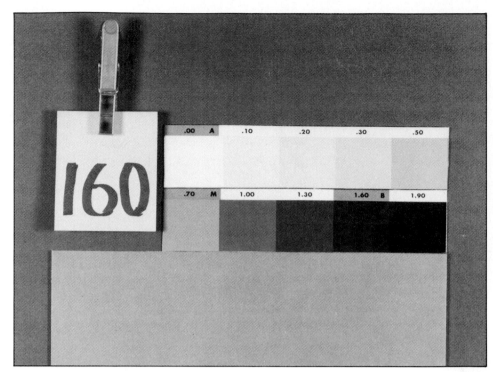

By using an 11x14 gray board as a base, attaching the gray scale to the center and a gray card below, and fastening a clothespin to the mount board, you can include all the information needed for film testing in one easy-to-use unit. These tests are described in detail in *How to Select & Use Photographic Materials and Processes.*

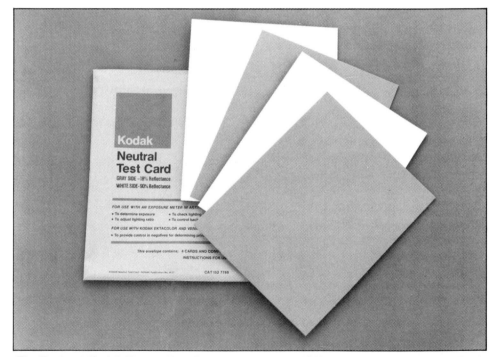

The Eastman Kodak Neutral Test Card, also called an *18% gray card*, provides a standard reference of known reflectance values for meter readings and inclusion in exposure-test subjects. The card has 18% reflectance on the gray side and 90% reflectance on the white side.

are dependable only for an average subject, nonaverage scenes can cause exposure problems.

Once you establish an effective E.I. by testing, you will have a basis for predictable exposures of average subjects. Then, based on an understanding of what film speed is and what a meter actually measures, you can use a

Recording all of the tones from detailed shadows to textured highlights requires careful metering and an understanding of the relationship between exposure, density, and the photographic printing process.

tographers using roll film. A landscape photographer will want to record a broad range, a still-life photographer a narrower range, and a portrait photographer a very limited range. Sometimes, scenes with different brightness ranges are photographed on the same roll of film.

A second factor is that the choice of a printing paper is influenced by variations in negative density ranges. Some enlarging papers are manufactured in several grades, or contrast ranges, to accommodate a wide variety of negative density ranges. Multigraded papers have a smaller contrast range but give you an easy way to adjust paper contrast to small differences in negatives. Warm-tone papers are seldom available in many different grades, severely limiting the variations in negative density they can accommodate.

Once you decide on the limitations of the printing paper, you can decide how many different development times are necessary when using one kind of film.

Tests and control techniques for converting a scene's subject brightness range to a usable range of negative densities are described in detail in *How to Select & Use Photographic Materials and Processes*, also published by HPBooks. These tests involve a simulated scene with a long subject brightness range. You shoot the test subject with a few rolls of the same film and develop each roll to a different development time. The usable density range of each roll then corresponds to a particular subject brightness range, measured in exposure steps. In addition, each development time will yield its own film speed.

Then you can measure the subject brightness range of a real scene with a spot meter and assign a particular exposure and development time to the roll of film. This gives a usable range of densities that will record important scene detail.

systematic approach to subjects and lighting conditions that are not average scenes. The system you use depends on the type of film material and process you use and the kinds of control your equipment has.

Controlling B&W Film—Consider the variety of subject brightness ranges faced by different pho-

Controlling Color Film Exposures—Color films do not allow density control by varying the development. Rather than avoiding nonaverage scenes, you can usually make a compromise—sacrifice recording some portion of a high-range scene or selectively place the exposure of a low-range scene. This is both an objective and subjective, esthetic judgement.

Consider a scene illuminated by soft, indirect light. It is made up of dark, low-reflectance objects with a short subject brightness range of 3.5 exposure steps. An ordinary reflected light meter reading won't necessarily provide the best exposure setting. The exposure base for your E.I. is an 18% midtone, and the actual average reflectance of the subject may be much darker—say 5% reflectance. The meter is calibrated to reproduce the average reflectance as an 18% midtone. If you expose according to your meter reading, the subject's midtones will be overexposed and therefore be represented much lighter in a slide than they appeared in reality.

In the opposite situation of a tree backlit by direct sun, the subject brightness range might be 10 exposure steps. Contributing to the backlit subject's long subject brightness range is the effect of direct light through the leaves. This raises the average light level above a normal 18%. The meter will again assume the subject has normal reflectivity and recommend a setting that will reproduce the subject's midtones darker than they really appear.

These examples show that when the subject brightness range is not average, the exposure base can also vary. If you determine exposure by metering the scene and assuming it has an average 18% reflectance, the resulting slide may be a false record of the visual effect you wanted to record. One way to avoid the problem is to substitute an 18% midtone into the scene and meter from it.

One such midtone is the *18% gray card*, made by Eastman Kodak. One side of the card is gray with 18% reflectivity, and the other side is white with 90% reflectivity. It will help you determine an exposure setting that reproduces the subject best. You can also use the gray or white tone to test color reproduction in color-checking tests. Both surfaces are designed to be neutral, which means that they don't change the color of the light they reflect.

Put the gray card in the same light as the subject and meter the gray side with a reflected-type light meter. The meter will recommend an exposure that would reproduce the 18% midtone as a midtone in the image. Brighter objects in the scene get more exposure and darker objects less exposure, so they reproduce brighter and darker than a midtone.

Using an incident meter at subject position will do the same thing. It has a spherical integrator over the metering cell that acts like a built-in gray card.

This midtone-metering technique favors reproduction of parts of the scene lit by direct light. Elements in deep shadow won't get enough exposure and will lack detail. If you want to favor reproduction of objects in shadow,

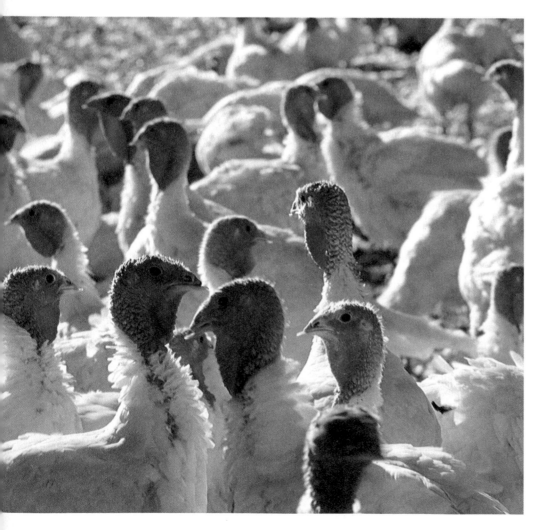

These backlit, white turkeys mislead an averaging-type exposure meter, which recommends underexposure of the turkeys. Over-correction for the reflectivity of the subject and the backlit highlights would wash out too much image detail. By bracketing exposures around a gray-card reading, I made an esthetically ideal exposure—and several others.

Bright back lighting can produce an unreliable averaged meter reading. Selecting an exposure that faithfully reproduces the scene requires judgement and a possible adjustment of the "correct" exposure. Usually, a reading of the light incident to the front of the subject will preserve detail in those sections and let the backlit highlights burn out.

put the gray card in shadow and meter from it. Of course, highlight detail can burn out in this case. In scenes composed of direct light and deep shadows, a setting between the two gray-card readings may give the best results. Parts of the shadows will lack detail and parts of the highlights will burn out, but this may give a better image than using either of the gray-card readings separately.

Let's go back to our examples to see how this gray-card procedure works in practice. When you expose the dark scene based on the gray-card reading, the subject will be reproduced as dark tones. However, the tones are reproduced on the low-contrast part of the film's characteristic curve, and there may not be sufficient tonal separation for the image to have impact. In this case, a better exposure of the subject might be one that gave slightly more exposure than the gray-card reading. Elements in the image might be lighter than they appeared in the scene, but the subject key would still be apparent. With this non-average scene, an interpretive exposure would probably give better

results than a "correct" exposure based on a gray-card or averaged meter reading.

Using the gray card as a reference with the backlit tree is a different situation. The light creating the highlights is direct sunlight, while the illumination of most of the subject area is indirect light reflected from the sky and surroundings. Because the influence of the specular highlights can't be eliminated from an average reading of the subject, you should use a gray-card reading of the indirect light striking the front of the subject. The highlights will be overexposed and burned out. Indirectly lit subject areas will be represented normally within the film's exposure range, creating a natural subject interpretation.

Bracketing—The case for bracketing exposures is obvious from both of these hypothetical, non-average situations. This is assuming, of course, that most photographers depend on the reflected-type meter built into their cameras. A spot meter would let you analyze the relationship of specific areas of subject brightness. Then by referring to a gray-card reading, you

could place the exposure of the subject where you choose, within the film's exposure range, and recreate the subject key in the photo.

Whether you expose a subject by the strict dictates of an averaged meter or gray-card reading, or according to your interpretation of the subject's visual effect has a profound influence on the success of the resultant image. Your best possible assurance of getting a successful image is to make several exposures. Bracket around the setting your analysis determines as the best exposure. I suggest you bracket a half step both ways.

Bracketing exposures is neither wasteful nor an adverse reflection on your skill as a photographer or the quality of your equipment. It is simply a rational acknowledgement that the representation of a subject on film is a success not because it is "correctly" exposed, but because it satisfies your personal taste and impression of the subject. The investment of a few extra frames of film is a small price to pay for results that fulfill your expectations.

THE CHARACTER AND SHAPE OF ILLUMINATED THINGS

Commonplace things that we can perceive may not be evident in a photograph because not all of the visual functions that make them recognizable to us are shared by the photographic process. Because of this, the effect of those it does have is critical. For this reason alone, you should be aware of the visual functions that affect only sight and those that affect *both* sight and photography. With this awareness, active control of light is most productive.

EFFECTS OF THE SOURCE

The nature of the source, especially its size in relation to its distance from the subject, plays a critical role in how shape, size, distance and surface texture are represented in a photograph. I think it's best to use simple models lit in different ways to help you gain an awareness of the effects of different sources. These examples will show various qualities of light and their effect in an image. Ideal subjects in this case are simple, easily recognized forms that have uniform reflectivity—a cube, a sphere, and a mannequin head painted flat, medium gray.

Hard and Soft Light Effects— First, we'll see the effect of the relative size of the source—how hard light from a relatively small source and soft light from a large source are produced. Let's isolate the effect of those two sources to just the representation of the subject's shape.

I made two photos of the models using two different light sources. For one photo I used a small spotlight about two inches long placed in quarter position. The light source was far enough away to just light the subject area. For the second photo, I used a large softlight about 40 inches long in the same position as the first source.

By comparing the accompanying photos produced by these two light sources, you can see that they both reveal the contours, flat planes and sharp edges defining the shapes of the objects. Distinct differences are also evident. The spotlight produces shadows defined by hard lines. The shadows are deep and evenly toned, creating an appearance of strong contrast. The same subject lit by the large source has shadows that are not distinctly shaped because the shadow tones are softer. The image seems much less contrasty.

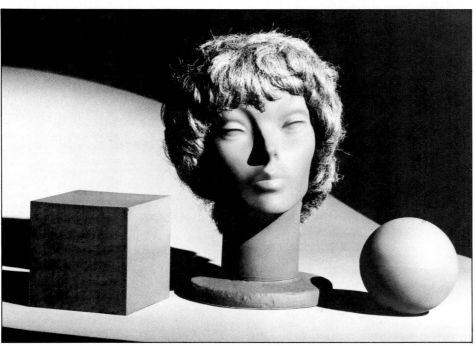

Test subjects lit with an optical spotlight from the right quarter direction produced sharply defined shadows that typically occur with hard light.

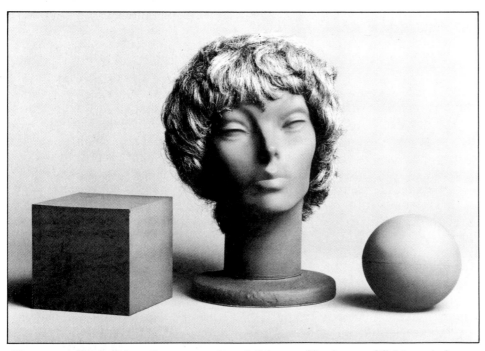

The same subjects lit from the same angle and distance with a large softlight created gentle tonal gradations between highlights and shadows. This is typical of a large, broad source producing soft light.

Shadow Effects—Shadows in a photographic image help create a relationship between the elements comprising the scene. Receding or converging shadows also help to provide an effect of distance.

Natural light gives another opportunity for comparison, but the difference is more pronounced. Objects struck by direct sunlight cast very distinct shadows. When the sun is obscured by an overcast of thin clouds, its light is spread out and diffused so much that it's almost directionless. The shadows cast under this very soft light are practically indistinguishable.

Textural Effects—The quality of light and shade created by hard and soft light also affects the representation of surface textures. In a photograph, which is two dimensional, only the highlights and shadows can represent what in reality are distinctly raised and indented surface shapes.

For example, the small irregularities in the surface of a stucco wall may not be apparent

The definition of shapes in a subject lit by the very soft and even illumination of an overcast sky is revealed only by differences in subject reflectivity.

when illuminated by relatively directionless soft light. However, the ridges, bumps, and depressions of stucco become apparent when the surface is illuminated by hard light from a relatively small source. Hard light striking a textured surface at an angle hits the

raised portions of the surface, creating highlights. Indented areas adjacent to the raised portions are in shadow, and some areas reflect a value between highlights and shadows. The lighter highlights seem closer than midtones, and shaded areas seem farther away.

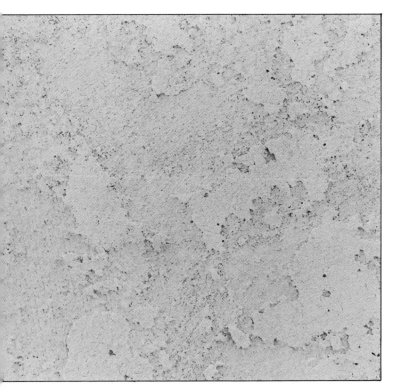

The uniform tone of a stucco wall in soft, open shade gives little indication of the surface's roughness.

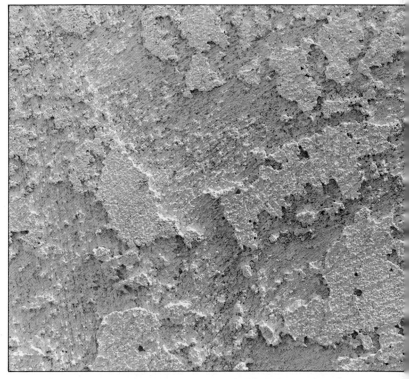

Hard, direct sunlight skimming across the surface of the same stucco wall creates highlights and shadows that define the surface texture.

19

Contrast Effects—A textured surface with subtle tonal differences will exhibit high local contrast when struck by direct, hard light. Another textured area with much greater tonal differences has low local contrast when in shadow and lit by skylight and reflections.

An example of this is a light, evenly-colored, textured rock wall in direct light. It appears to have greater contrast than doors of dark, multitoned and textured wood in the indirect, soft light of shade. If the rock wall and doors receive soft illumination from the same source, the opposite conditions of local contrast are apparent. The rock wall has very low contrast and the dark doors show relatively higher contrast.

Although similar effects are common, this particular effect on local contrast cannot be taken as a general rule. There are exceptions that produce just the opposite effect. Each source displays its own particular qualities. These qualities affect different subject features in different ways.

The reflectivity of the stone wall surrounding the weathered doors is uniform. Cross light brings out the texture of the wall's surface, creating a relatively strong area of local contrast. Doors set into the wall, however, are illuminated only by open shade, which is soft front light. Even though the doors have a greater reflectivity range than the stone wall, they don't appear to in this photograph.

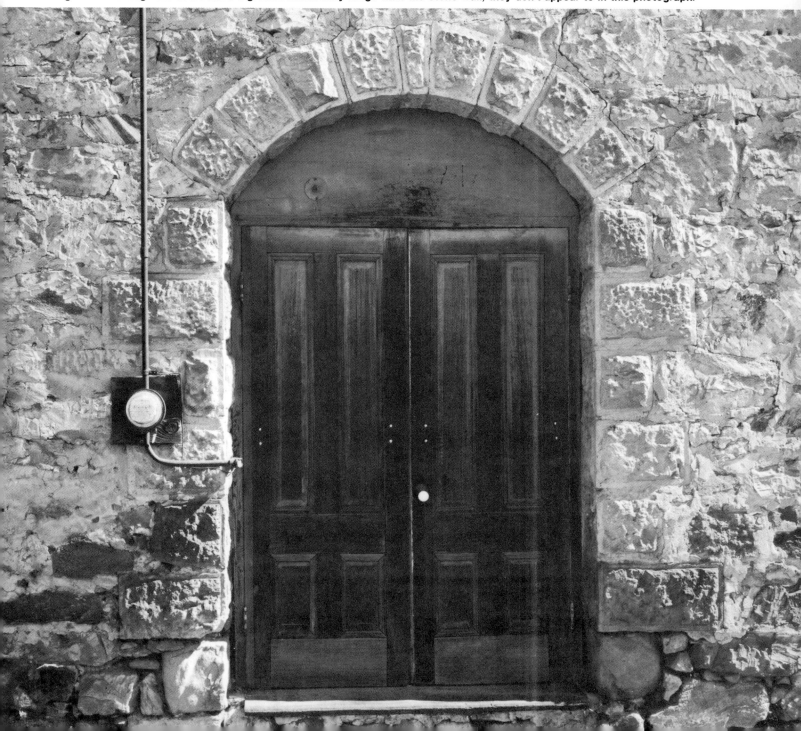

EFFECTS OF LIGHT DIRECTION

Implicit in the photographs illustrating the effects of hard and soft light on a textured stucco wall is the effect of light direction or the angle of incidence. To demonstrate the effects of light direction on shapes in a photographic image, let's use the models again.

Front Lighting—As a basis for comparison, I lit the objects with an electronic flash attached to the camera. With the light source in this position, the angle of incidence is almost zero. This flat, front lighting produced little modeling of subject shapes. Surfaces facing the camera reflect much of the light falling on them, creating subtle highlights on matte surfaces and strong specular highlights if the surface is smooth and shiny.

As subject shapes curve away from the subject plane, there is a loss of reflected light, even though the subject's reflectivity remains the same. Subject planes almost parallel to the lens axis are reproduced as dark tones. This fall-off of light models the subject.

If the light source is increased in size to several square feet rather than just a few square inches and the source remains adjacent to the camera lens, less fall-off and modeling result. If the source size is increased so light strikes the subject from as much as 45° from the lens axis, light fall-off disappears entirely. Subject shapes are not very distinguishable in the photo.

Then I positioned a small light source above the camera with a vertical angle of incidence approximately 30° from the lens axis. The subject remained front lit, but some shadows are created, improving the modeling of the subject.

This minor change in light direction significantly increased definition of the subject. Because the light source is still at a 90° angle to

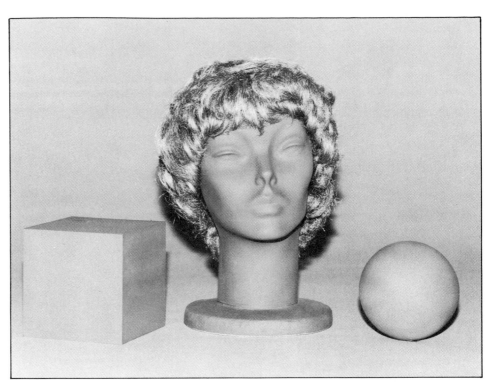

For this photo I used front lighting from a portable flash mounted on the camera.

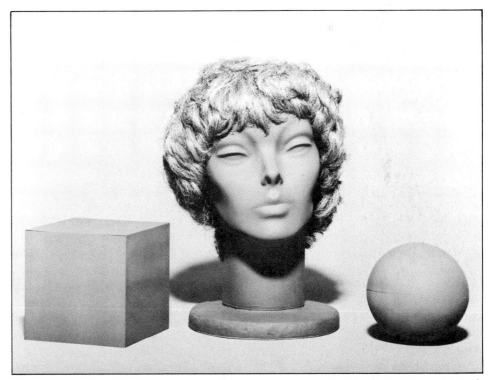

Front lighting for this photo was created with a 10-inch photoflood source positioned directly above the camera and raised 30° above horizontal.

the subject plane, most of the subject remains lit. The effect of the flat light is retained, but definition of subject shapes is improved by moving the source a small distance above and away from the camera.

In addition to the improved modeling by light from above, there is also a psychological benefit. The light we are most used to, from the sun and indoor artificial sources, originates from above eye level. Light from an angle above the camera models subject features with shadows and highlights in a familiar way.

21

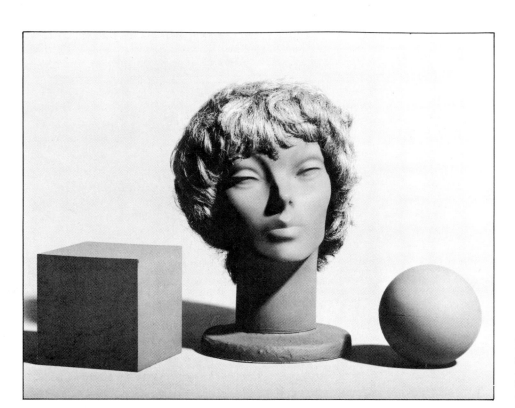

For quarter lighting I positioned the source 45° to the right of the lens axis and 30° above horizontal.

Quarter Lighting—For the next example, I kept the light source above camera position but moved it to one side at a 45° angle from the lens axis. This created quarter lighting.

From this angle, the light source illuminated the protruding features of the subject and created shadows. This provided additional image information that helps define shapes. Quarter lighting is a good choice when you need to keep a large portion of the subject illuminated directly and still model subject shapes.

When the source is relatively small and produces hard light, there is a disadvantage to quarter lighting. Detail is lost in the shadows. Without sufficient illumination in the shadows, the contrasty effect can be unpleasant.

These problems are partly remedied when you use a relatively large source, such as a softlight, in quarter position. In this case one edge of the softlight is close to the camera lens axis. Even though the shadows due to the soft light are essentially the same shape as those due to the hard light, illumination from the outer portions of the larger source wrap around the protrusions that cast the shadows. This fills those shadows with light.

The wrap-around effect lets you use a softlight as a single source. This way you can create angled light for good subject modeling without a contrasty effect and loss of image detail in shadows. This is also apparent in the photos on page 18 showing the effects of a hard and soft light.

Quarter lighting has been a basic position for the main light source in traditional studio portraiture. When b&w photography dominated the commercial portrait business, a hard source was frequently used as a main light in quarter position.

Now that color photography has essentially replaced b&w commercial portraiture, softer sources have become more common to reduce the contrasty effect of the lighting.

Side Lighting—Moving the light source in line with the subject plane produces side light. A much larger portion of the subject is in shade than with quarter lighting. With side lighting, it makes relatively little difference whether the source produces hard or soft light. Substantial portions of the subject are without light, creating shadows with little or no detail.

You can use these shadows in some photos. When you need strong contrast to separate a subject from background with a similar tone, use side lighting. If the subject surfaces are textured and parallel to the subject plane, side light creates the strongest contrast between raised and indented elements. This reveals them most dramatically in a photograph. Side lighting can be used with human subjects to create drama and mystery, or to make a round face appear longer.

When you use side lighting, the height of the light source is much less important than it is with either front or quarter lighting. The same psychological functions do not come into play because side lighting is naturally associated with the low angle of the sun at dawn or sunset or the effect of window light. If the height of the source is within your control when you use side lighting, adjust it for best subject modeling.

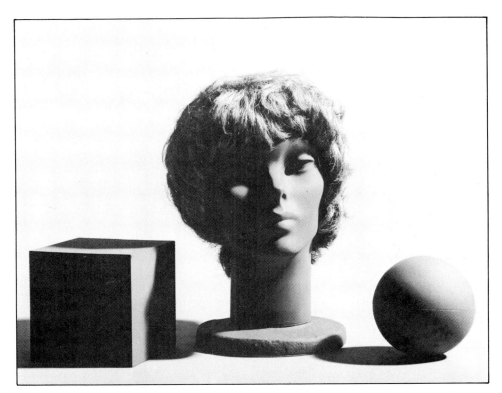

Here I created side lighting with the source 90° to the camera axis, and 30° above horizontal.

Back Lighting—When you place the primary light source anywhere behind the subject plane, the subject is backlit. This produces the most diverse effects of light. With back lighting, the source may be within the field of view.

If the source is relatively small and intense, such as the sun on a clear day, it can record as a highlight with star-like flares radiating from it. This is caused by the shape of the lens aperture formed by blades of the diaphragm. In some cases, particularly with wide angle lenses, a series of "ghost" images of the aperture radiate away from the source highlight. These are multiple reflections created by light reflecting off the lens elements.

Back light is used to outline shapes, separating similarly toned objects from one another with a rim of strong highlighting around each object. This is often referred to as *rim lighting*. Back light that rims subject shapes can be used effectively in natural scenes, separating and defining shapes that recede into the distance.

I used a wide-angle lens and back light to include the light source in the picture. The shape of the lens diaphragm causes the star-shaped flare pattern. Multiple reflections on the lens elements create a series of diaphragm-shaped ghost images in line with the source.

Another advantage of rim lighting is that the visual effect does not require detail in the highlights. You can adjust exposure and image contrast to define the rest of the image area. You can expose a rim-lit subject by overexposing the backlit highlights.

With b&w photography you can also ignore the very long subject brightness range that includes the backlit highlights. Adjust film development to create close-to-normal negative contrast within the subject areas unaffected by the backlight. This technique of exposure and development of rim-lit subjects insures adequate contrast and tonal separation of the areas not affected by the back light.

Another function of back lighting is similar to side lighting in the way it defines textured surfaces. Textured surfaces almost parallel to the lens axis may exhibit strong contrast between highlight-raised and shadow-indented irregularities in the surface. Smooth surfaces parallel to the lens axis may reflect back light to create sharp, gradated specular highlights, depending on how smooth and shiny the surface and how hard or soft the source.

Rim lighting is a technique using back light to create highlights that outline the shape of a subject.

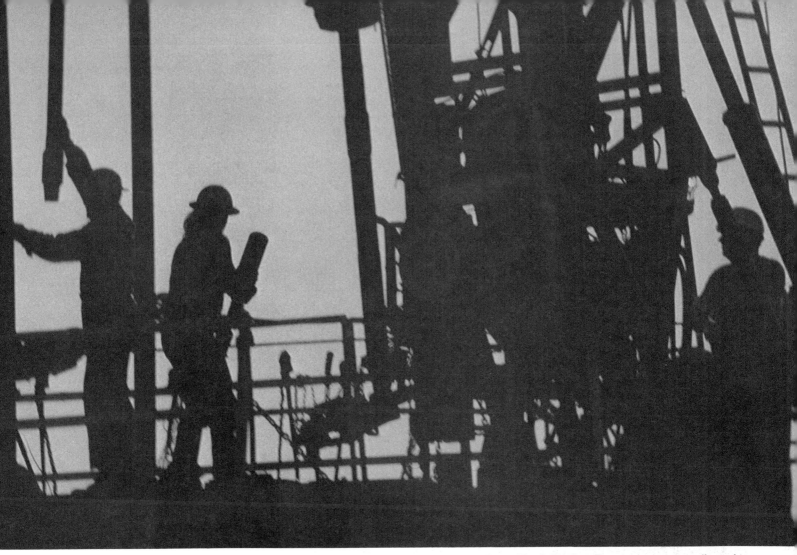

This silhouette of oil-field workers at a derrick demonstrates an extremely dramatic effect of back lighting. The exposure was adjusted to reproduce a midtone density of a broad diffuse light source. Photo by Richard Y. Fukuhara.

THE EFFECTS OF REFLECTION

When considered as a *source* of illumination, reflections are indirect light. Due to selective reflection and the texture of the surface, the qualities of reflected light may be different than those of the original source.

For example, imagine a scene with the subject in the shade of a building. The light illuminating the subject is primarily reflected sunlight from a light-yellow building on the other side of the street plus some illumination from open sky above. The warm light reflected by the building mixes with the cool light from the sky, but the highlights created by the sky light are cool.

In addition to the complex color qualities of the light, let's also assume that the yellow building has many small-paned windows reflecting rays of sunlight into the subject area. These rays may create subtle reflections that you would not expect to find in a shaded area. This example is hypothetical but not impossible.

Reflecting surfaces contribute with many variations to the qualities of sunlight. When photographing with reflected light, be aware of the nature of the reflecting source and the qualities of the original source to judge their combined effect on the image.

Light Loss Due to Reflection— Reflected light is invariably less intense than the primary light source being reflected. This is due to two factors. The first is that all reflective surfaces reflect less than 100% of the light that strikes them. Some light is absorbed, some scattered, and the rest reflected toward the subject.

The second factor is that reflected light striking a subject travels farther than the direct light on the subject. Because light from most artificial sources diverges as it travels away from the source, the area covered by the light grows proportionately greater as the distance from the source increases.

Inverse Square Law— As the distance between source and subject increases, the amount of light on the subject decreases inversely with the square of the distance. When the distance doubles, intensity decreases by a factor of four. For example, the intensity of light ten feet from an artificial source is one-fourth the intensity of the light five feet from the source.

In practice, the Inverse Square Law has a significant effect only on light from sources that produce divergent light rays. When the sun is a direct source of light, its light rays do not diverge and the inverse square law does not apply. However, when sunlight strikes a reflective surface that is not mirror-like, divergent rays result. The reflecting surface becomes the source of light, and the Inverse Square Law applies. See the accompanying diagram.

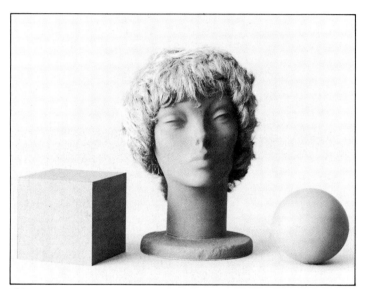

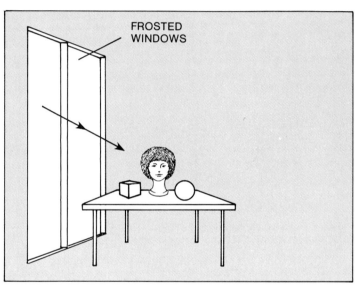

Although the sun is the primary light source, the direct source for this photo is the frosted window area. It diffuses sunlight and provides soft illumination on the test subject.

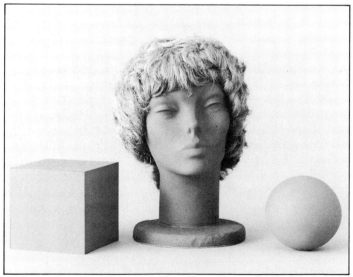

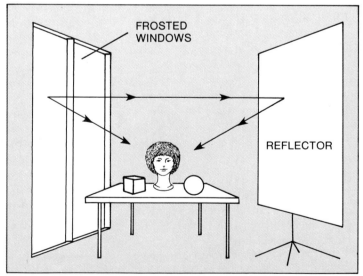

I reduced the light ratio by using a very bright reflector opposite the windows to fill the shadows. The amount of light reflected from a surface depends on its reflectivity and also on the light fall-off due to the increased distance the light has to travel. As the distance from the windows to the reflector increases, less fill light strikes the subject.

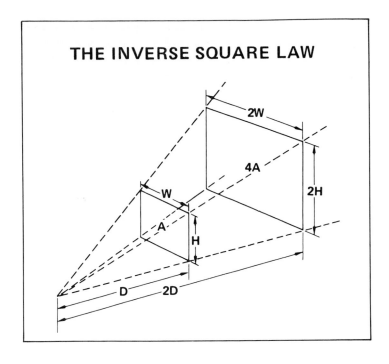

THE INVERSE SQUARE LAW

As an expanding beam travels farther from the source, it illuminates larger surfaces. This illustration shows that as the distance doubles, the illuminated surface quadruples. Because the same amount of light is distributed over an area four times larger, the intensity is one fourth as much.

Other Qualities of Reflected Light—Other qualities of reflected light may remain unchanged from those of the incident light, or they may be altered in several ways. For example, a flat, mirror-like surface reflects hard light when hard light strikes it and soft light when soft light strikes it. An irregular shiny surface reflects most of the light but scatters the light in different directions, changing hard light to soft light as the size of the reflecting surface is increased.

Mirror-like surfaces, such as chrome and glass, reflect the full range of the visual spectrum. Matte surfaces that appear gray also reflect all colors of the incident light. However, some light is absorbed.

Reflecting surfaces appear colored because they reflect light selectively, reflecting some portions of the spectrum and absorbing other portions. Remember, a color absorbs its complement and reflects the other colors.

For example, if tungsten light is reflected by a warm-colored surface some of the blue light is absorbed, making the tungsten

Reflective surfaces that are both smooth and shiny, like still water, redirect the light rays relatively intact.

light even warmer than before. When the same tungsten light is reflected by a blue surface, much of the warm portion of the light is absorbed and most of the colder portion is reflected. This shifts the color temperature of the reflected light closer to standard daylight.

When photographing outdoors with the sun as the direct light source, you must be aware of the way different materials can change the quality of reflected light. Rather than assuming daylight is always the same, you should carefully evaluate the intensity of reflected light; its effect on shadow illumination; whether or not it softens the light; and its effect on the color of the reflected light.

EFFECTS OF THE ENVIRONMENT

Besides reflections from surroundings, there are also other important environmental conditions you should know about. Then you can anticipate their potential influence when actively controlling light. Some are the enclosure or openness of space; subject distance; atmospheric conditions; and the balance of different secondary light sources.

Space—Again let's use a simple example, the experience of a novice photographer. His experience with a manual electronic flash on his camera has been indoors, calculating exposures with guide numbers. He has obtained well-exposed results on most occasions, but now he decides to take a picture outdoors at night with the same flash. Instead of getting the well-exposed pictures he expects, the pictures are underexposed.

Here's what happened: Inside a room with typically light-colored walls and ceilings, a considerable amount of light emitted by a flash bounces around the room, adding to the direct light from the flash. Flash guide numbers are based on indoor photography.

Outdoors, all that reflected illumination was lost into space, and the subject was lit only by direct rays from the flash. The difference between the closed, reflective indoors and the open, non-reflecting outdoors is enough to cause noticeable underexposure. With a better awareness of how light reacts in different spaces, this photographer could have avoided underexposure.

When a shiny surface is textured, as water is when affected by wind, light rays are dispersed in many different directions.

Distance and Atmosphere—Our imaginary photographer has just acquired a long-focal-length telephoto lens. Noticing an interesting group of trees standing out in strong side lighting some distance away, he makes an exposure with the new lens. The resulting photograph is disappointing because it has much less contrast than the photographer expected. Two environmental factors caused the problem—distance and atmosphere.

When we look at a scene, our eyes take in a wide angle of view even if we are focusing our attention on a distant object. So when we concentrate on a distant object, we get an idealized impression of contrast because other things we can see are not the center of attention. However, if we take a picture of the scene, objects in the foreground have much greater contrast than those in the distance. Unlike our vision, photography does not have the ability to automatically compensate for low contrast scenes.

When you use a long-focal-length lens, it seemingly brings the subject closer, but it does not compensate for the distance the light travels through the atmosphere. Air contains dust and moisture particles that reflect and scatter light. When we take a photograph of a distant subject, the light is scattered by particles in the air, reducing the clarity and contrast of the image. As distance increases,

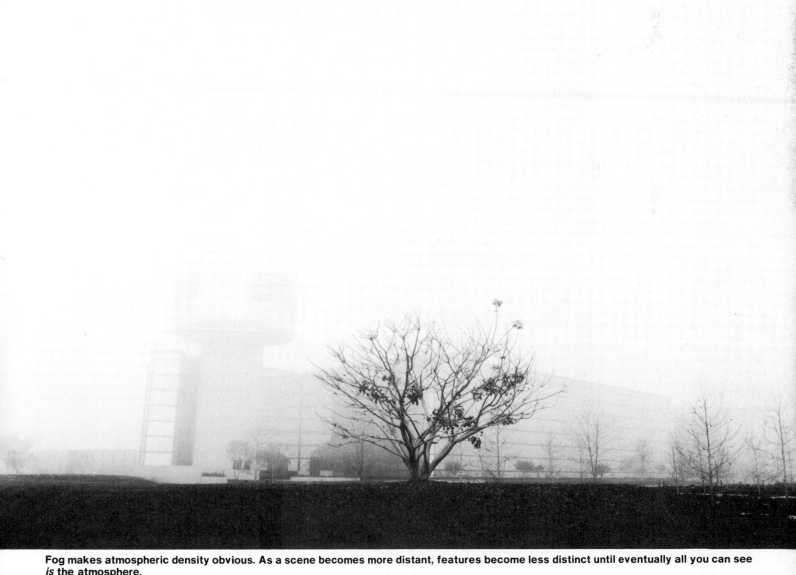

Fog makes atmospheric density obvious. As a scene becomes more distant, features become less distinct until eventually all you can see *is* the atmosphere.

more light is scattered because it travels through more particles, lowering image contrast further.

When atmospheric conditions are visually apparent, their effect is obvious. Intense haze or fog may function as the direct source of incident light, while at the same time obscuring what you see and photograph. On a foggy day we are very aware of how the atmosphere interferes with seeing subjects. It's when the effects of the atmosphere are not visually obvious that they are ignored. In this case the effect on image formation may come as an unexpected surprise.

As subject distance increases, light rays reflected by a subject travel through more and more atmosphere. Dust and moisture particles in the atmosphere scatter the light, lowering contrast.

Controlled Environment—You can do little about many environmental conditions that affect photography because they are essentially unalterable. You must deal with them passively through an awareness and understanding of their effects. Then you can control the light entering the camera lens.

However, active control is possible in an environment chosen or designed for photography. Whether that environment is a studio or an outdoor location, the factors of reflection, space, distance and atmosphere should be part of your control. An indoor space is as much a part of the lighting as the light sources you use to illuminate the subject.

There is no one way to design an ideal photographic environment. One photographer may want to maximize the effect of reflective surfaces to bounce light or use window light efficiently to keep the lighting contrast as low as possible.

Another photographer may do the opposite and use dark, non-reflecting floor, ceiling and walls to minimize reflections. This way he can create the most possible contrast. A photographer who uses color films may want the environment to be absolutely neutral in its effect on color, or a warm color may be desired to create a certain effect.

Ceiling height limits the vertical angle of incidence on subjects of various heights. The size of the space might also limit some horizontal lighting angles. In addition, a small space with light-colored or white walls and ceiling is reflectively more efficient than a larger space because the fall-off of reflected light is less.

The orientation of a space lit by daylight affects the intensity and color of the available light. The traditional northlight studio, which has windows facing north, presents problems for the color photographer. Light from the sky is very blue and of relatively low intensity.

I converted a living room to an efficient daylight studio by frosting the windows to disperse and diffuse the sunlight entering the room. The walls and ceiling were painted with white, semi-gloss enamel, and the floor was covered with white tile. This makes reflectors out of all the surfaces. Regardless of what direction the camera is pointed, the light ratio remains within a limited range. This is ideal for color photography.

A studio with south light receives direct sunlight, which is hard and requires diffusion to match the soft light of the north-light studio. Direct sunlight from the southern exposure also provides a much higher light intensity and a daylight color temperature closer to 5500K light.

Choosing an outdoor location should include a consideration of the environmental effects on the light available, in addition to the appropriateness of the setting for the subject. For example, very few photographers pay as much attention to what is behind or beside them as they do to the subject in front. It is necessary to observe all of the environment rather than just paying attention to the small part seen through the lens.

Cross light striking a subject from both sides is rare and disconcerting. But an unnatural subject in the artificial environment of Las Vegas makes this lighting effect plausible.

light sources both in the studio and on location. Frequently, one of several lights is used as a primary source and is often referred to as a *key* or *main light*. It usually has greater intensity than the others. Light sources other than the primary source usually serve one of three functions—to provide fill light to shadow areas created by the primary source; to provide illumination for areas of the subject not lit by the primary source, such as a background; and to provide accent light to create limited areas of highlights in the subject. The last is often called a *kicker* or *hair light* in portrait photography.

There is an almost universal rule in using multiple sources of artificial light: *The lighting effect should illuminate the subject in such a way as to mimic natural light conditions or familiar indoor light.*

This will create a psychologically comfortable effect in the photograph. For instance, photographers usually avoid having more than one shadow cast by a subject even though the subject is lit by more than one source. Besides being an unfamiliar phenomenon, multiple shadows unnecessarily complicate the image. The only common exception occurs when interiors are photographed because we expect multiple sources of artificial light.

Generally, each light of a multiple-source setup should have the same quality as the others. This is most important when using color films because they are balanced for either daylight or tungsten light. If you light a subject with both daylight from windows and incandescent house lamps, the color-temperature difference between the sources will be apparent in a color photograph.

If you use tungsten-type film, the areas lit by window light will be excessively blue, while areas lit by household lights will be too warm. If you use daylight-type film in such a mixed-light situation, the areas illuminated by daylight will reproduce correctly while the areas

THE EFFECTS OF MULTIPLE LIGHT SOURCES

Sunlight, whether direct or redirected by overcast clouds, is a single main source that defines highlights and shadows. All other sources of illumination of a naturally lit subject—reflections from various surfaces or light from open sky—are secondary and invariably much lower in intensity than the primary source. Light from the sun can display simple qualities outside in the open on a clear day or more complex characteristics when sunlight is indirect.

Even though the varieties of natural illumination are numerous, they are sufficiently limited and so visually familiar that they are always psychologically comfortable. Even on rare occa-

sions of unusual atmospheric conditions that produce striking visual effects, we can recognize the naturalness of the source and be comfortable with the effect.

With artificial light sources, any number of primary sources of light are possible. When several lamps illuminate a family living room, we are also psychologically comfortable. However, multiple sources of light on a subject outside of an accustomed, identifiable environment can be both unnatural and visually unfamiliar. When an unfamiliar subject is lit artificially by multiple sources, the result does not conflict with our experience and expectations so it can be pleasing.

Many photographers who work with artificial light use multiple

lit by the incandescent lights will be visibly warm.

Another problem can occur when you use electronic flash as a secondary source to sunlight for shadow fill. Electronic flash is color balanced to simulate standard daylight, about 5500K. If you use the flash at the beginning or end of the day when light from the sun is much warmer than 5500K, the flash light will not match and gives a cool cast to the shadow areas in a photograph.

Although using multiple light sources presents potential problems, the effects can also be used to intentionally create unusual images that would not otherwise be possible. To create unusual photos you can mix and use different sources that are essentially incompatible for normal purposes.

CONTROLLING LIGHT WITH FILTERS

Passive control of reflected light is essential to creating a photo that meets your expectations. It's important to remember that film can respond to reflected light qualities that are either beyond the scope of our vision or not readily apparent. Film records an image differently than we visualize it.

As mentioned before, the color sensitivity of color films is balanced for only three kinds of light—standard 5500K daylight and tungsten light of either 3200K or 3400K. Color and b&w films also have varying degrees of sensitivity to unseen portions of the spectrum, both ultraviolet and the near infrared.

When you use films with light sources other than those they were designed for, you may not get the best image qualities. Many photographers passively control the reflected light with filtration to better match the light to the characteristics of the film. In addition to these correction filters, there are others you can use to increase the impact of the image.

KODAK WRATTEN LIGHT-BALANCING FILTERS			
Effect on Light	Filter	Change in Color Temperature (K)	Exposure Correction (steps)
Warming (amber)	81	-100	+1/3
	81A	-200	+1/3
	81B	-300	+1/3
	81C	-400	+1/3
	81D	-500	+2/3
	81EF	-650	+2/3
	85C	-1700	+1/3
	85	-2100	+2/3; To balance type A film with 5500K light.
	85B	-2300	+2/3; To balance type B film with 5500K light.
Cooling (bluish)	82	+100	+1/3
	82A	+200	+1/3
	82B	+300	+2/3
	82C	+400	+2/3
	80D	+1300	+1/3
	80C	+1700	+1
	80B	+2100	+1-2/3; To balance daylight film with 3400K light.
	80A	+2300	+2; To balance daylight film with 3200K light.

Color Correction Filters—There are two basic kinds of color correction filters. One corrects the color balance of the light source to match the film's sensitivity. These *light-balancing* filters are various densities of blue for cooling a warm color and various densities of orange-brown for warming cool colors. They are available in gels or glass screw-in filters that fit on your lens. See the above table.

RECOMMENDED CORRECTION IN EXPOSURE STEPS FOR KODAK COLOR-COMPENSATING (CC) FILTERS			
Subtractive Primary Colors		**Additive Primary Colors**	
CYAN (Absorbs red light)		RED (Absorbs blue and green light)	
CC025C	0	CC025R	0
CC05C	+1/3	CC05R	+1/3
CC10C	+1/3	CC10R	+1/3
CC20C	+1/3	CC20R	+1/3
CC30C	+2/3	CC30R	+2/3
CC40C	+2/3	CC40R	+2/3
CC50C	+1	CC50R	+1
MAGENTA (Absorbs green light)		GREEN (Absorbs blue and red light)	
CC025M	0		
CC05M	+1/3	CC05G	+1/3
CC10M	+1/3	CC10G	+1/3
CC20M	+1/3	CC20G	+1/3
CC30M	+2/3	CC30G	+2/3
CC40M	+2/3	CC40G	+2/3
CC50M	+2/3	CC50G	+1
YELLOW (Absorbs blue light)		BLUE (Absorbs red and green light)	
CC025Y	0		
CC05Y	0	CC05B	+1/3
CC10Y	+1/3	CC10B	+1/3
CC20Y	+1/3	CC20B	+2/3
CC30Y	+1/3	CC30B	+2/3
CC40Y	+1/3	CC40B	+1
CC50Y	+2/3	CC50B	+1-1/3

ment affect the color reproduction. Use a number of CC filters of varying color densities that would likely correct an imbalance the source tends to indicate.

Using the window-lit room as an example, you know that skylight coming through the window will need correction for excess blue. In this case, you could choose a gel filter from the Kodak Wratten 81 series. Then you expose the color film to a standard test subject, such as a color checker or a skin tone and gray card. Bracket exposures with each of the filters or filter combinations you are testing. Use the processed images to find the exposure and filtration that gave the best results. You should do such a test for each type of color film you plan to expose whenever you expect to use a certain environment and light source often enough to justify the time and expense of the test.

The other kind of color correction filter corrects an excess or deficiency of one of the primary colors, as reproduced on film. These color-compensating, or CC, filters are made in a series of densities in all of the additive and subtractive primary colors. The most common variety is the 3x3 inch (75x75mm) gel.

Mixed Light Sources—A combination of light sources that come close to a photographic light standard is difficult to identify visually. For example, a window-lit room may be receiving a mixture of light from the sky and reflections from several surfaces next to the window. A test with color film is the best way to determine how a particular light source and environ-

The Macbeth Color Checker serves as an excellent model for testing the effects of color filters with a particular light source and color slide film. Make a short bracketed series of exposures with each filter. When the film is processed, cull the under- and overexposed frames. You can then identify the filter that produces the most desirable color rendition from the remaining exposures.

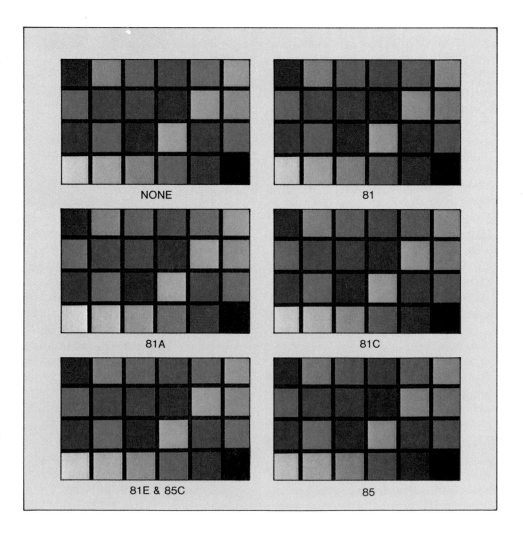

NONE

81

81A

81C

81E & 85C

85

Adjusting Color Reproduction—Although all color films are balanced for a neutral response to one standard color temperature, this does not mean that different color films reproduce the same subject colors identically. For example, one film may reproduce skin tones well while another under the same conditions yields tones with too much magenta. According to the usual method of correcting for an imbalanced source, you could use a green gel filter over the lens to absorb excess magenta. However, the effect of green filtration may produce a skin tone that is too neutral and a green cast in more neutral subjects.

Magenta is a component of normal Caucasian skin. Excess magenta in an image may be due to a relative weakness of the film's cyan and yellow dye layers. Rather than thinking subtractively to eliminate magenta, you could add some yellow and a little cyan filtration to correct the skin tones. A test with different filtration will indicate what works best.

Fluorescent Lights—The continuous light produced by a source can be divided into three basic components.—red, blue, and green light. Color temperature is a way of stating the relative amounts of each. However, some common light sources, such as fluorescent lamps, also emit narrow bands of light from certain parts of the spectrum. This makes color temperature ratings an unreliable way of predicting their effect on film.

For example, the most common daylight-type fluorescent tube produces continuous light with a color temperature that corresponds to 5500K light within a few hundred degrees. However, daylight-balanced color film typically responds to this type of light with an objectionable bluish-green cast. This happens because narrow spectral bands in the blue and green portion greatly influence the photographic results.

The usual color correction for matching daylight-type fluorescent light to daylight-balanced color films is to use a complementary color filter for each of the primaries in excess. A substantial amount of magenta and yellow filtration is usually recommended by the lamp manufacturer to reduce the green and blue bands. Use these recommendations as starting points for your own tests.

Each type of fluorescent lamp will affect each color film differently, necessitating different filtration for best results.

You can also use special light-balancing filters for fluorescent lights. These filters screw into your lens. They are designed to give approximate and convenient color correction with most kinds of fluorescent lights and color films.

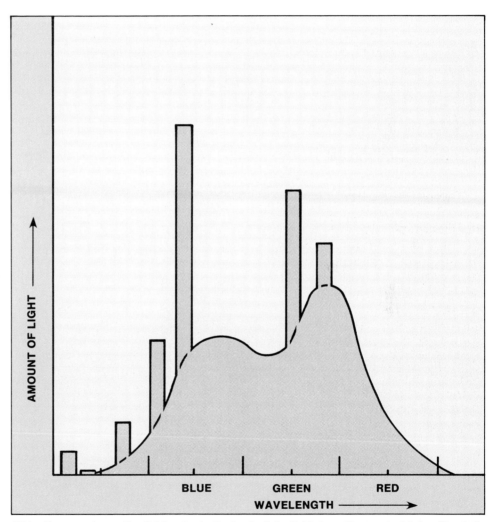

This diagram shows the light output of a typical daylight-type fluorescent tube. The tall spikes rising from the continuous curve are spectral bands of blue and green light. We don't notice them, but daylight color film does, giving a bluish-green cast to the image.

Reciprocity Failure—Films respond predictably only to a limited range of exposure times. When you use an exposure time either longer or shorter than the range for which the film was designed, the film loses some sensitivity to light—called *reciprocity failure*.

Film manufacturers deal with the problem of reciprocity failure by recommending exposure-correction factors you should use with long or short shutter speeds. Color correction filters are also recommended for color films because of the color change due to reciprocity failure. In addition, b&w films require a change in development to compensate for reciprocity failure. Remember that this information is only a guide. I recommend that you bracket around these recommendations for best results.

If possible, make film tests before the final shooting by bracketing exposures around the manufacturer's recommendations. Lighting conditions requiring reciprocity-failure correction are far from normal and may also vary in more ways than just intensity. Therefore, virtually any circumstance requiring reciprocity-failure correction is likely to involve other light qualities, such as color and light ratio, that you should consider and possibly correct for the final shooting.

EXPOSURE AND FILTRATION RECOMMENDATIONS FOR RECIPROCITY FAILURE IN SOME COLOR FILMS

FILM TYPE	INDICATED EXPOSURE TIME (sec.)			
	1/10,000	1	10	100
Color Negative Film				
Fujicolor F-II		+2/3 step no filter	+1-2/3 steps no filter	+2-2/3 steps no filter
Fujicolor F-II 400		+1 step no filter	+2 steps no filter	+3 steps no filter
Kodacolor II	none	+1/2 step CC15C	+1-1/2 steps CC30C	+1-1/2 steps CC30C
Kodak Vericolor II, Type S	none	NR*	NR	NR
Kodak Vericolor II, Type L	NR	see data sheet	see data sheet	see data sheet
Kodacolor 400	none	+1/2 step no filter	+1-1/2 step CC10M	+2 steps CC10M
High Speed 3M Color Print Film	none	+2/3 step no filter	+1 step no filter	+2 steps no filter
Color Reversal Film				
Agfachrome 64		+1/2 step CC10B	+1 step CC10B	+3 steps CC15B
Agfachrome 100		+1/2 step CC05B	+1 step CC10B	+3 steps CC15B
Fujichrome 100		none	+2/3 step no filter	+1-2/3 steps CC10C
Kodachrome 25		+1/2 step no filter	+2 steps CC10B	+3 steps CC20B
Kodachrome 40 Film 5070, Type A	none	+1/2 step no filter	+1 step no filter	NR
Ektachrome 50	none	none	+1/2 step CC10B	NR
Ektachrome 64	+1/2 step no filter	+1 step CC15B	+1-1/2 steps CC20B	NR
Kodachrome 64	none	+1/2 step no filter	NR	NR
Ektachrome 160	+1/2 step no filter	+1/2 step CC10R	+1 step CC15R	NR
Ektachrome 200	+1/2 step no filter	+1/2 step CC10R	NR	NR
Ektachrome 400	none	+1/2 step no filter	+1-1/2 steps CC10C	+2-1/2 steps CC10C
3M Color Slide Film 100	none	+2/3 step no filter	+1 step no filter	+2 steps no filter

*NR: Not Recommended

Recommended exposure compensations include the effect of the filter. If possible, make the correction with the aperture instead of shutter speed. For shutter speeds in between those listed here, estimate correction. Blanks represent unpublished data.

TYPICAL EXPOSURE INCREASE FOR RECIPROCITY FAILURE OF KODAK B&W FILMS				
Film Type	If Indicated Exposure Time Is (Seconds)	USE ONE OF THESE CORRECTIONS (NOT BOTH) Increase Aperture	Exposure Time	And Change Developing Time:
Panatomic-X	1/100,000	1 step	Use Aperture Change	20% more
Plus-X	1/10,000	1/2 step	Use Aperture Change	15% more
Tri-X	1/1000	None	None	10% more
	1/100	None	None	None
	1/10	None	None	None
	1	1 step	2 seconds	10% less
	10	2 steps	50 seconds	20% less
	100	3 steps	1200 seconds	30% less

Polarizing Filters—Light from direct sources vibrates in all directions perpendicular to its line of travel. When light is reflected from a surface other than painted metal, it becomes *polarized* and vibrates in only one direction perpendicular to its line of travel. For example, if it is reflected from a horizontal surface, it is polarized horizontally by the surface.

Because most subjects are composed of a variety of surface planes, light reflected from a subject vibrates in many different directions. A polarizing filter lets light vibrating in only one plane pass through the filter.

As you rotate the filter and view the scene through the lens, you can see the effect of polarization. Reflections from glass surfaces can be eliminated and glare reduced. Rotate the filter until you are satisfied with the effect, meter, and shoot. See the instructions for your camera or filter for information on metering through the filter. Some camera meters don't work well with these filters.

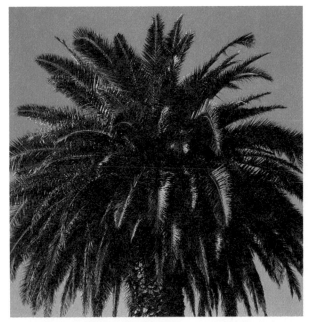 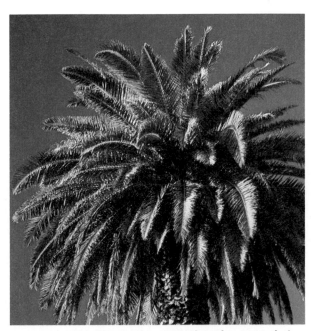

By removing some haze and glare, a polarizing filter can increase the contrast and color saturation of scenes photographed with color film.

Blocking Ultraviolet Radiation— Most light sources, especially the sun, produce some ultraviolet radiation. This is radiation that is outside the visible spectrum but not outside the range of film sensitivity. An unsuspected source of ultraviolet radiation is electronic flash. Although many modern flash units use a built-in filter to block ultraviolet, many older portable and studio flash units do not.

Ultraviolet can have several effects on the image. The most obvious is the blue cast that color films reproduce in light areas and the overall cool color balance of the image. Occasionally, an extreme color shift occurs when a garment with a fluorescent color brightener is lit by an unfiltered flash.

This has been a problem for many wedding photographers. The white bridal gown can be various shades from green to purple while everything else in the picture is colored normally. What happens is that the ultraviolet from the flash excites the fluorescent dyes in the material, producing colors that expose the film unpredictably.

In b&w photography, excess ultraviolet creates unwanted density in the negative, which makes the afflicted areas appear too light and lack detail in the print. This is a problem in landscape photography on hazy days. The haze scatters ultraviolet and this non-image-forming radiation reduces image contrast.

One of the qualities of ultraviolet radiation that is beneficial in b&w medical and scientific photography is its ability to penetrate. However, this is a disadvantage when you photograph people for esthetic reasons. The penetrating ability of ultraviolet can make skin blemishes more apparent, even through most makeup. Some photographers advise models to use a professional-type makeup, which contains pigments that block ultraviolet.

This scene of golden hills below a bright blue sky filled with white clouds was shot with panchromatic film with no filter over the lens. Notice how light the sky appears.

You can eliminate some of the effects of excess ultraviolet radiation by using a filter that absorbs only that portion of the spectrum. These are usually called *UV* filters. To visible light they are clear, so you can use them on your lens all the time to block ultraviolet radiation effectively.

Color Filters for B&W Film— There are two obstacles to our perception of colors reproduced in black and white. Some colors that appear dark and intense do not produce corresponding dark tones in the print. Different colors of equal brightness may reproduce with similar gray tones. For example, a b&w photo of a red rose against green leaves may show the rose and leaves as the same shade of gray.

The most common example of color misrepresentation in b&w photography is blue sky. We usually see it as being much darker than b&w panchromatic film actually records it. One reason is the ultraviolet radiation from blue sky. Another is that most panchromatic films are slightly skewed in their color response. They tend to be more sensitive to the blue portion of the spectrum.

For these reasons, many landscape photographers use a light-yellow filter over the lens to get a more natural representation of the scene, including the sky. The yellow filter absorbs ultraviolet radiation and some blue light, reducing the effect of blue during exposure and darkening the sky in the print. Orange and red filters will darken the sky even more.

An alternative to these filters is a light-green filter. It also absorbs some blue light, but also passes green light, which records dark foliage lighter relative to the tones representing the sky and red objects.

In the example of the rose, the leaves would reproduce much lighter than the rose. If you want the opposite effect, a red filter will make the rose lighter than the leaves. Color filters darken complementary colors and lighten their own in the b&w print.

When a #25 red filter is used over the lens, much of the blue and virtually all the ultraviolet radiation from the sky is absorbed, reproducing the sky as a much darker tone and creating a striking contrast with the clouds. The golden color of the field reflects a substantial portion of red light and reproduces with a comparatively lighter tone.

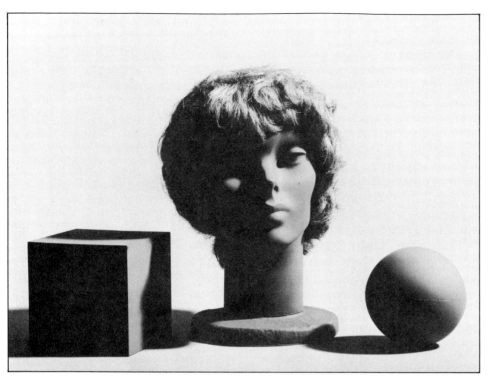

The test subjects are illuminated by a single source at right-quarter position 30° above horizontal. This creates a contrasty effect.

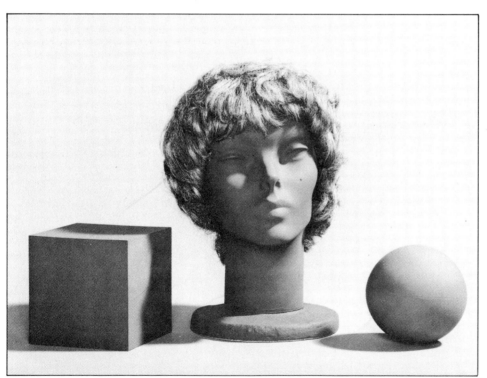

While keeping the quarter light unchanged, I added another light next to the camera lens to fill the shadows created by the first light. This lowers lighting contrast.

LIGHT AS CONTRAST

Subject contrast is a combined effect of the subject's reflectivity range and the light ratio. It can also be described as the subject brightness range. We usually think that a subject with a high light ratio appears contrasty. If you add more light to fill the shadows to reduce the light ratio, then subject contrast decreases. You would expect that the contrast in a print made of each of these lighting setups would be different.

Actually, the range of densities in each print representing the extremes of shadows and highlights is the same. The objective difference is that shadow areas with little detail in the print of the higher light ratio are a greater part of the image than with the other print. When the light ratio is reduced, much of the shadow area creating the effect of contrast is made of midtone densities, creating an illusion of contrast difference between the prints of the two setups.

Most average subjects photographically reproduced with the full range of densities have the same image contrast, as measured by density range. If the light ratio is low, the image will be composed of predominantly light tones, creating what is called an *open effect*. If the light ratio is higher, detail of low reflectance elements in shadow may be lost. In addition, a greater portion of the image area consists of darker tones, creating the *effect* of greater image contrast.

This lighting effect on contrast makes photographic images appear to differ in contrast as they do in reality, though the range of densities in the reproduction may actually be the same. Even though there is a limited range of densities available in the photographic image, you should consider controlling lighting contrast for its effect on the reproduction of the subject.

For example, the limited exposure range of early color films led film manufacturers to recommend

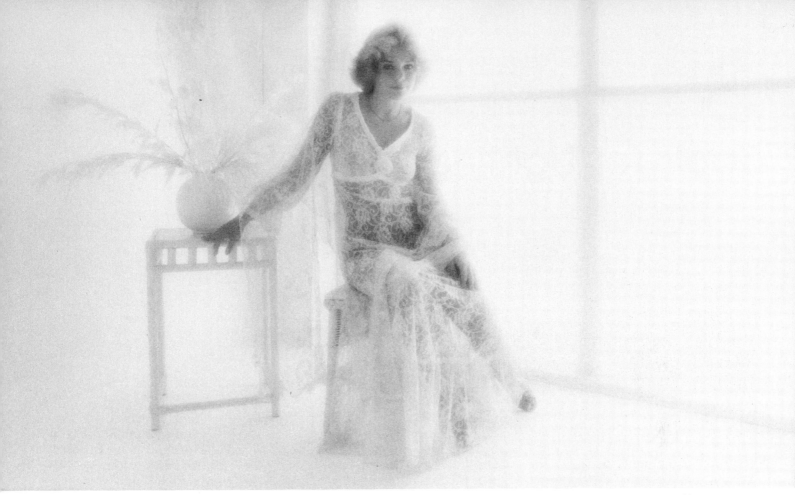

A softly lit high-key subject made up of predominately light tones may appear to have a short subject brightness range. However, you should not immediately assume that underexposure and overdevelopment are required to preserve this effect in the resulting image.

using no more than a 1:3 light ratio for color photography. This way the subject brightness range would not exceed the exposure range of the film. This recommendation produced color photographs with both textured highlights and detailed shadows when the film was properly exposed.

Eventually, photographers realized that this limitation on lighting contrast produced photographs of boring similarity, regardless of subject differences. Then they began to expose color films to subjects with both longer and shorter subject brightness ranges relative to the film's exposure range. They knew that some of the subject tones would not reproduce in the first case, or the subject tones would utilize only a portion of the densities the film could produce. Even though the subject brightness range may not be reproduced completely or proportionally by a color film, different

subject contrasts can be *implied.* Photographers continue to do this today with modern color films that have longer exposure ranges.

With b&w film there are at least two possible ways to capture the effect of lighting contrast in a scene with a long brightness range. If the detail in shadow areas is not important, you can underexpose the film and develop it normally or close to normally. The bright portions of the scene will be recorded, preserving the tonal separation of the highlights. In a print made on normal contrast grade paper, the shadows will lack detail, requiring the viewer's imagination to fill in the detail implied by the dark areas.

Another option is to expose for the shadows and develop a negative with a longer range of densities than will fit onto a normal grade of paper printed normally. To reproduce all of the tones you could use a normal printing paper

and expose the paper to produce normal densities representing the diffuse highlights. Hold back exposure to the shadow areas by dodging or masking. This way, you can reduce exposure of the shadow areas to preserve detail in them. This causes some distortion in the relationship between the midtones and shadow tones by bringing them relatively closer together. However, it still preserves the separation between highlight tones, recreating the brilliant highlight effect of the subject.

Capturing the scene as you visualize it very often means neither a direct nor proportional correspondence between subject and image tones. The photographic recreation of a subject is by nature a distortion of reality. Whether that distortion faithfully renders or sadly belies your perception of the subject depends on your control of both the light and the photographic process.

3
Tools for Lighting

Whether you add light or work with existing illumination to make a photograph, controlling the light requires equipment designed for specific photographic tasks. Some light-modifying equipment is designed to work with some sources and not with others. Also, many light meters have features that are useful only with certain kinds of lighting.

Selecting lighting equipment to suit your needs is crucial to success and satisfaction. There are a few basic guidelines that will prove helpful. Begin with simple equipment and master its use before moving on to more complex items. In fact, the simplest solution to a lighting problem is usually the most effective.

First is your choice among three basic artificial light sources—photoflood, tungsten-halogen lamps, or electronic flash. Base your decision on how much you'll use the lighting, what subjects you'll use it for, what type of cameras and film you'll use with it, and how large an investment you can make. Having made that decision, start considering specific brands offering particular features. Once you've chosen a basic lighting system, determine whether you'll need light-modifying

accessories for a variety of subjects and working conditions. After choosing this equipment, select an appropriate light meter.

In this chapter you will find descriptions of the basic artificial light sources, light modifiers, and light meters. I've used particular brands to represent typical features and functions for each kind of equipment. This is not intended to indicate which brands and models you should choose, but rather to provide a basic understanding of functional features and how to use them. Then you can make an informed choice from the equipment that's available.

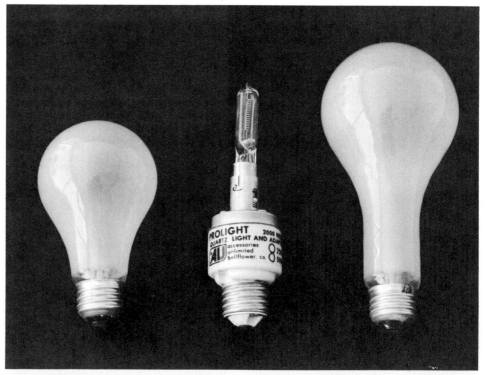

Photoflood bulbs come in various sizes. Pictured here are a 250-watt #3 on the left and a 500-watt #2 on the right. In the middle is a Prolight adapter with a tungsten-halogen lamp, which you can use in place of photoflood bulbs.

ARTIFICIAL LIGHT SOURCES

I've limited this discussion to three kinds of artificial sources—photofloods, tungsten-halogen lamps, and electronic flash. They are designed for photographic purposes, while others, such as fluorescent lights, are not. Flashbulbs are not discussed because their use is steadily declining due to the overwhelming advantages of electronic flash. By limiting your selection to the three sources described here, you'll be able to control artificial photographic lighting effectively and efficiently.

PHOTOFLOODS

Of all lighting equipment, photofloods have the longest history of continuous, popular usage. This is especially true among amateur photographers who are just beginning to use artificial lighting.

Although the shape and socket of photofloods and ordinary bulbs are identical, there are important internal differences. The tungsten filament in the photoflood glows much more intensely than the filament of a household bulb. The photoflood bulb has a higher wattage rating, produces more light and much more heat. The life of a photoflood bulb is extremely short compared to a household bulb.

Types—Photoflood bulbs are commonly available in three sizes rated at 250, 500 and 1000 watts. The two smaller sizes have common, screw-in bases, while the 1000-watt uses a screw-in mogul base like large, three-way household lamps.

Standard photofloods have a color temperature rating of 3400K for type A tungsten color films. Photofloods rated at 3200K are available for use with type B color films. The latter bulbs produce less light at each wattage rating than the same size 3400K bulbs.

Besides these, there are blue photofloods, which produce a color temperature between 4000K

and 5000K. However, manufacturers of these bulbs do not recommend using them as the sole light source with daylight-balanced color films. They are intended to be supplemental sources in scenes lit by daylight.

Balancing Light and Film—When you use daylight color films with photofloods, it is best to use either the 3400K or 3200K bulbs and a conversion filter over the lens. If the photofloods are 3200K, use an 80A filter. If the photofloods are 3400K, use an 80B filter. The 80A filter requires 2 steps of exposure compensation, and the 80B requires an increase of 1-2/3 steps.

Light-balancing filters are also necessary when you use type A tungsten color film with 3200K

photofloods or type B film with 3400K photofloods. An 82 or 82A filter will cool the effect of 3200K photofloods for type A films and requires only a 1/3 step exposure increase. An 81A filter will warm a 3400K photoflood for type B film, and 1/3 step more exposure is required.

If you frequently use photofloods with color films, it is best to use a tungsten-balanced color film. To use tungsten films with daylight illumination, an 85 filter converts type A film to daylight use and requires an exposure compensation of only 2/3 step. An 85B converts type B color films to daylight use with the same exposure compensation.

Photoflood Reflector Housings—Photoflood bulbs are usually used

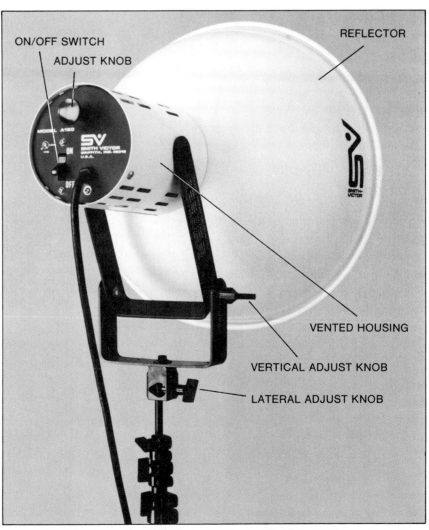

The vented housing makes it easy to handle Smith-Victor Ultra Cool housings without discomfort from the heat generated by photofloods.

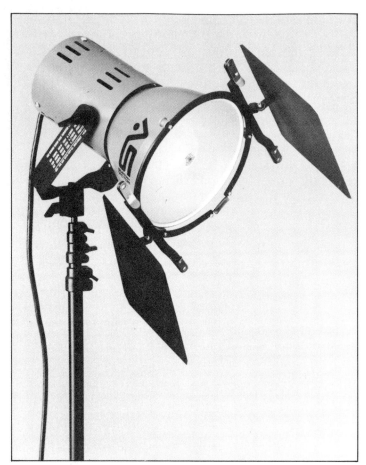

Photoflood accessories include combined barn doors and gel-holder frame, as shown on this Smith-Victor Ultra Cool Studio Light.

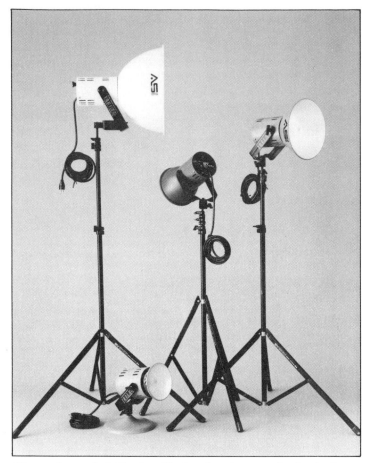

These four photoflood reflector housings and stands have features making them much easier to use than previous models. Each has a special vented housing with modern heat-resistant plastic controls and a built-in switch.

At the top left is Smith-Victor Ultra Cool Studio A-160 with a 1000-watt photoflood for general-purpose use. In the center is a Smith-Victor Ultra Cool A-80, which produces a broad, flat beam with a 500-watt photoflood lamp. On the far right is a Smith-Victor Ultra Cool A-100 general-purpose model for use with a 250-watt photoflood lamp. At the bottom is a Smith-Victor Ultra Cool A-50 for background and special-effects use with a 250-watt photoflood lamp. Its pedestal is not a Smith-Victor product.

in reflector housings designed for them. The shape and inside surface of the reflector projects the light from the photoflood bulb efficiently and evenly within a prescribed angle. General-purpose parabolic reflectors project a broad light beam. In addition, there are reflectors with shapes designed to produce narrower beams.

For example, Smith-Victor manufactures a line of housings called Ultra Cool Studio Lights. Each of the five different designs features a baffled housing with vents and an insulated knob and switch.

The housings accept many accessories, including combined barn doors and diffuser/gel holder for each size. Diffusion materials and colored gels cut-to-size for each light are also available from Smith-Victor.

Photofloods of this type are useful for simple multiple-light setups. They are very effective when used for traditional lighting configurations using key, fill, hair, and background lights. Standard parabolic floods of 1000 or 500 watts are commonly used as main light sources, while the same type of reflector with a 250- or 500-watt bulb is used for filling shadows. The deeper parabolic or conical reflectors produce either narrower beams of light or more graduated patterns. They can be used for accent effects and background lighting with 250- or 500-watt bulbs.

Left: General-purpose photoflood housings, such as the Smith-Victor Ultra Cool models A-160, A-120 and A-100, produce a 60° beam angle that gradually falls off at the edges. Using edges of the light to illuminate a subject is called *feathering*.

Below left: The light pattern produced by the Smith-Victor Ultra Cool A-80 is wider and has a less feathered edge. The 100° light beam is intended for background illumination, copy lighting, and special effects.

Below: The Smith-Victor Ultra Cool A-50 has a very gradual light pattern. It is intended for highlighting, background, and special-effects applications.

Reflector Photoflood—This is a special type of photoflood that is frequently used to provide illumination for copying. The inside surface of the bulb is silvered to reflect the light in a narrow beam.

Many enlargers and copy stands include, or use as optional accessories, adjustable brackets and light sockets for these reflector-type photofloods.

A special copylight using reflector photofloods is the Kodak Pola-Light. This unit is designed to direct the light emitted by the photoflood through an easily adjustable polarizing filter. When you use another polarizing filter over the camera, you can minimize glare and surface reflections. Kodak recommends using a 375-watt reflector photoflood with the unit. Reflector photofloods are manufactured in a range of wattage ratings, with both narrow and wide beam angles.

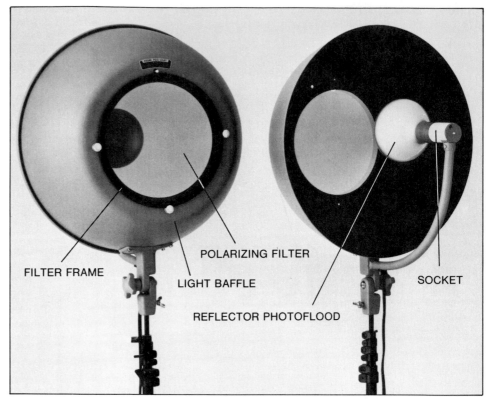

FILTER FRAME • POLARIZING FILTER • LIGHT BAFFLE • REFLECTOR PHOTOFLOOD • SOCKET

The Kodak Pola-Light produces polarized light for copying. The polarized light is produced by a standard 375-watt reflector photoflood shining through a sheet of polarizing material. The filter is held in place by a ring-shaped frame in the opening of a baffle, which prevents unfiltered light from striking the subject.

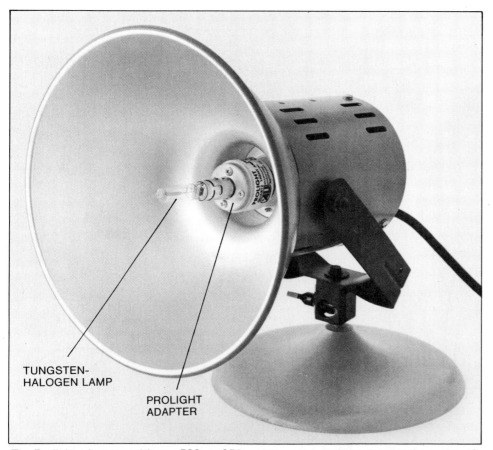

TUNGSTEN-HALOGEN LAMP • PROLIGHT ADAPTER

The Prolight adapter positions a 500- or 250-watt tungsten-halogen lamp at the center of the reflector, providing the same beam angle and lighting effect that would be produced with a photoflood lamp.

Disadvantages—Choosing a photoflood or set of photofloods should involve a consideration of their limitations as well as their features and cost. Besides the bulb's short life, it emits less light as it is used. This is due to a buildup of tungsten that deposits on the inner surface of the lamp after vaporizing from the heated filament. Another problem is that the color temperature of the bulb decreases with use.

Because of their bulk and awkward shapes, photofloods do not pack well, so they are essentially limited to use in one location, such as a studio. In addition, the size of the reflector reduces the practicality of using photofloods in combination with umbrellas and other light-bouncing accessories.

TUNGSTEN-HALOGEN LAMPS

Like photofloods, tungsten-halogen lamps use a tungsten filament that glows when electrical current passes through it. However, this is where the similarity ends. Tungsten-halogen lamps can be made much smaller because the bulb is usually made of relatively thick quartz, which is stronger and more heat tolerant than thin glass. They are also called *quartz* or *quartz-halogen* lamps.

The bulb is filled with a halogen gas rather than evacuated. Instead of collecting on the inside of the bulb, vaporized tungsten combines with the halogen. This compound then migrates to the filament, where the high temperature redeposits the tungsten back on the filament. This cycle is constantly going on during illumination, promoting a clean lamp and long filament life.

Tungsten-halogen lamps are available in various wattage ratings, the most common ranging from 150 to 2000 watts. Tungsten-halogen lamps are available in several color temperatures, including 3200K and 3400K. They are made with a variety of bases, including screw-in, a pair of pins, or a twist-and-lock design. Some have the electrical connections on each end of a tube-shaped lamp. You can also plug tungsten-halogen lamps into adapters that screw into the sockets of regular photoflood housings.

The lamps are available with a frosted or clear bulb in most sizes and configurations. Although a blue tungsten-halogen lamp for daylight-balanced film is not made, you can use dichroic daylight conversion filters. These expensive filters are made of very strong glass with multiple metallic coatings. Unlike blue photofloods, the lamp and filter produce a reasonably close approximation of 5500K daylight and may be used as the sole source of light to expose daylight-balanced color films.

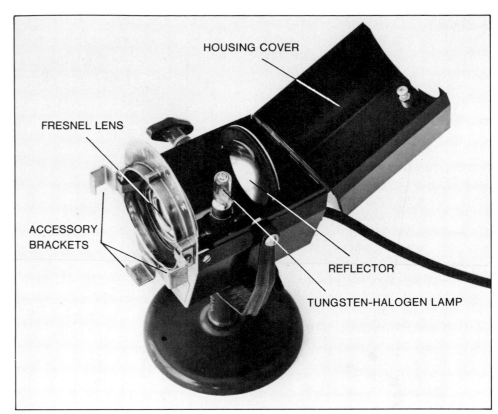

A Fresnel spotlight has a Fresnel lens, which redirects the light rays passing through it into a more parallel path. The lamp, lamp socket and reflector are in fixed positions on a movable base, which you can adjust forward and backward with an external control at the rear of the housing. This widens or narrows the light beam. Fresnel spotlights range in size from the 200-watt model pictured here to a 2000-watt model.

A Fresnel spotlight produces a very even light pattern with graduated but more sharply defined edges than a flood light. By adjusting the angle of the light beam, you can change the size of the light pattern while the basic characteristics of the light remain the same.

Reflector Housings—Because tungsten-halogen lamps are small, reflector designs are also compact and lightweight. For example, Lowel-Light Manufacturing Inc. offers lights and housings originally intended for film and television use. They are unusually compact, light and easy to pack.

One of the unique features of Lowel lights is the comprehensive range of accessories available, including interchangeable reflectors, barn doors, snoots, scrims, gels and gel frames, dichroic filters, flags, umbrellas, stands, clamps and special mounts. In addition, you can get low-voltage tungsten-halogen lamps and portable battery packs.

Disadvantages—Tungsten-halogen lamps produce much light. And because of the way they work, they also produce much heat. In some photographic setups, the heat can be uncomfortable and dangerous. The hot lights must be handled carefully to avoid damaging the filament and burning your skin. In addition, tungsten-halogen lamps cost more than photofloods, although in the long run you can save money due to their longer life.

Two Lowel-Lights having very different configurations are typical of the versatility of tungsten-halogen lamps. The Omni-Light on the left uses a round lamp with a base at the bottom. It also features interchangeable round reflectors. An array of accessories is available.

The Tota-Light on the right has a tubular lamp, which you insert into spring-loaded clips at the ends of the lamp housing. The reflector is in three parts with two hinged sides, so you can adjust the spread of the light beam.

Lowel-Lights have a special socket that accepts an umbrella's center pole and have a built-in vertical adjustment. The Tota-Brella fitted to a Tota-Light is a bounce source 27 inches in diameter in a simple two-piece unit that attaches directly to a lightweight light stand.

The Lowel Soft-Light is a portable unit that collapses to fit into a fiber case. The light uses two tube-type 750-watt tungsten-halogen lamps behind the center cross bar. The 23x21 inch reflector opening projects a bright, even beam of soft illumination. You can adjust the light spread with two built-in barn doors.

ELECTRONIC FLASH

All electronic flash units have the same basic parts. A glass or quartz tube filled with xenon gas emits a burst of light when a high-voltage charge of electricity is released through the tube from storage in one or more capacitors. The capacitors are charged from a power supply using standard AC household current or batteries. In addition to the circuitry for charging the capacitors, there is also a triggering circuit, which fires the flash unit by a synchronizing signal activated by the camera shutter.

Automatic electronic flash units have a light sensor containing a photoelectric cell similar to those found in light meters. When it detects the right amount of light for exposure, it turns off the flash. In modern "energy-saving" units, a thyristor circuit stops the flow of electricity from the capacitor to the flash tube.

On-Camera Flash—Electronic flash units offered by camera manufacturers are primarily intended to produce flat, front light from camera position. Besides the fixed light direction, extremely hard light is produced because the source is small.

The flash duration of these small, on-camera units is very short — between 1/50,000 and 1/1000 second. The color temperature is 5500K, and most have filtered reflector lenses to reduce ultraviolet radiation.

With some flashes, you can turn the reflector portion of the flash housing to bounce light from the ceiling or a wall. To simplify exposure calculations, these flashes are usually automatic. Other accessories include filters, diffusers, small bounce-light attachments, and attachments to widen or narrow the beam angle.

The light produced by these portable flashes used directly without accessories is quite uniform and gives consistent, predictable results. As you gain experience with one, you will be able to predict the results, regardless of minor changes in subject and environment.

Because the flash duration is so short, however, you'll never be able to observe the effect of the flash during exposure. When you use bounce lighting and light-modifying accessories, your control diminishes because you can't see the effect before shooting or judge exposure well. Predictable results are difficult.

The Minolta Auto 200X is a modern on-camera flash providing automatic exposure control. It automatically sets the camera shutter to the correct speed and flashes a ready-light in the viewfinder when the flash is ready to use.

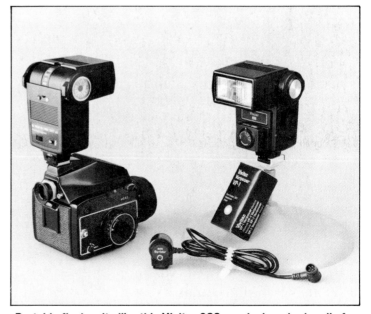

Portable flash units like this Vivitar 283 are designed primarily for on-camera use, as shown on this Mamiya M645 medium-format camera. With a few simple accessories you can also use them off the camera as part of a multiple-light setup. Remote cords permit the flash and its automatic sensor to be separated. A manual control lets you adjust the light output of the flash to easily control light ratio.

This does not mean that you can't use these units for bounce light or with other sources to provide different kinds of light qualities. It does mean, however, that you should limit such use to situations where visualization of the light quality is not crucial, such as copying. Or, you should base the lighting setup on testing and experience.

Studio Flash—The disadvantage of being unable to see the light from an electronic flash was recognized by some manufacturers soon after the introduction of the first commercial units. They solved the problem by putting an incandescent lamp next to the flashtube.

These *modeling lights* simulate the effect of the flash to give you both a visual means of control *and* light for composing and focusing. Early studio units used incandescent tungsten lamps for modeling lights, but today tungsten-halogen lamps are used almost exclusively.

Partly because of the modeling lamps, studio-type flashes are powered by AC current and therefore are designed for indoor use. Most studio units with modeling lights are at least as powerful as the largest on-camera units and usually several times more powerful.

The power of studio flash units is usually stated by the storage ability of the capacitors in watt-seconds. The power of portable units is stated by the guide number at a particular film speed. There is a basic measure of light output that applies to all types—beam candle power seconds (BCPS). This number is the product of light output and the flash duration for a flash tube and reflector combination.

The problem with applying BCPS ratings to studio units is that most units have interchangeable reflectors. The light output rating will change with each reflector you use. For the same reason, the guide number also changes when different reflectors are used.

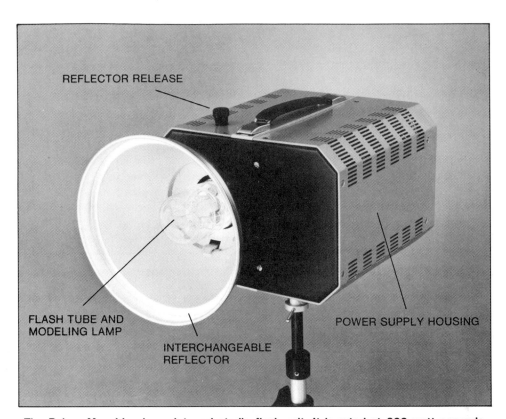

REFLECTOR RELEASE

FLASH TUBE AND MODELING LAMP

INTERCHANGEABLE REFLECTOR

POWER SUPPLY HOUSING

The Balcar Monobloc is an integral studio flash unit. It is rated at 600 watt-seconds, giving a guide number of 280 (feet) with ASA 100 film. The latest Monobloc 2 produces over twice the light output and is only slightly heavier. U-shaped flash tubes are used with Pyrex-glass protectors and center-located tungsten-halogen modeling lamps. Balcar Monoblocs feature continuously variable output with a greater than four-step range with the model 2. The modeling light has a separate control and provides either full power at any flash power setting or illumination proportional to flash output. It has a built-in stroboscopic capability giving continuous flashing at a rate up to 25 flashes per second with the Monobloc 2. The flash rate varies according to power setting—slower at maximum power and faster at lower settings. Recycle times are very short with the Monobloc 2, requiring 0.7 seconds at full power. A full line of Balcar accessories are available for both Monoblocs.

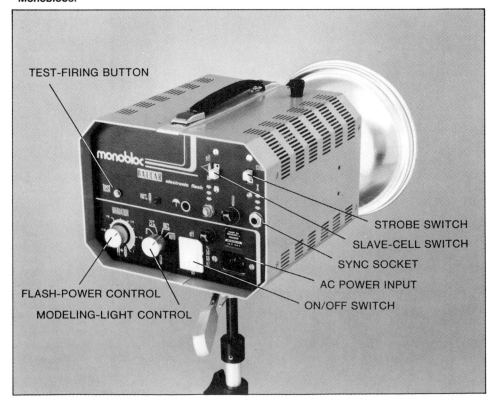

TEST-FIRING BUTTON

STROBE SWITCH

SLAVE-CELL SWITCH

SYNC SOCKET

AC POWER INPUT

ON/OFF SWITCH

FLASH-POWER CONTROL

MODELING-LIGHT CONTROL

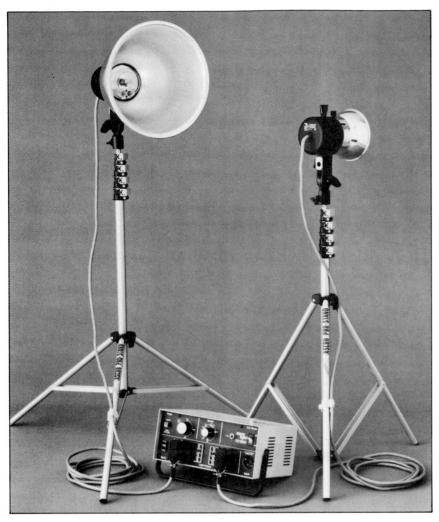

The Ascor CD-1200 is a lightweight, separated studio flash power supply. The unit is rated at 1200 watt-seconds and will accommodate one to four flash heads. Ascor offers many flash heads besides the two shown here that you can use with the CD-1200 power supply. It has symmetrical power distribution to the four flash sockets. The flash output is adjustable to three power settings—1200, 600, or 300 watt-seconds. A separate control adjusts the level of the modeling light.

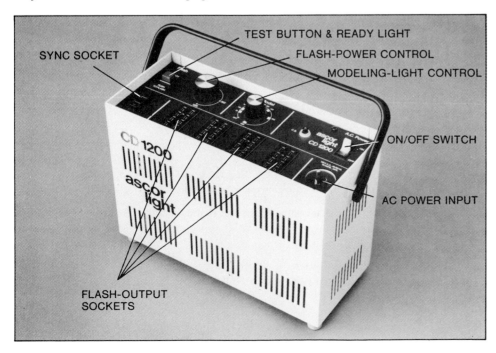

SYNC SOCKET
TEST BUTTON & READY LIGHT
FLASH-POWER CONTROL
MODELING-LIGHT CONTROL
ON/OFF SWITCH
AC POWER INPUT
FLASH-OUTPUT SOCKETS

For example, suppose a unit with a standard flood reflector has a guide number of 160 (feet) with a particular film speed. If a wide-angle reflector replaces the standard one, dispersing essentially the same amount of light over a greater area, the unit will have a lower guide number.

Guide numbers are the most reliable for determining exposure when a single, fixed reflector is pointed directly at the subject. Until the advent of automatic portable flashes and flash meters, an exposure setting for bounced flash could only be approximated based on an estimate of the extra distance the light travels and the reflectivity of the bounce surface.

In addition to being more powerful than most portable units, the configuration of studio units is different. There are two basic types. *Integral units* have the power supply, capacitors and circuits in the same housing as the flash tube and reflector. These are also called *monostrobes*. *Separated units* have the power supply separated from the flash head and reflector. The power supply of a separated unit is usually placed on the floor or on a special base. Both types are designed to be used on light stands.

Separated power supplies are designed so two or more flash heads can be plugged into them and triggered simultaneously for multiple-light use. If more than one integral unit is used, there must be some way to fire them simultaneously. This is done with *slave cells*. These are light-sensitive cells connected to any flash not triggered by the camera. When the flash connected to the camera is fired, the slave cell detects the light and almost instantly fires its flash. Most integral units and some currently available separated units have built-in slave cells. Accessory slave cells are also available.

The power supplies of both kinds of studio flashes have switches for turning the power on

and off, and most have separate controls for regulating the modeling lights. Some have a range of power settings, letting you adjust the flash output of the unit. This adjustment is usually in increments, although some units are continuously adjustable over a limited range.

With some units you can turn the modeling light on and off separately from the main power supply switch. With these the modeling light level is automatically adjusted in proportion to the flash output. In conjunction with the main power-supply switch, some units have a provision for dual-rate capacitor recycling. This means that powerful units can be charged slowly to reduce the likelihood of blowing fuses or tripping circuit breakers.

Basic separated power supplies distribute the power equally to each of the flash heads. Others allow unequal or asymmetrical distribution of power to the flash heads. A third type features both symmetrical and asymmetrical power distribution. Virtually all power supplies have a signal light that comes on when the capacitors are charged—some at a percentage of full charge, while others signal 100% charge. Some units have both a ready light, indicating charged capacitors, and an audio signal that does the same thing.

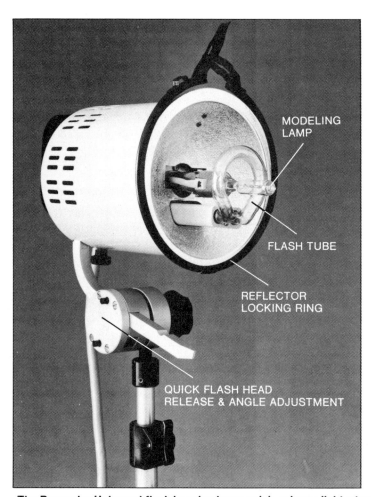

MODELING LAMP

FLASH TUBE

REFLECTOR LOCKING RING

QUICK FLASH HEAD RELEASE & ANGLE ADJUSTMENT

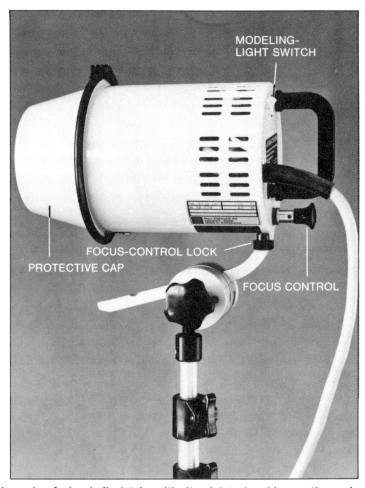

MODELING-LIGHT SWITCH

PROTECTIVE CAP

FOCUS-CONTROL LOCK

FOCUS CONTROL

The Broncolor Universal flash housing has a quick-release light-stand coupler. A plug-in flash tube with ultraviolet-absorbing coating and a 250-watt tungsten-halogen modeling lamp are attached to a carriage. This carriage moves the flash tube and modeling light in and out so you can focus the light beam. When the unit is not in use, you can replace the reflector with a cap to protect the flash tube and modeling lamp.

The most sophisticated units often use this audio capability for additional functions, such as indicating that a flash head misfired or that the unit is overheating.

The most widely used flash tube shape looks like a ring or a thin donut, with the modeling light inside the ring. A few studio flash units have tubes with special coatings to reduce ultraviolet radiation. With some you can move the flash tube and modeling light in and out of the housing to adjust the spread of the light beam.

Interchangeable reflectors are common, though the least expensive flashes have fixed, standard flood reflectors. The range of interchangeable reflectors is extensive, including wide-angle types to cover large areas, normal floods of various sizes, and large metal or framed-fabric reflectors that produce varying degrees of soft illumination.

Several reflectors are available for Broncolor flash heads. From right to left: the softlight has a 145° beam angle; the normal has a 60° beam angle; and the wide-angle has a 160° beam angle. Not shown is a model that provides a very narrow 45° beam.

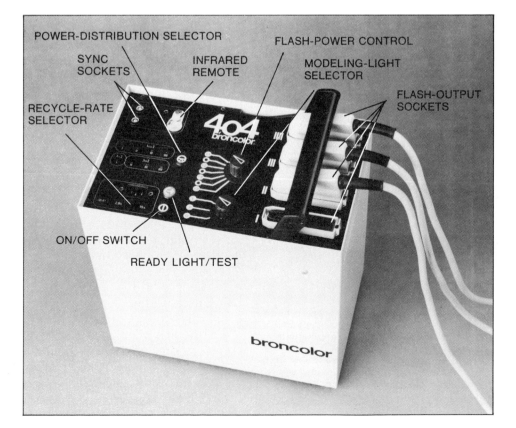

POWER-DISTRIBUTION SELECTOR
SYNC SOCKETS
INFRARED REMOTE
FLASH-POWER CONTROL
MODELING-LIGHT SELECTOR
FLASH-OUTPUT SOCKETS
RECYCLE-RATE SELECTOR
ON/OFF SWITCH
READY LIGHT/TEST

The Broncolor 404 is a 1500 watt-second separated power supply for a comprehensive studio flash system. It has outlets for four flash heads. Power can be distributed symmetrically or with 70% to one outlet and 30% divided among the remaining three. You can adjust the output of the unit over a three-step range in half steps. The tungsten-halogen modeling lights can be switched to full power, off, or automatically proportional to flash output.

You can select either a slow 15-second or fast 1.8-second recycling time at full power. When the unit has recycled and is fully charged, a buzzer sounds and the ready-light signals. The buzzer is also used to warn of a malfunction or misfire. The Broncolor 404 also has a built-in slave cell and an infrared receiver for cordless flash sync.

Softlights—One of the most popular and useful special flash heads is the large softlight. The most frequently used type is a large reflector, about 40 inches square. It accommodates one or more flash heads. It has diffusing material across the light-emitting opening to produce very even, soft illumination. This makes it ideal as a single light source for many studio subjects.

Unlike accessory softlights, these are rigid and fit on special stands, which allow easy adjustment of the light so it can shine on the subject from above, below, or the side.

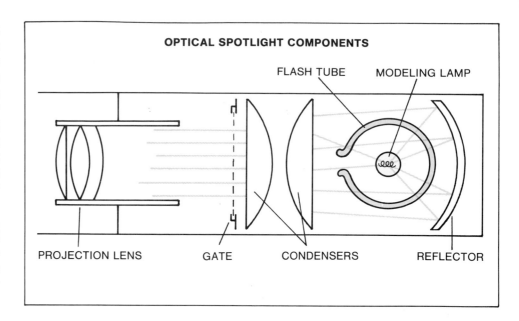

OPTICAL SPOTLIGHT COMPONENTS

FLASH TUBE · MODELING LAMP · PROJECTION LENS · GATE · CONDENSERS · REFLECTOR

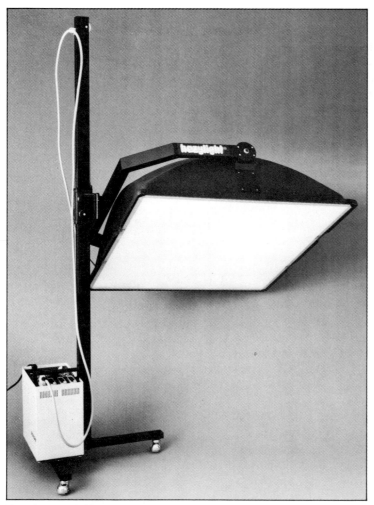

The Broncolor Hazylight produces very soft illumination. The reflector is made of rigid, molded fiberglass with clips to hold a 40x40 inch diffuser. It is mounted on swiveling joints attached to a yoke with a swivel-stand connection.

Two stands are available for the Hazylight. Both have bases that hold the power supply. The stands and mounting brackets of the Hazylight make it simple to position and provide light at any angle from above or below a subject.

Spotlights—At the other extreme, some manufacturers offer Fresnel and optical spotlight flash heads. Fresnel spotlights are similar to the tungsten-halogen Fresnel spotlight shown and described on page 47, except for the flash tube surrounding the incandescent lamp. The size of the incandescent lamp is reduced to act as a modeling light.

An optical spotlight has a non-adjustable fixed lamp and reflector that directs the light through a double condenser lens. In front of the condenser lens is usually a gate to hold material to be projected, such as color transparencies. An adjustable diaphragm that varies the size of the light beam may also be included next to the gate. At the front of the spotlight is a focusing mount that holds a projection lens similar or identical to those used in slide projectors.

You can use optical spotlights in a number of different ways. The condenser system lets you project a sharply defined beam of light. With the iris diaphragm you can create beams of various sizes, or use different shaped masks in the gate to produce similarly shaped light beams. With a color transparency in an optical spotlight

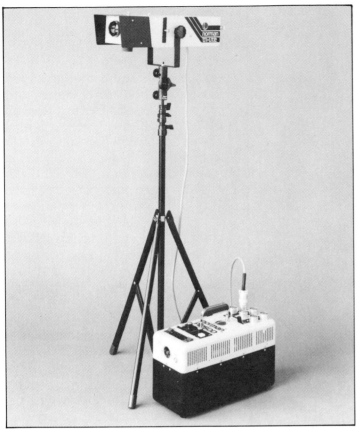

The Norman Tri-Lite is an electronic flash in an optical spotlight. It projects an adjustable, hard-edged light beam and can also project patterns and photographic transparencies. The unit is used in the same way as other flash heads with separated power supply.

The Tri-Lite features a choice of two flash tubes rated at 250 and 1200 watt-seconds. An efficient condenser system is used, and the 125mm lens is interchangeable with most lenses for Kodak Carousel projectors, including zooms. A combined gel/transparency holder and an adjustable iris diaphragm to control the size of the projected spot of light are included.

you can use the projected image for front or rear projection.

Ringlight—This is a ring-shaped flash tube mounted in a donut-shaped reflector. The unit is usually mounted with an adapter ring that screws into the front of the camera lens in the same way as a screw-in filter. Because the lens is surrounded by the light source, the flash produces front lighting almost parallel to the lens axis. The light is shadowless, except for a slight halo-like shadow sometimes visible around a subject close to a background. If the subject has shiny surfaces parallel to the subject plane, very strong specular highlights are produced.

The ringlight has long been available for use with power supplies up to 200 watt-seconds. Recently, a ringlight flash head has been designed for a studio-flash power supply. In the last few years

The Ascor Light Auto 1600 II portable flash features a ringlight head as an accessory. The ringlight attaches to the camera lens with a swiveling adapter ring and has an electrical connection to the flash power supply. With a normal lens and a slow-speed film, the Ascor Light Auto 1600 II is powerful enough to provide full-figure illumination of a person.

The Hershey Profoto Ringlight is large. It measures 150mm in diameter and has a rating of 1800 watt-seconds. It does not attach directly to the camera lens. Instead, it has an adjustable bracket that screws into the tripod socket on the camera. This lets you support the camera and ringlight on a tripod and use the unit with larger lenses and cameras than other portable ringlights. Shown here is the Mamiya RB67 Pro-S medium-format camera with 127mm lens.

The circular flash tube in the Profoto ringlight reflector is made in four sections to reduce what would otherwise be a long flash duration. An accessory reflector is available to increase the spread of the light for wide-angle lenses.

sity comparable to full sunlight. The flash duration is short, from approximately 1/50,000 second with smaller units to about 1/150 second with some of the largest. Flash duration with some units can vary, depending on the number of flash heads used with a power supply. It becomes shorter as more flash heads are plugged in.

For the amount of light produced, electronic flash requires very little electric power and produces little heat, compared to photofloods or tungsten-halogen lights. For many photographers working both indoors and outdoors, the fact that electronic flash is balanced for daylight film is another significant advantage. This gives you a greater range of films from which to choose.

The one major drawback for many photographers may be the cost of the equipment, which can be several times greater than photofloods or tungsten-halogen lights. However, if the equipment gets regular use, some of the initial cost is recovered by savings in power consumption and by not having to replace lamps often.

LIGHTING ACCESSORIES

There is a huge variety of other tools and materials you can use to modify light. Some have already been mentioned as accessories for specific lighting equipment. There are also a number of materials not specifically designed for photographic lighting that you can use to modify various light sources.

The lighting equipment described so far provides basic illumination. The following accessories and materials let you tailor this basic illumination to the individual requirements of a subject and environment.

Lighting accessories and materials greatly enhance the flexibility of a particular light source. Many of these are also used to modify the effect of outdoor light.

the use of the ringlight in fashion photography became so popular that it generated interest in the device for a greater range of applications. This created demand for the more powerful model. Smaller portable units for 35mm and some medium-format

cameras are designed primarily for close-up and technical photography demanding flat, shadowless illumination.

Advantages and Disadvantages— There are many advantages in using electronic flash as a light source. The units produce inten-

MANUFACTURERS' ACCESSORIES

These items are generally offered by the makers of lighting equipment. They are designed to fit specific models. Although some may be interchangeable with other models and brands of equipment, most are limited to the unit for which they were designed.

Barn Doors—These attach to the front of a light or flash head to restrict the light beam. They are flaps or plates on a frame that surrounds the opening of the reflector. Two or four plates can be moved into the beam of light, working like doors to shape the beam's size and direction.

Two-door versions have the doors hinged on opposite sides so they can close together and restrict the light beam to a narrow slit. Four-door versions have hinged doors on all sides of the square frame. Two opposing doors are usually triangular, and the other two are rectangular. Besides holding the doors in place, most barn door frames also hold gels, scrims and diffusers in front of the light source. Photographs of lights with barn doors are on pages 44 and 48.

Snoots—These are round or conical tubes that restrict the light beam of a spot, flood or flash head. They do not significantly alter the intensity of the beam of light. Rather, they only make the beam narrower and decrease the size of the light pattern at any given distance from the source. Very often, snoots are supplied in sets for use on a particular light, with each snoot providing a different reduction of the beam.

Scrims—These are screen materials used in front of light sources to diffuse and reduce their output. Scrims used with tungsten lights are made of wire screening with fine or coarse mesh. Some scrims cover only a portion of the reflector opening, thus affecting only part of the beam of light.

Snoots for Fresnel spotlights are sheet metal tubes or cones on flat bases which mount on the front of the light. The unit shown is an old Beatty model. Modern tungsten-halogen spotlights use similar devices. Materials and fastening methods for snoots on electronic flash heads vary in design, but not in function.

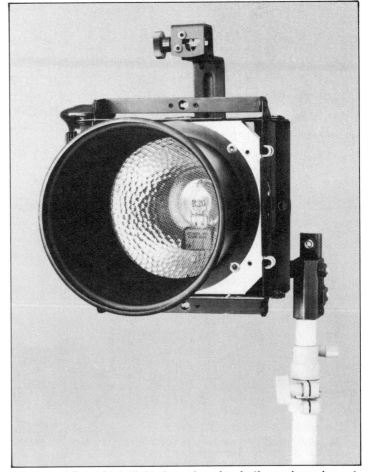

The Lowel Omni-Light light shown here has both a scrim and snoot attached to the frame. The arm with socket and retaining knob extending above the light accepts other accessories, including an umbrella and gel frame.

Others are more closely meshed or have several layers of screen on one side, providing a gradual effect on the light pattern.

Honeycomb Grids—These devices have the effect of narrowing the beam of light, like a bundle of snoots. The thicker the grid and the finer the pattern, the more it narrows the light beam. A honeycomb grid is particularly effective when used on flood lights and softlights, which are too big for a snoot. Honeycomb grids are also useful with front- and rear-projection work to keep stray light from a soft source off of the background.

Gel Frames—These frames attach to the front of a light, around the reflector opening, to hold thin transparent or translucent materials in front of the light source. Some have metal clips that hold the material, while others have slots to hold thin metal frames which hold the material. On page 48 is a photo showing a gel frame attached to a tungsten-halogen lamp.

INDEPENDENT ACCESSORIES

You can use most of these lighting accessories with several brands and models of light sources. Many lighting manufacturers also offer similar items for use with their own equipment. Accessories made from cloth or similar materials should be treated with extra caution if you use them with high-wattage incandescent lights. The fabric can easily be damaged by heat from the lamps.

Umbrella Reflectors—These are probably the most popular accessories used to modify a light source. They are made with a frame of ribs on a center pole, like a rain umbrella. Some have many ribs making the shape a dished circle, and some have only six ribs and are not so deeply dished. Another variety made with four ribs is either square or rectangular and may be used flat as a reflector or dished as other umbrellas. The

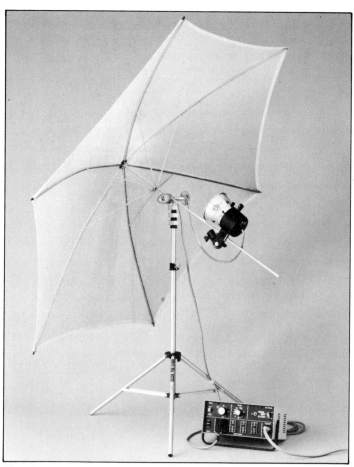

The Larson Reflectasol Hex is an example of a mildly dished umbrella designed to produce soft illumination. The umbrella is held on the light stand with a Reflectasol clamp that adjusts the vertical angle of the umbrella. The umbrella shown here is a 72-inch model with a standard silver cover. An Ascor CD-1200 power supply and standard flash head with wide-angle reflector are also shown.

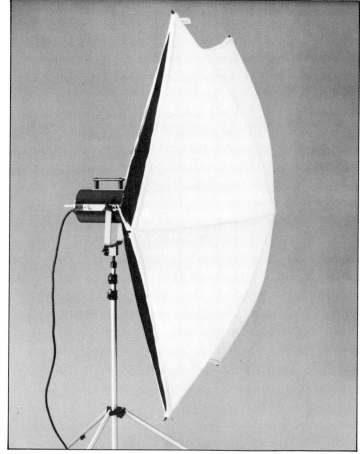

The Larson Starfish is a hexagonal umbrella with a translucent covering and black fabric side panels with an inner silver lining that acts as a reflector. The Starfish is used as a large source of soft, diffused light. It is available in the 72-inch model shown and in a 52-inch model.

colors of cloth used on the umbrella range from satin white to matte silver to a very bright metallic silver. Some are available with blue or gold coverings.

The purpose of an umbrella is to increase the size of the light source by bouncing light from the source toward the subject. This softens the light. The larger the bounce area of the umbrella, the softer the light produced. White and matte silver materials diffuse and scatter the light effectively, ensuring even illumination. Bright silver materials reflect the light more efficiently but do not provide as broad and even a distribution. In addition, there is always some danger of hot spots of light with a bright silver umbrella.

Umbrellas designed to be used with certain brands of light sources attach directly to them. The center pole fits into a special receptacle built into the light. Universal umbrella models can also be attached directly to these receptacles. However, most umbrellas are supplied with a swiveling clamp that secures the center pole of the umbrella to a light stand. The light source is then attached to the center pole of the umbrella and can be adjusted along the length of the pole so you can adjust the width of the light beam to fit the reflecting area of the umbrella.

Some umbrellas are covered with a thin translucent material for diffusing rather than bouncing light. Instead of using the light reflected from the interior dished surface, the umbrella is turned around so the convex surface faces the subject, which is illuminated by the light passing through the cover material. One independent manufacturer, Larson Enterprises, has improved this idea. The back side of the umbrella cover has an opening for the flash head. The back cover material is made of highly reflective silver material on the inside and black material on the outside. This redirects the light reflected by the umbrella's

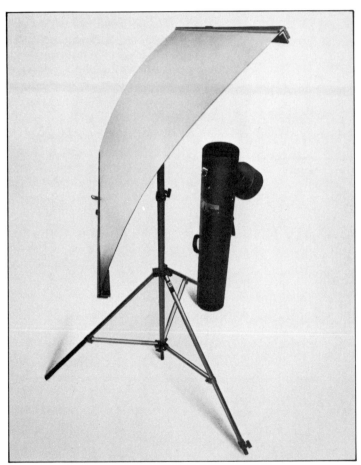

The Lowel Variflector is a collapsible metal reflector with a curved shape providing a 1:3 concentration of the light reflected from it. It is available in two sizes, 42x27 inch and 24x17 inch.

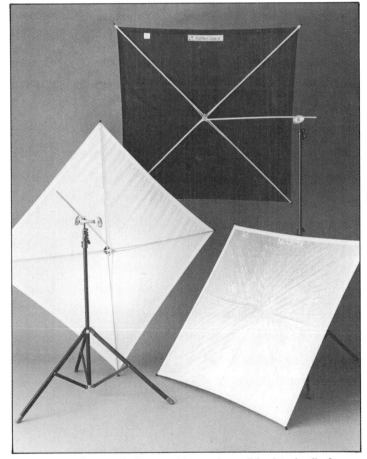

The Larson Square Reflectasol has a four-ribbed umbrella frame with braces, locking hub and hinged center pole. Besides using it in a dished shape as an umbrella, you can use it flat for a reflector. A variety of different cover materials is available, including black, translucent, and metallic surfaces. The metallic materials are for umbrella and reflector uses. The translucent fabric allows the Square Reflectasol to be used as a diffuser, and the black cover converts it into a flag.

translucent front cover, efficiently sending all of the light forward.

Reflectors—Any shiny surface that can be secured and positioned can be used as a reflector. To preserve the color of the incident light, the surface should be neutral, preferably white or silver. The surface should be flat or uniformly curved and you should be able to adjust the position and angle of the reflector to control the direction of the reflected light.

Solid wooden boards covered with aluminum foil and suspended in a yoke on a steel stand have been used for many years in motion picture production. Lighter, collapsible models better suited to the needs of the individual photographer have been made available in the last few years. In a permanent studio situation a supply of white poster or foam boards makes effective improvised reflectors. Attach them to light stands with welder's clamps. You can also create a larger reflective area with white seamless background paper suspended on a pole between a pair of stands.

Flags—These are black surfaces used for the opposite purpose of reflectors. Flags are used two ways: To obstruct and block direct rays from a light source, and to cover reflective surfaces that would otherwise reflect unwanted light onto a subject.

Like a reflector, a flag requires some way to secure and position it in a flat, rigid configuration. Square, four-ribbed umbrellas usually have optional black cloth covers that readily convert them into collapsible, lightweight flags. In a studio, black poster board and black seamless background paper can do the same thing.

Softlights—Collapsible, accessory softlights are devices that convert standard studio flash heads into large, diffused flood lights for relatively soft illumination. The general shape of a softlight is like a pyramid. The base is a large square of diffusion material that serves as

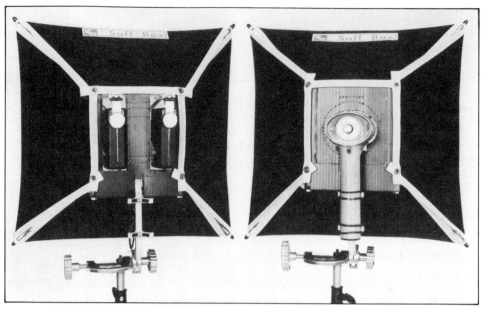

The accessory softlight made by Larson Enterprises is called a *Soffbox*. They are available in a variety of sizes to accommodate different kinds of flashes. The bottom photo is a cutaway view of a Larson Soffbox.

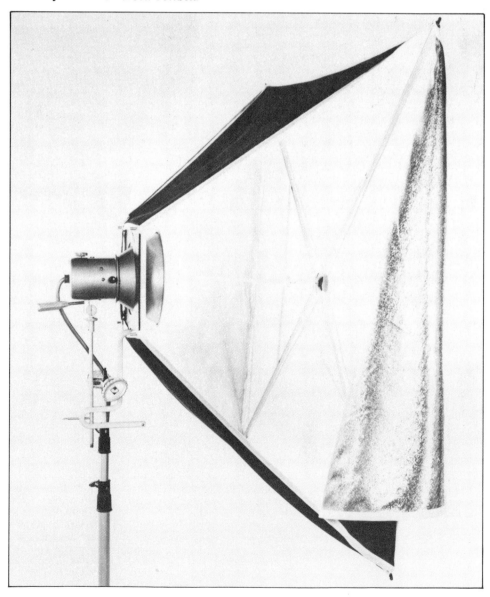

the direct source of incident light. The sides of the pyramid are made of opaque material with a bright silver interior surface acting as a reflector. A lightweight metal frame keeps the softlight rigid. The attachment for the frame is at the apex of the pyramid and includes a way to secure the unit to the flash head you use with it.

These softlight accessories have the advantage of being light and portable, making them good for occasional use or on location. They are usually limited to use on a standard light stand, are somewhat less efficient, and do not provide illumination as even as their rigid counterparts.

Stands—These are available in just about every imaginable size and weight to hold and position lighting equipment. Some are made of lightweight aluminum and are collapsible for easy portability. Some stands are heavy, rigid supports constructed of steel. These are intended for permanent use in one location. Some stands, called *booms*, have a cross arm that is counter-weighted at one end to balance a light at the other. With a boom you can safely suspend a light source above a subject.

You should take three factors into account when selecting light stands. Consider the way you'll use them. Will you transport them frequently to locations or set them up permanently in a studio? What kind of lighting equipment do you have? What kind of subjects will you shoot?

Of equal importance is the selection of an appropriate stand or tripod to support your camera. Using tungsten lighting frequently means long shutter speeds, necessitating a steady camera support. Not even an electronic flash eliminates the need for a good tripod. A tripod or other camera stand maintains a rigid camera position, thereby ensuring accurately focused and carefully composed images while you make changes in the lighting or set-up.

A good tripod is an important photographic tool. One manufacturer, Gitzo, makes a variety of tripods for different format cameras. Shown here are tripods you can use for 35mm and medium-format cameras.

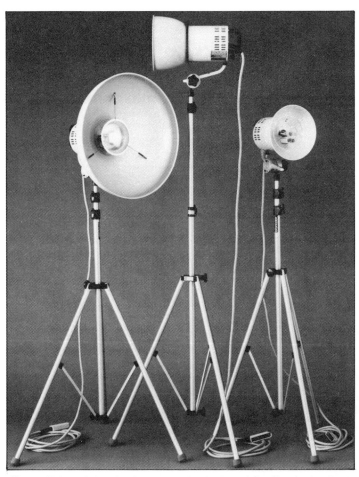

These lightweight aluminum stands designed for Broncolor flash heads are very convenient for location lighting.

Light Tables—These table-like structures are translucent white supports and backgrounds used as miniature studios for photographing small objects. The table surface is a single piece of Plexiglas material, part of which is curved up into a vertical position. It is held by a frame that supports it at the front, sides and top.

This provides a continuous, one-piece setting and background that you can illuminate from underneath, behind, and from the front. Some light tables are convertible to light tents. They are used extensively to photograph small products and are particularly well adapted for photographing all kinds of transparent glass, plastic, and shiny reflective objects.

This page from a Studio Specialities catalog shows a selection of seamless paper backgrounds. When you have the page, you can photograph it to determine how the colors will reproduce under particular light conditions with a certain film.

The Studio Specialties light table has a framework of square steel tubes with special joints so you can assemble or disassemble it in minutes. The plastic surface is shiny on one side and matte on the other.

SUPPLEMENTARY ACCESSORIES

Although not considered lighting equipment in a strict sense, there are some materials and accessory devices that you'll find helpful and occasionally essential. You can find useful accessories at camera, art, hardware, fabric, and housing-supply stores.

Diffusion and Reflective Materials—Diffusion materials include a variety of translucent plastics—some are rigid pieces of sheeting and others are porous and flexible. In addition, there are several kinds of spun glass in thin sheets. You can use these next to tungsten lights because the glass is much more heat resistant than plastic and will not burn. These diffusion materials are available at reasonable prices, making them practical for covering even large window areas.

An excellent reflective material is Mylar mirror, which is transparent plastic sheeting coated with a reflecting surface. It is tough and flexible and can be purchased with or without an adhesive backing or already mounted on a flat, lightweight support to function as an unbreakable mirror. Smooth, matte-silver material on a plastic or compressed-paper backing is sometimes used to create diffuse reflections. Another type of silver-colored material has a textured surface to bounce light efficiently and produce evenly dispersed diffuse light. These reflective materials are available at reasonable cost in rolls of varying widths and lengths.

Another studio aid is the seamless paper background in many colors. White and black background paper have already been mentioned with regard to their use as flags or reflectors. The colored varieties are, of course, used as backgrounds most frequently. They can also be used on the rare occasions when you desire a colored bounce light. When you use it as background material, you can make subtle color changes in the color reproduction of seamless paper. Due to selective reflection, the appearance of the background color may be altered by different kinds of light sources and recorded differently by various brands of color film.

Gels—These are placed over the opening of the reflector housing to alter the color of the light. Most are plastic or acetate sheets available in a wide range of colors. Some lighting equipment manufacturers offer a selection of colored gels to be used with their lighting equipment.

Because gels are used most frequently on stage and in motion picture studios, the best sources with the largest selection of colors are companies supplying theaters and movie producers. You can find a listing of such supply houses

No. 03 Light Yellow (LY) No. 07 Lemon (L) No. 18 Amber (A)

No. 19 Dark Amber (DA) No. 21 Fire Red (FR) No. 39 Magenta (M)

No. 47 Steel Blue (SB) No. 54 Daylight Blue (DB) No. 68 Yellow Green (YG)

Dura 60/70 color filters from Olesen are available in both acetate and polyester with a wide range of shades. Some samples are shown here. Acetate filters are primarily intended for use with photofloods. Polyester filters have greater durability and heat resistance and are more suitable for tungsten-halogen lamps.

in the Yellow Pages, or see the appendix for the address of Olesen Inc. Their catalog is available on request.

Compendium Lens Shades— These adjustable lens shades attach to the camera by means of a screw-in adapter ring that fits the filter threads on the lens. They have a front standard with an opening that approximates the shape of the picture format of the camera for which it was designed. You can adjust this movable standard so that only the light rays reflected by the subject enter the lens. All extraneous light from the sides is prevented from striking the lens front element and producing glare.

The shade's second function is to hold gel filters, which are often needed to convert or correct the color of the light. With a compendium lens shade you need only one set of filters that fit the shade. In addition to the wide range of Kodak gel filters for both color and b&w photography, some accessory manufacturers are now offering a selection of gel and plastic special-effects filters in the standard 3x3 inch (75x75mm) square size.

The Shade + by Ambico is an adjustable compendium lens shade with a screw-in adapter that mounts it to a variety of lenses. The Shade + accepts standard 3x3 inch (75x75mm) gelatin filters. Accessory masks for vignetting and matte effects are also available from Ambico.

The Honda EM400 is a compact 110-volt AC generator with a maximum output of 400 watts. This will run a 600 watt-second power supply or higher rated units if set for slow recycling rates. This generator is easily carried by one person.

Portable 110-Volt AC Power— With one of these generators, you can use studio lighting equipment in locations without AC power. The smallest of these lightweight, gasoline-engine generators are easy to carry and will produce enough current to run a medium-size studio flash power supply or a couple of 200-watt tungsten-halogen lights. It's even possible to photograph very large subjects on location at night by using a generator to power a studio flash unit. Because these small, portable generators are used by campers or by contractors to run electric power tools, they are usually available from equipment-rental companies.

The SinarSix is a spot meter that reads reflected light through the camera lens at the film plane. Made for Sinar cameras, it works with most view, field and press-type cameras designed to use sheet film.

With most built-in meters, you can only guess what portions of the image area influence the meter most. Typically they read a center-weighted average of the light reflected by the subject through the camera lens.

In addition, all meters are misled by unusual subject conditions. These include backgrounds that differ drastically from the main subject, high- and low-key subjects, and backlit subjects. In these cases, metering on a gray card is helpful.

Some cameras, notably those using sheet film, do not come with built-in meters. However, with a specially adapted hand-held meter you can actually measure small portions of the image area on the focusing screen.

These meters have adjustable, light-sensitive probes that you insert into the film plane in front of the focusing screen. This type of through-the-lens meter gives you the option of reading a discrete area of the scene. This lets you measure the subject brightness range.

LIGHT METERS

Today almost all photographers have a light meter because there are very few cameras currently available that don't contain one. These built-in meters, whether used to control an automatic-exposure system or used manually, read the light reflected by the subject. In addition to camera meters are accessory hand-held meters that you can use to measure either reflected or incident light.

Built-In Camera Meters—Some professional-quality camera meters, such as those designed for the Canon F-1 and the Mamiya RB67 Pro-S, show precisely what part of the scene the meter is actually reading.

An accessory Incident Light Receptor is available from Topcon for use on their cameras. The accessory fits over the camera and resembles the dome-shaped receptors used with hand-held incident meters. When in place, the receptor converts the camera's built-in meter to read the light falling on the subject.

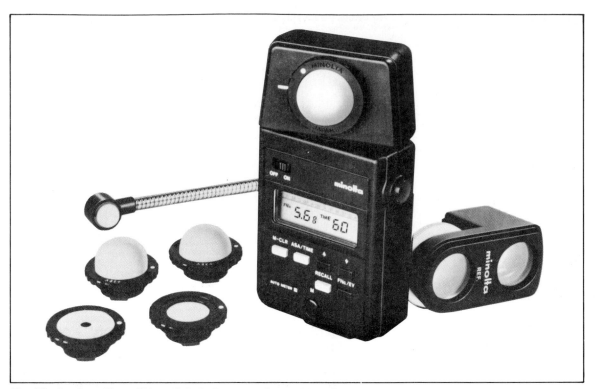

The Minolta Auto Meter III is a digital, direct-reading incident light meter with a memory capability of two readings for comparison with a third. It has a reading range from EV −2 to 19.5 at ASA 100 in the incident mode. A full array of accessories is available, including a 10° spot-type, reflected-light attachment; a mini-receptor for measuring light in small spaces; a flat diffuser disk for measuring discrete light sources or for copy work; and a spot mask to convert the meter for use with an enlarger.

Accessory Hand-Held Meters—If you don't use a built-in camera meter, you should use an accessory, hand-held meter. There are several different types. Some see large areas, some small, and others are designed to read flash. In addition to these differences, various brands and models offer features that can make metering easy for the type of shooting you do most. There are even "system" meters that accept a variety of accessories that expand the uses of a particular model.

Averaging Meters—This kind of reflected-light meter has a fixed angle of view, about 30°. When you point it at the scene and meter, it averages the brightness values it sees and displays a reading. You transfer this reading to a calculator dial that recommends exposure settings based on the film speed.

Like a built-in camera meter, it works fine in average scenes. However, the meter's angle of view will rarely match that of the lens, and you can never be sure of exactly what the meter sees. One way to solve this problem is to meter from an 18% gray card, as described earlier, in average and nonaverage scenes.

Spot Meters—These reflected-type meters have a lens that shows an image of the subject on a ground glass screen visible through the viewfinder eyepiece. In the center of the ground glass is a small circle representing the meter cell's angle of view, usually between one and ten degrees. Superimposed on the ground glass of most spot meters is a scale or digital readout.

Spot meters are designed to measure small, discrete areas of reflected light from the scene. This very selective capability enables you to determine an exposure setting based on certain brightness values, such as diffuse highlights and detailed shadows, and measure subject brightness range.

Incident Light Meters—These hand-held meters are designed to read the light falling on a subject. An incident meter is equipped with a hemispherically shaped light integrator over the light-sensitive cell. To use the meter, hold it at subject position with the light receptor pointing toward the camera. When metering incident light from divergent sources, you must hold the meter at subject position to avoid the effects of light fall-off. The round shape of the light receptor simulates a three-dimensional subject having an average reflectance of 18%. In this way it gives the same result as metering a gray card with a reflected-type meter.

Depending on how you hold the meter, part of the sphere may be in shade. Used in this manner, an incident meter provides an averaged reading between direct illumination and shade.

Another important function of an incident meter is to read the light from individual sources. By pointing the receptor at a light source rather than at the camera,

you can measure the intensity of the source. Make another reading of the incident light illuminating the shadows in the subject. The difference in exposure steps between the two readings is a measure of the light ratio affecting the subject.

Most incident meters are supplied with tables that convert the meter reading expressed in exposure value into lux or footcandles. Usually, you make the reading with a flat disk replacing the hemispherical receptor. This feature is handy when you need to adjust a light to a recommended level for exposing color duplicating and internegative film.

With an appropriate attachment, you can use most incident light meters to read the light projected through a negative in an enlarger. This converts an incident meter to an enlarging meter capable of determining exposure times to make enlargements. When the meter is equipped this way you can read negative densities by finding a zero point and reading the relative light fall-off caused by specific areas of negative densities. Each light change of 1/3 exposure step recorded by the meter equals a change in negative density of 0.10.

Flash Meters—These meters are essentially incident light meters designed to read light of short duration. Some models are actuated by the flash of light they measure and then shut off at the end of the flash duration. Others have an electronic shutter and are adjustable to correspond to camera shutter speeds. With this type of meter you can fire the flash through a synchronizer cord connection with a switch on the meter.

Several models can distinguish between flash illumination and ambient light, so they can either integrate the ambient light into the reading or not. Frequently, this feature also lets you use the meter to read continuous incident light, making it an all-in-one meter. Some flash meters even have accessories like regular incident light meters for comparable extended applications. The same techniques you use to make exposure determinations and read light ratios with continuous-type incident light meters apply to flash meters.

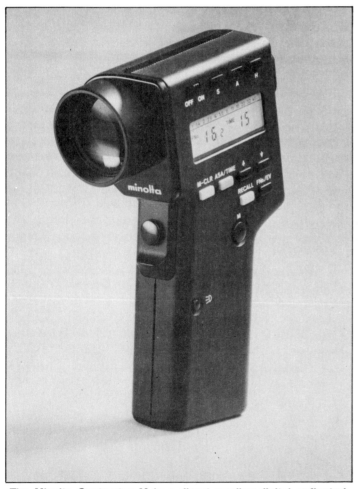

The Minolta Spotmeter M is a direct-reading digital, reflected-type 1° spot meter providing displays in the viewfinder and body exterior. It has a memory like the Autometer III and a capability for computing the average of a highlight and shadow reading. It uses a silicon photo cell and a fully corrected, coated focusing objective with an adjustable eyepiece.

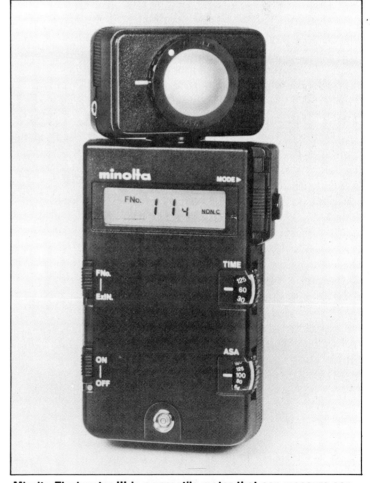

Minolta Flashmeter III is a versatile meter that can measure continuous or flash light and the two combined. It has a direct-reading LCD display in *f*-stops at 1/3-step increments. The meter has an electronic shutter controlling the silicon cell. You can set it to any standard shutter speed from 1/1000 to 30 seconds.

4
Lighting for People

People are the most frequently photographed subjects. Much of this photography involves some type of controlled lighting whether the people are indoors or out and illuminated by the sun or artificial sources.

Selecting the most appropriate and effective lighting for people is very important. The selection process depends on a number of seemingly unrelated factors. These include the characteristics of the camera, lens, and film. Location and setting also affect the kinds of light sources you can choose because they can limit your lighting options.

The purpose or intended use of the finished photograph may require the exclusion of some lighting effects and demand the inclusion of others. In addition, you need to consider the cultural context of the image. This includes the lifestyle and self image of the subject and how your lighting techniques disclose these individual factors.

Before 1900, photography became a popular way of making portraits. However, portrait photographers were restricted by large cameras, slow lenses, and slow film. Daylight was the only light source with sufficient intensity, although a few portrait photographers in large cities used carbon-arc lighting.

The location and environment in which portraits were made during this early period were influenced by traditional fine arts. The artist's studio with its large window area exposed to north light was a practical place to make portraits. It gave sufficient and pleasant light, protection from the weather, and privacy. Some limited control of the lighting was possible in these northlight studios with translucent curtains that were drawn over portions of the window area. The subject and camera relationship could also be altered to allow different light angles illuminating the subject.

The lifestyles and self images people had in the late 1800's also contributed to the formal qualities of the portraits and provided little incentive to create varied lighting effects. Nor did the times allow many differences in the ways

This is the daylight studio of the English photographer A. Walter Barnett. To control daylight in the room he used curtains on the windows and drapes over the skylight, seen in the upper left-hand part of the photo. Photo from IMP/George Eastman House.

people presented themselves in public or in a photograph.

All of these factors restricted the potential for varied, controlled lighting. Today most of these limitations are gone and options are almost unlimited. The problem the modern photographer has is not externally imposed restrictions, but rather the need for disciplined, practical choices and self-imposed limits within a broad array of possibilities.

One Example— As a practical example of the problem and possible solutions, suppose for a moment that you're an industrial photographer who is occasionally required to make executive portraits on location. First of all, you should consider a limitation automatically imposed by your primary activity—photographing industrial installations. You use a small-format camera and daylight-balanced color slide film for eventual lithographic reproduction. These factors should also apply to the executive portraits you'll be making. Because you'll do portraits only occasionally, your budget for the lighting equipment is modest.

Color slide films have relatively short exposure ranges, so you'll need at least two light sources to control the light ratio. The executive portraits will usually be made in offices, which are likely to be lit by both fluorescent and tungsten sources with the possibility of some daylight from windows. Due to the conservative nature of most businessmen, the portraits will be relatively formal and static.

The equipment you choose for lighting should be capable of a variety of basic lighting techniques appropriate to the character of the subjects and the purpose of the pictures. You might use two small, studio flash units or two lightweight tungsten-halogen lights. Electronic flash is balanced for daylight, but dichroic filters would be needed to balance the tungsten-halogen lamps to daylight. A couple of light stands, one or two umbrellas, and several extension cords will fit into a carrying case.

Both the small flash system and the tungsten lights could be used direct, bounced, or with the umbrellas to balance with the intensity of the ambient room light. A two-light setup would allow controlling the light ratio to the recommended 1:2 to 1:4 range for portraiture. You could do this by placing them at different distances from the subject, or use one with an umbrella and the other direct or bounced.

The tungsten lights should allow exposures between 1/30 to 1/60 second at a midrange aperture with ASA 200 color slide film. The smaller studio flash units could do the same thing with the advantage of freezing subject movement. Although electronic flash produces more light than the tungsten lights, easier visualization of the balance with ambient room light favors tungsten sources in mixed-light situations.

Obviously, the factors affecting the selection of lighting equipment for this hypothetical situation limit the techniques you can use. Some basic lighting techniques with different kinds of subjects and a variety of light sources are described in this chapter.

Photographs of people made in the 19th century were almost always formal portraits. Because the slow films of the day required long exposures, the subject had to hold very still while the photograph was being made. This contributed to the typically stiff and expressionless look.

USING DAYLIGHT

As electric lighting equipment was developed for the theater stage and photography, the northlight studio almost entirely disappeared. Electric lighting permitted the use of multiple sources and a whole new array of lighting techniques. Even though cameras were still large and lenses and films slow, tungsten floods and spotlights with 1000-watt bulbs provided sufficient intensity for exposing film. And they were dependable night or day in good weather or bad.

In recent years, many of the factors influencing how light can be used to photograph people has changed. These changes are both cultural and technological. The popularity of smaller cameras with fast lenses and films has made the use of natural light to photograph people much easier and much more practical. This and the trend toward natural and individualized self images has encouraged a revival of the daylight studio.

THE DAYLIGHT STUDIO

Today a daylight studio does not have to copy the specialized configuration of the artist's northlight studio. A contemporary daylight studio can be any converted normal room, like the one pictured on page 31. North light can, in fact, be a disadvantage when you use color film because the light is both too blue and low in intensity. Direct sunlight through diffused windows provides a better color balance and much more light, even with a smaller window area.

Any room used as a daylight studio will produce its own unique lighting characteristics. Rooms that can be devoted solely to studio use can be modified to achieve a desired result. You can install textured window glass, which diffuses the light, and finish interior surfaces in neutral colors from glossy white to matte black.

Rooms that you must use for purposes other than photography can also be used as studios if you have temporary and portable means of diffusing window light. You can control and redirect window light with reflectors. White seamless paper background works well instead of white walls. Portable reflectors, flags and diffusers on stands provide additional control of light contrast. Spread and disperse window light temporarily by using sheets of diffusion material, such as BD Dif-fuse or Flexiglass from Studio Specialties, across the inside surface of the window. If you include the window in the picture, place the diffusion material over the outside.

The direction of window light in a daylight studio depends on the locations of the subject and camera relative to the window source. For example, if the lens axis is parallel to the window and the subject is opposite the window, side lighting is produced.

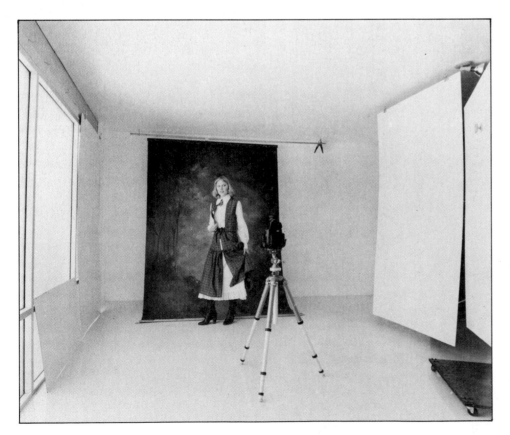

The most convenient way to use window light is with the lens axis parallel to the window wall. In this photo the wall of textured glass windows provides side light on the subject. Masonite panels cover a portion of the windows, preventing some light from striking the left side of the painted background. Fill light, which gives a normal 1:3 light ratio comes from a 4x8 foot white panel hanging from the ceiling on the subject's right side. A second white panel is on a stand to the far right of the subject. The medium-format camera shown is a Mamiya RB67 Pro-S.

Opposite Page: Side light from a large window, a hand painted background, and appropriate dress capture much of the look of an old portrait. The broad window source gently models the subject's features, while the side lighting defines the texture and detail of the subject's garments.

Without the panels blocking some of the light from the left side of the painted background, it would receive much more light than the right side. Without the fill provided by the white panels, the light ratio would be much greater than 1:3 and a significant amount of detail in the dress would be lost.

Low Light Ratios—The reflectivity of the surface on the other side of the subject, opposite the window, determines the light ratio. If this surface is close to the subject and is an efficient reflector, the ratio is low. If it is distant and non-reflective, the ratio is high.

The amount of light on the subject and the light ratio are also affected by the distance between the subject and the window source. The closer the subject is to the window, the higher the intensity of the light striking the subject directly. For example, if you desire low-ratio lighting when the subject is close to the window, move a reflector close to the subject.

If the subject is moved close to a highly reflective wall opposite the window source, the light ratio will also be quite low. The light intensity, however, will be significantly reduced due to the fall-off of light. Indoors, the windows are the source and they diffuse the light. As the distance from the window increases, the area lit by the window increases by the square of the distance.

When only a partial figure is in the field of view, you can position the subject close to a small window and still preserve the soft quality of the light. The light intensity will be quite strong, but if a reflecting surface is brought in close, the light ratio can be kept low. Because the subject is near the window, it is also possible to increase the light ratio considerably by moving the reflector far away from the subject or by eliminating it entirely.

For this photo, I moved the reflector away from the subject, increasing the light ratio to compensate for the loss of image contrast caused by using a soft-focus lens.

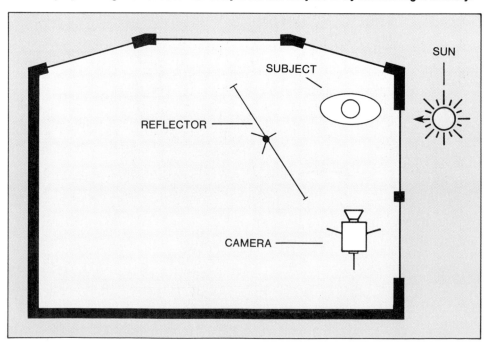

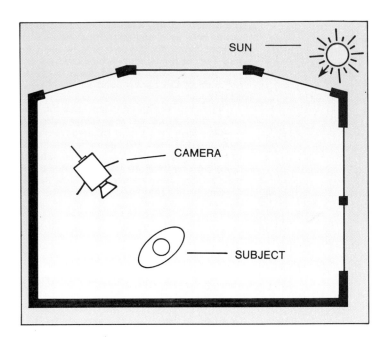

When you use side light from small windows to illuminate a complete figure, it may be necessary to move the subject far from the source to provide even illumination of the subject. In this photo, the white wall close to the subject and opposite the window provides a low light ratio. Even in this all-white studio, the increased distance of the subject from the window reduces the light intensity considerably. This lower light level means using either a faster film that allows a 1/30 or 1/60 second shutter speed or a tripod and a static subject pose.

High Light Ratios—It's a natural tendency for a photographer using a daylight studio to make it as efficient as possible with light-colored walls, ceiling and floor to get the most out of the available light. This gives plenty of fill light and a low light ratio. Some subjects, however, are better served by a higher light ratio creating strong shadows and image contrast.

For these cases it is very easy to reduce the amount of fill light. All you have to do is use a non-reflecting material relatively close to the subject, opposite the window. It will eliminate reflections from the interior surfaces of the room that would otherwise fill the shadows.

If the subject is standing, you'll need a non-reflecting area approximately four feet wide by eight feet tall. A temporary solution is a piece of black seamless background paper suspended between two light stands. For a more permanent setup, a 4x8 sheet of Masonite panel painted matte black on one side and mounted with a clamp to a sturdy light stand works well. Paint the other side of the sheet white so it can serve double-duty as a reflector.

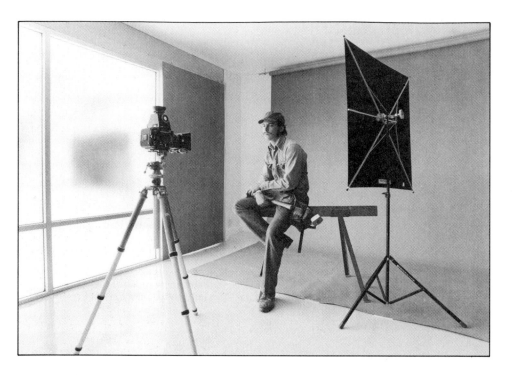

A 42-inch Larson Reflectasol with a black cover acts as a flag to reduce the amount of light filling the shadow side of the subject. Part of the window is blocked by a 4x8 foot panel to keep some of the light off the left side of the background so it will be lit evenly.

This setup, designed to increase the light ratio, puts more of the subject area in shade. To make a meter reading from subject position that will normally reproduce the skin tones on the lit side of the subject, point the sphere of an incident meter at the window. Or, from camera position, take a reading from a gray card reflecting the window light.

You can get an *effect* of greater contrast by changing the orientation of subject and camera to the window source. If the subject is moved close to the window source, but not in front of it, and the camera angle is shifted about 45° away from the window wall, the light on the subject will be from behind and to one side. Light from the window reflected from subject planes parallel to the lens axis will create specular reflections in shiny subject surfaces. Thus the ratio between subject highlight and shadow brightness will be greater than with side light.

If you wish, you can reduce this apparent contrast with additional reflected light or by using a soft-focus lens. A soft-focus lens will put light from the bright part of the image in the shadow areas and lighten them. A small reflector close to the subject will provide some fill and also create catch lights in the eyes if placed near the camera. When the subject faces away from a window source and is primarily lit reflected light, distinct highlights in the eyes will not be present.

Take care to choose a background that contrasts with both the highlight and shadow side of

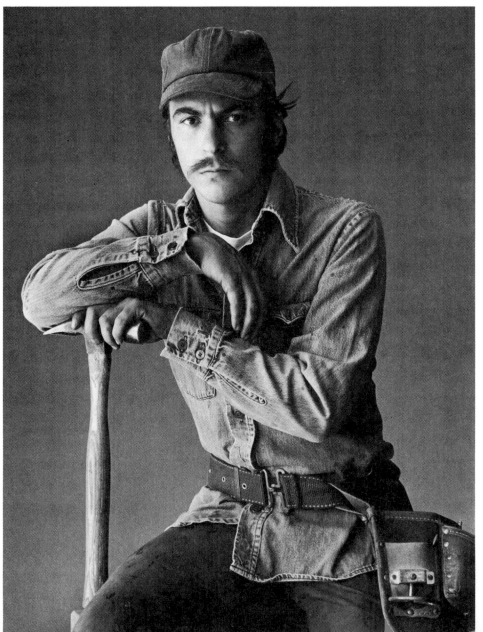

Even though the reflectivities of the subject are in the midrange, there is a high light ratio with much of the subject in shadow. This reproduces a large area of the image in dark tones and creates a low-key effect.

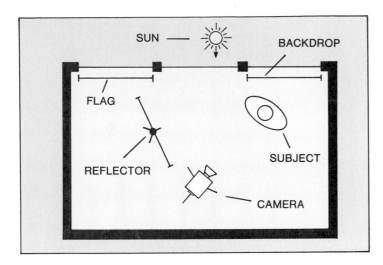

the subject. Remember though that the light level on the background may be considerably less than the illumination of the subject. Even a white background can become a gray tone when it reflects only ambient light.

Backlit Scenes—In a backlit situation such as this, you have two options for determining exposure. You can average the highlight and shadow brightness levels to record some highlight detail and fairly deep shadows. Or you can base the exposure on the fill light, which causes the directly lit highlights to be overexposed—called *block-up* or *burn-out.*

If you are using an incident meter with a normal spherical integrator and you place the meter at the subject position with the sphere pointed at the camera, the direct window light will strike part of the sphere. This gives an averaged reading and an exposure with some highlight detail. If you prevent the direct window light from the meter, then you will be exposing for the indirect fill light.

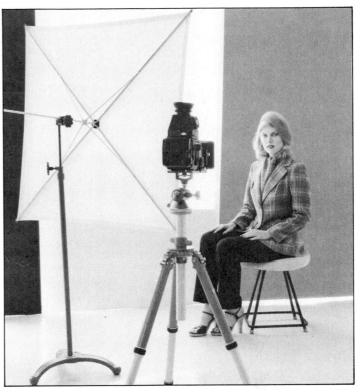

Only fairly large windows provide sufficient illumination for backlit portraits. Position the subject slightly to one side of the window. If you want to use an artificial background, place it parallel and next to the window wall. A 42-inch Larson Reflectasol with a standard silver cover redirects sufficient light from the window to create a 1:4 or 1:5 light ratio.

The slightly higher lighting contrast produced by back lighting combines well with the soft-focus effect you can get with a soft-focus lens. Because the soft-focus effect spreads light into the image's shadow areas, highlights take on a soft glow, and the scene is reproduced with an image contrast close to normal. Take special care when you combine back light and a soft-focus lens or diffusion filter. Be sure the light doesn't strike the lens directly, causing flare and wash-out of the image.

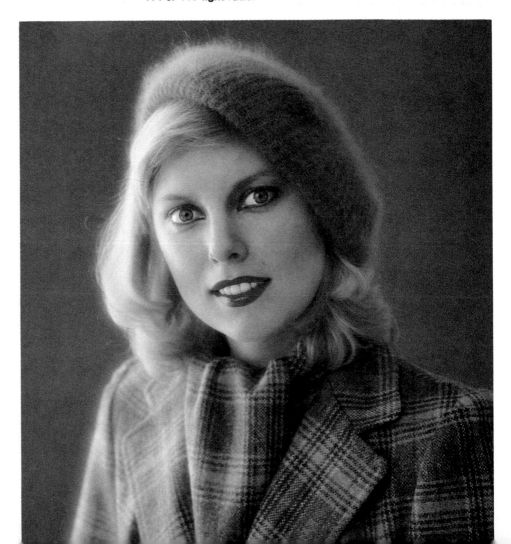

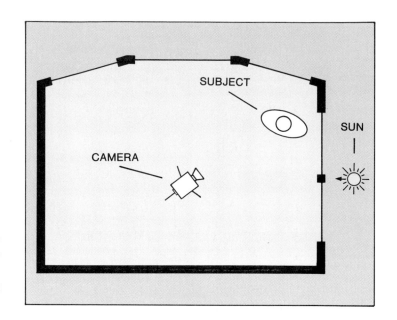

An incident light meter was used to meter this scene. The meter was held at subject position and pointed toward the camera. This guaranteed good skin-tone reproduction and burned-out highlights on the skin and dress near the window. When printed normally, the window and the highlights on the subject do not record detail and reproduce as paper-base white.

Skin tones struck by direct light may burn out. Skin-tone reproduction is most important in determining exposure.

This kind of back lighting is the one situation where predictable exposure readings require an incident reading. You should not make a reflected light reading directly from the subject because the reading can mislead you. First, average Caucasian skin tones reflect about 36% of the light falling on the subject. A reading based on a skin-tone brightness level underexposes film about one exposure step. Backgrounds and clothing will also present an unpredictable array of brightness values to confuse an averaging reflected-type meter. Of course, this can also be true with front light.

With the further influence of strong backlit highlights, you can never be sure how skin tones will reproduce. If the average reflectance of the subject is under or over 18%, a built-in camera meter will recommend over- or underexposure, and skin tones will not reproduce well. I don't recommend using a gray-card reading in this case because the card is two-dimensional. It is difficult to have both back light and indirect light strike the card as it does the spherical light integrator of an incident meter.

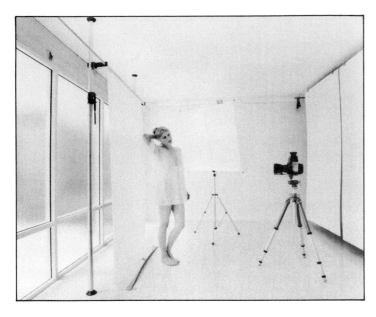

To create a seamless background effect, I hung a sheet of Flexiglass a short distance from the window to ensure even background lighting. The light coming through and around the background from the window is reflected toward the subject by the studio walls and ceiling and 4x8 foot reflector panels. A Larson Reflectasol with standard silver cover provides additional light on the subject with some highlight accents. Even though the subject apparently has a limited range of predominantly light tones, the eyelashes, pupils and nostrils extend the reflectance range to average. The background of diffusion material illuminated directly by window light is about one step brighter than a diffuse highlight in the subject. Therefore, it reproduces as paper-base white.

With all other light directions you can substitute a gray card for the subject. Meter the card to determine exposure settings. In this way you can get an exposure that will reproduce skin tones accurately. A single 8x10 inch card is adequate when the subject is a close-up portrait. Half and full-figure framing of a human subject is more effectively simulated by four gray cards attached to a 16x20 inch board. This method gives the same result as using an incident meter.

If the window source is behind the subject and the camera in front of the subject, none of the light from the window strikes the subject directly, as seen from the camera's point of view. In this arrangement, the light illuminating the subject is either redirected by the studio environment or by reflective materials in front of the subject. This indirect reflected light is what you measure.

If you use an incident meter, you should replace the light integrating sphere with a flat receptor disk or take great care that none of the direct light from the window strikes the sphere and influences the reading. If you use a gray card and camera meter, hold the gray card parallel to the plane of the window and completely fill the field of view when metering.

You can achieve a similar effect by using a standard white seamless background if you have a large window area. Hang the paper so it receives even illumination directly from the window. Limit the light from the window to just the background. The subject standing in front of the paper is then lit only by indirect light reflected from room surfaces.

The goal is to give the white background more illumination than the subject. It will then reproduce with no density in a print or transparency. Even a white garment will be separated from the background by some difference in image density.

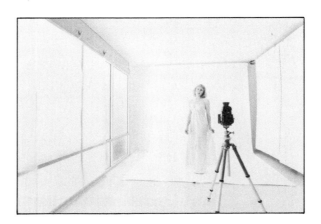

To get more light on the background, the window should be covered with diffusion material to lower the intensity on the subject. The window adjacent to the white seamless paper background is uncovered so the light intensity on the background is greater. White reflective panels opposite the windows are next to the background so it will be lit as evenly as possible.

Although the traditional north-light studio had only one large window area, contemporary daylight studios may have several windows on more than one wall. These multiple sources allow variations on the theme of using a window source as a background. When there are windows on two different walls, the intensity from one side will be greater. In addition, there may be a color temperature difference between the light coming through the windows.

As the sun moves during the day, the qualities of the light in each studio will vary. Identifying and controlling all of the potential lighting qualities and knowing how each affects different subjects require time and practice. You can make a series of tests using a test subject. Photograph the subject in various places in the room, from different angles, and at different times of the day. The processed results will show what kind of light qualities and results you can expect in that room.

In this photograph the front light on the subject is indirect light from studio walls, ceiling and floor. There is also some direct light from the windows to the subject's left, creating highlight accents on her cheek, nose and chin. The shadow in front of the subject is a clue that the intensity of the light from behind is stronger than the front light. This should tell you to exclude the effect of this back light on the meter reading. However, light from the windows to the left of the subject should be included in the exposure measurement to get good skin-tone reproduction.

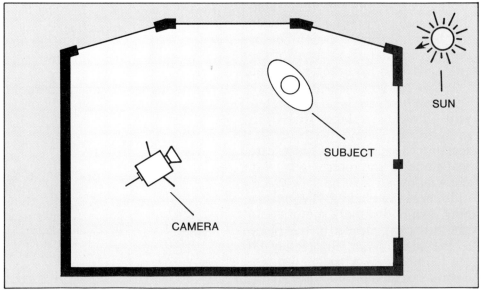

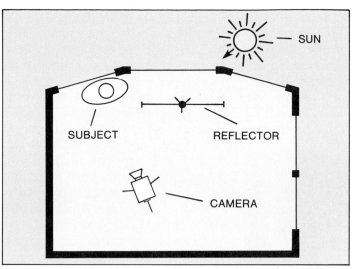

When there is more than one window in a wall and one of them is used as a background and framing device for the subject, you can use a reflector to direct light from another window onto the subject. This reflected light illuminating the subject is the light you meter.

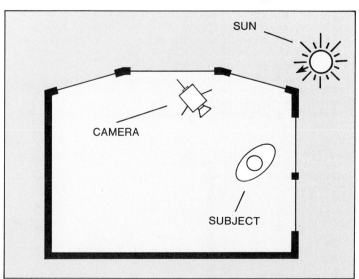

In the photo at left, the gown is receiving more intense light from the window on the subject's right side than the overall level of indirect light on the subject. If the purpose of the photo is to illustrate the gown, base exposure on the window light directly incident to the garment. If the purpose is portraiture, base exposure on the light incident to the subject's face, allowing part of the gown to be overexposed, as was done here.

Front Lighting—This is possible with window light, but there are some physical limitations you must consider. It should be obvious that the camera position cannot be right in front of the window source because you will block some of the light. Of course, you can't move the camera behind the source either. Put the camera a few feet in front of the window. The subject can be moved away from or toward camera position to alter how much of it is within the field of view.

With most window heights the

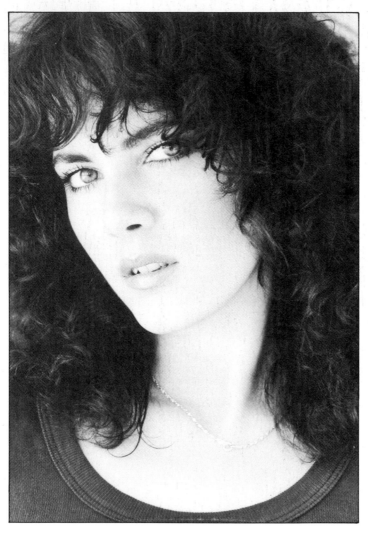

Front lighting from a large window giving even illumination allows the subject to change position considerably without altering the effect of the light. With the rapid firing capability of a modern 35mm camera, you can make exposures quickly to capture fleeting expressions.

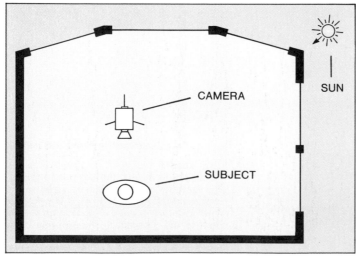

vertical angle of incidence will not be much above the camera lens axis. This relatively low angle of front lighting does not provide much modeling of subject features. Unless you use a wide-angle lens, the subject has to be far from the window source to include very much of the figure in the picture. The longer this distance, the more light fall-off there is, requiring relatively longer exposures than the the other lighting directions already described.

Even with these limitations, front window light has some advantages. The soft, relatively flat effect of diffused window light minimizes the subject's complexion irregularities. This makes close-up portraits made with a small-format camera much less of a potential problem because retouching a small negative is exceedingly difficult and retouching a color slide is virtually impossible.

A close-up portrait allows the subject to be fairly close to a relatively large window source, providing soft and subtle tonal gradations representing facial lines and shadows under the eyes. Front window light can be the most flattering of all techniques for portraits in a daylight studio.

There are several variations of front window light. A higher angle of incidence, for example, is possible even if the window source is not very high. One way is to have the subject sit on the floor so both camera and subject height are lower than the window source.

Another variation is to recline the person on the floor, with the head toward the window. Photograph the subject from above. When shiny, reflective background materials are combined with window light, the reflection provides a multi-toned effect. If the background is highly reflective, light reflected from it onto the subject can produce highlights that are usually possible only in lighting setups with multiple sources.

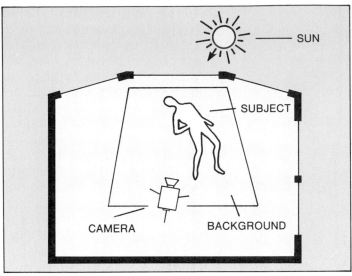

A sheet of glossy vinyl laid on the floor serves as a background for a reclining subject photographed from above. The shiny vinyl surface reflects the window source, creating a highlight accent next to the subject's head. The angle of incidence from the window source provides the same kind of modeling as a light source directly above camera position would on a standing subject.

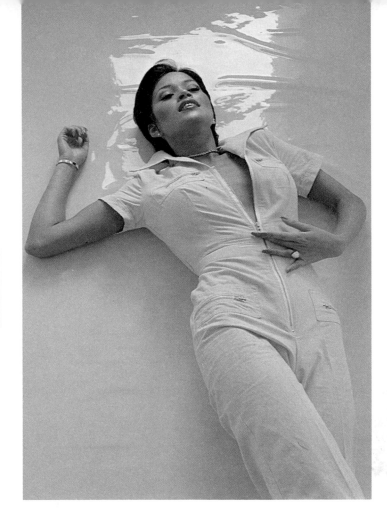

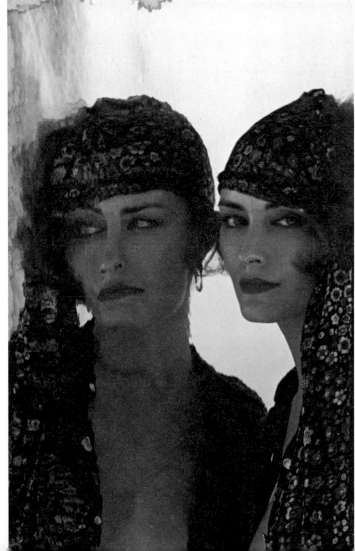

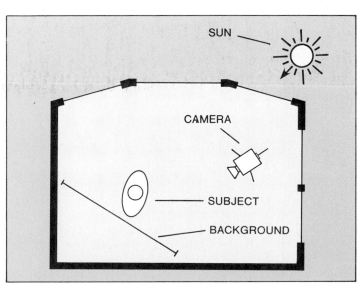

In addition to creating interesting tonal gradations in a background, metalized plastic materials can be used to mirror the subject and add some soft highlight accents.

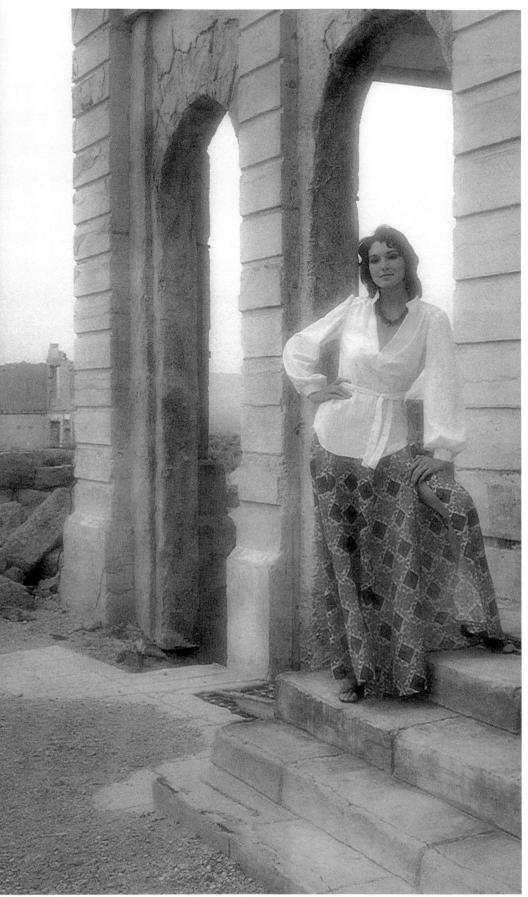

A hazy overcast day provides light that is very similar to front window light or open shade. The effect of diffused sunlight can be increased by using a diffusion or fog filter over the camera lens.

Outdoor Applications—Direct sunlight is, of course, quite different from a diffused window source. The light is very hard, and in most circumstances the light ratio between direct sunlight and shadow illumination is much higher than most purposes require. With the exception of some dramatic effects used with male subjects, lighting ratios for portraits should be considerably less than those you'll find in the average outdoor scene lit by direct sunlight. Even so, fashion and illustrative pictures requiring strong contrast to accentuate textures may be made in full sunlight.

However, these daylight studio setups and their effects can still apply outdoors. Atmospheric conditions of haze, fog or an overcast of thin clouds naturally provide the softness and moderate contrast considered most flattering to human subjects. In addition, they are compatible with the inherent limitations of the photographic process.

Because ideal portrait lighting conditions seldom occur in sunlit areas outdoors, most contemporary portrait photographers select locations in the shade. Shaded areas that receive much fill light provide lighting qualities similar to those of a large diffuse window source. As in a daylight studio, the effect of the light depends on the orientation of subject, camera, and source. In addition, light from the sky and reflections from the surroundings may be modified for a desired effect. You can increase or decrease the light ratio, for example, by using a portable reflector to put additional light on the subject, or a flag to eliminate some of the light striking the subject.

One common way of reducing the light ratio outdoors is with flash fill. But within the context of controlled lighting, I can't recommend this method, even though it effectively serves some journalistic and documentary purposes. The primary drawback in

using flash fill is that you can't see its effect on the subject illumination. Usually, the effect is incongruent with the natural light illuminating subject. This often gives the image a peculiar character that readily identifies the photo as a flash-fill shot.

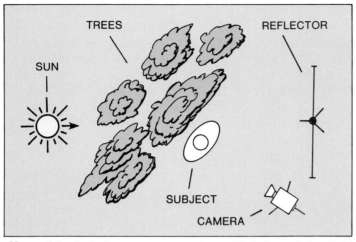

Many of the techniques you can use to modify indoor window light also apply to open shade outdoors. In open shade the indirect illumination from the sky and reflecting surroundings may be too soft and uniform. You can redirect some sunlight onto the subject with a reflector so modeling of facial features is accented with soft highlights. The reflector will also create sparkling catch-lights in the eyes.

When making portraits outdoors, the soft, indirect illumination of open shade is most flattering and usually preferred. However, cross light from the sun can often be useful, as in this photo illustrating a garment's texture and color. The hard light and a high light ratio define the highlights and shadows in this rough material.

83

USING INCANDESCENT LIGHTING

Controlling daylight indoors in a studio or outdoors in open shade is easy to learn and requires only a few pieces of equipment. It is a forgiving kind of light that only subtly reveals a less-than-ideal technique. Many of the advantages it has are shared with incandescent sources. The most important of these advantages is that the effect of the light on the subject can be seen during setup. The equipment is simple and easy to use too.

Daylight and incandescent light sources require different types of color film. There is a wide choice of daylight-balanced film in all format sizes in both color negative and color slide emulsions.

The choice of tungsten-balanced color films is much more limited. Kodak Ektachrome slide films, which are balanced for 3200K light sources, are available in two ASA speeds—50 and 160. Kodachrome Professional Type A slide film is balanced for 3400K light sources and has an ASA speed of 40. The only color negative film for use with tungsten light is Kodak Vericolor Professional Type L, recommended for use with 3200K light. It is designed for commercial illustration rather than portraiture. Its contrast is comparable to general-purpose films rather than the lower contrast of daylight Type S, which is made for portrait use.

Only limited lighting control is possible with daylight, whereas incandescent lighting demands full control of an almost infinite range of lighting effects. One positive aspect of this control is that you can use incandescent lighting wherever needed, at any time of day, in good weather or bad. A photographer dependent on a daylight studio is restricted by the hours of sunlight and the weather.

With incandescent lighting you need sufficient space to arrange lights, subject, camera and background. The area must also be equipped with an adequate source of 110-volt AC power. It's preferable to have at least two typical household electrical circuits available to power a three- or four-light setup. You should not use more than 1500 watts of equipment on any one household circuit. This way you won't blow fuses or trip circuit breakers. Another safety measure is to wear soft leather work gloves when handling the hot lights while they're on or soon after they're turned off.

USING PHOTOFLOOD LIGHTING

Because of their low cost, photofloods are the logical choice for beginning your experience with artificial lights to photograph people. It is also logical to start with some of the well-proven, standard portrait techniques. But before I get into the specifics of arranging the lights relative to subject and camera, let's first consider what is needed to work most effectively

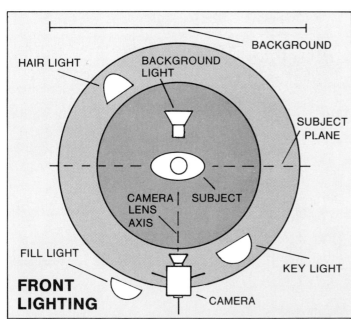

FRONT LIGHTING

To create front lighting, place the key light above or next to camera position. The key light should be high enough so the shadow cast by the subject on the background is outside the field of view. You can use barn doors on the key light to shield the background from spill. Lower the upper door to cut the beam off just above the subject's head. Place the fill on the opposite side of the camera as close to the lens as possible. Adjust it to camera height.

The hair light goes above and behind the subject's head—if a boom stand is available. Otherwise, place it behind, above, and just outside the field of view on the same side of the camera as the fill.

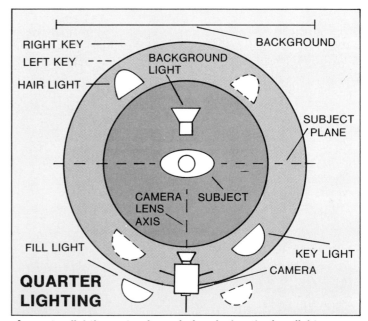

QUARTER LIGHTING

A quarter-lighting setup is made by placing the key light on one side midway between the camera and the subject plane. If the subject is facing the camera, adjust the height of the light to create a triangular shadow on the subject's cheek. It should not be so high that the nose shadow intersects the line of the subject's upper lip.

After adjusting the key to provide the desired modeling of the subject's features, place the fill light close to the camera on the opposite side from the key. Position the hair light behind the subject, approximately opposite the key light. For example, if the key is on the right of the camera, the fill and hair lights should both be on the left.

with these useful sources.

Equipment—To create portraits with incandescent lighting, a basic setup should include three or four lights with stands. The key or main light should be at least 500 watts with a normal flood reflector. A fill light should have half the wattage of the key light and a normal flood reflector. Although not essential, a background light with a 250-watt bulb and conical reflector is helpful. An accent or hair light with a 250-watt bulb and a narrow-beam reflector is useful to add the brilliance of additional highlights in the subject.

Part of the role of a hair light can be performed by a small efficient reflector attached to a light stand. Adjustable light stands for the key, fill and hair lights are necessary. The background light can be mounted on a small pedestal or short stand. Barn doors for the key and hair light allow a wide range of light control and also provide a way of keeping direct light from

striking the camera lens.

In addition to this basic lighting equipment, it's essential that you have a moderate telephoto lens for close-up portraits to eliminate distortion of the subject's features. The telephoto also provides a comfortable working distance between subject and camera and prevents the camera from blocking light to the subject. A sturdy tripod is necessary to help assure image sharpness when using slow shutter speeds. A tripod also lets you hold subject framing in the viewfinder as you adjust lights.

Finally, you need a light meter to measure both the overall light incident to the subject and the light ratio. A hand-held incident meter is ideal for this purpose. The through-the-lens meter built into most SLR cameras used with a gray card is almost as effective with most lighting configurations.

For accurate reflected metering, I recommend you use four Kodak 18% gray cards attached to

a 16x20 inch piece of mount board. With all but half- and full-figure portraits, the gray card essentially covers the camera's field of view without moving the camera.

Arranging Lights—The procedure for using photofloods begins with the establishment of the camera, subject, and background relationships. The usual distance between subject and background is roughly the same as the distance between the camera and subject. At least the same space on each side of the subject should be available for positioning the lights. Begin by setting the key light close to and above camera position. Turn it on to provide illumination for composing and focusing with the camera.

When the subject position is basically set, you can move the key light to establish the main modeling of the subject's features. Next, position the light that will fill the shadows created by the key

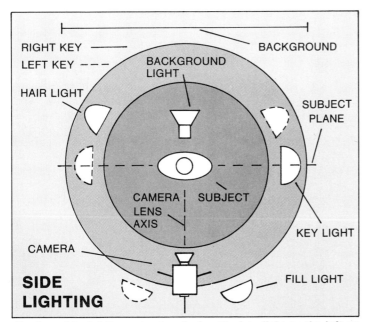

SIDE LIGHTING

Begin a side-lighting setup by placing the key light on the left or right side of the subject at a right angle to the lens axis. You can adjust the height of the key anywhere from the subject's head height to a 45° angle above the subject, depending on how you want to model the subject.

Unlike front or quarter lighting, the fill may be placed on the same side of the camera as the key. The hair light goes behind the subject plane opposite the key. A relatively broad-beamed hair light is most often used in this arrangement to create highlights that will assure good separation between subject and background. For the hair light to do this, you may need to set it lower than usual.

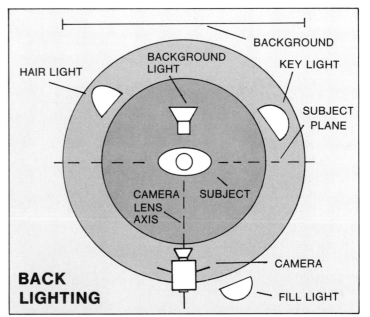

BACK LIGHTING

In a basic back-lighting setup, the key light goes behind the subject plane. Because the light skims the subject, much of it reflected by the subject has a specular quality. Therefore, it's common practice to use a relatively low intensity light as the key. Do this by switching the lights used in other arrangements—the fill becomes the key, and vice versa.

Then place the fill light next to the camera on the same side as the key light. You can adjust the height of the key light from head height to 30° above the subject, based on the most effective subject modeling. The hair light should provide less light on the subject than the key and should strike the subject from slightly behind the subject plane and opposite the key.

A typical photoflood setup can use a 1000-watt bulb in a Smith-Victor Ultra-Cool housing with barn doors and diffusing material for the key light. Two 250-watt bulbs in smaller housings act as fill and background lights.

In this quarter-lighting setup, the barn doors on the key light restrict the light beam to the subject. This keeps the spill from the background. The barn doors on the hair light also limit its effect on the subject and prevent any direct light from striking the camera lens. The background light is attached to a low pedestal and produces gradual tones from a light shade behind the subject to one much darker above the subject's head.

Although quarter lighting was used here, the modeling of the subject's features is more like the effect achieved with front lighting. With the subject's head turned toward the key light, a shadow is cast immediately below the nose. This lighting effect has several names, including *butterfly, paramount* and *front-light modeling*.

Because most of the subject's face is fully lit by the key, a relatively high light ratio may be used—even with color reversal film—without fear of losing important image detail in deep shadows.

light. The usual position of this fill source is right next to the camera lens and at the same height as the camera. The reason for this placement is to avoid creating any modeling of subject features that would conflict with the effects of the key.

The hair light is usually positioned on the other side of the subject opposite the key light. Put it in its approximate location and turn it on. Do the same with the optional background light. With all lights turned on, measure the light ratio and the illumination incident to the subject.

Measuring Light Ratio—Begin measuring the light ratio of the key and the fill by making a measurement at subject position where all the light strikes the subject. If you use an incident meter, point it at the key light, being careful not to shade the meter from the fill source. If you use a gray card, angle it so that it's fully lit by the key light and make a measurement from camera position. Make a note of this reading.

Now take a second reading at subject position with an incident

meter or gray card shaded from the direct effect of the key light. *Do not turn the key light off to make the fill reading.* Note the difference in exposure steps between the two readings. Refer to the table on page 9 to find the corresponding light ratio. A ratio about 1:3 is standard for portraiture. Higher or lower ratios are used to create more or less apparent image contrast and to complement a low- or high-key subject.

Adjusting the Light Ratio—You can adjust the light ratio a number of ways. Move either or both the key and fill lights closer or farther from the subject. For example, if the light ratio is too low, move the key light closer to the subject or move the fill light farther away, or both. If the ratio is too high, do the opposite. Move the key away, the fill closer, or both.

If it's not possible to move the lights, turn them so less direct light from the source strikes the subject. This *feathering* technique uses the outer boundaries of the light beam to light the subject. If the ratio is too high, turn the key light toward camera position and away from the subject until it lowers the amount striking the subject and you get the desired ratio. The same can be done with the fill if the ratio is too low. Another method is to use diffu-

sion material over the key light if the ratio is too high, or over the fill if the ratio is too low.

Metering—Once you adjust the lights to provide the desired ratio, you can read the incident light to determine exposure. But first you need to decide which portion of the subject's face should be reproduced normally. Based on that decision, measure the light illuminating that area. You can use an incident meter at subject position pointed at the center of the source lighting that part of the face. Or use a gray card set at an angle corresponding to the important plane of the subject area and read from camera position with a reflected-type meter.

With front and quarter lighting, hold an incident meter at subject position with the dome facing the camera. With side lighting, position an incident meter or gray card at an angle between the camera and the key light. With back lighting there is also a range of choices for placing the exposure level. The area of skin tone that should reproduce normally may be either the area lit by the key light or by the fill, or some area between the two.

Final Adjustments—After metering, make minor, last-minute adjustments to fine-tune the effects of the hair and background light. Usually, the hair light intensity at the subject position is less than that of the fill at subject position.

The light level on the background should be the same as on the subject if you want the background to reproduce accurately relative to subject tones. If the light level on the background is less than on the subject, the background will reproduce darker; if the level is greater, it will reproduce lighter. Frequently, a graduated tone is created in the background by selectively positioning and feathering the pattern of light on an even-toned surface. This creates separation between subject and background for a feeling of depth in the image.

The lighting setup in this photo is the same as the one at left. However, the facial shadows and the effect of the hair light are different because the model's head is turned.

Using barn doors, particularly on the key light, is important for controlling the background illumination. Flood lights produce a light beam considerably wider than required to illuminate a portrait subject. Some of the excess is likely to spill onto the background unless you narrow the beam with barn doors to illuminate only the subject. Barn doors are also used on the key light to reduce the amount of light falling on light clothing near the subject's face. This tones down the apparent brightness of an area that could otherwise distract attention from the face.

Used on a hair light or background light, barn doors offer additional control by isolating the beam to specific parts of the subject area. When barn doors are used on lights pointed toward the camera from behind the subject, they shield the camera lens from direct illumination, reducing the possibility of flare.

Variations—I've identified only four lighting arrangements tied to the basic light directions of the key light. However, the setup can be varied to include key light directions at every angle between the four setups. By altering the light ratio and using the hair and back-

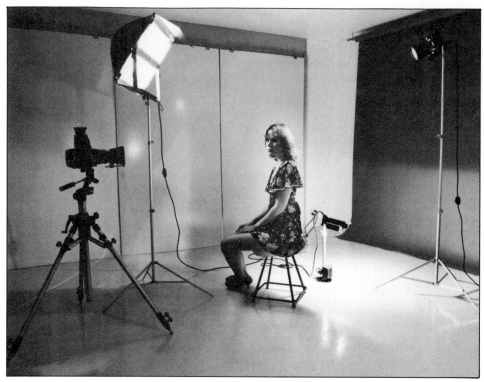

In this setup the Lowel Soft-Light is used as a key source. Besides providing the gently graduated shadows of a soft source, it also has sufficient spill to be redirected onto the subject to fill the shadows. I used a Larson Reflectasol on the right side of the subject to do this, although it is not shown in the photo.

The Lowel Omni-Light with a snoot produces a narrow beam to illuminate just the subject's hair. A Lowel Tota-Light with adjustable reflector works well as a background source.

ground lights differently, you can adapt the basic four-light portrait setup to suit almost any subject and image style.

Before you experiment with any of these variations, you should first practice the standard setups. Then you'll have a thorough understanding of the effects of the lights on image formation.

USING TUNGSTEN-HALOGEN LIGHTING

You can use tungsten-halogen lighting equipment to create the same effects of photofloods, but there are some basic differences to consider. The typical flood reflector designed for the tungsten-halogen bulb is usually smaller, having a reflector diameter of only 3 to 5 inches, as compared to the 10- to 16-inch size of photoflood reflectors. Therefore, a tungsten-halogen flood used to replace a photoflood produces somewhat

USING THE COLORS OF THE SOURCE

Another effect of light and color on the formation of a b&w image is evident when using tungsten light for portraiture. Because skin tones contain red and yellow pigment and tungsten light predominates in red, a panchromatic b&w film records skin tones with greater density than other colors. This makes flesh tones in a b&w print lighter than usual. It also smooths the appearance of skin by making skin blemishes reproduce with less contrast. Add to this the fact that tungsten light has little ultraviolet radiation, so the penetrating effect on skin layers and makeup is reduced. A high-speed b&w film with extended-red sensitivity, such as 120 Tri-X Professional, will contribute even more to the flattering effect of tungsten light in portraiture.

Opposite Page:
Even though tungsten-halogen lights are extremely portable, they provide more than enough light to expose medium or fast films. Sharp, brilliant portrait images with the sparkle of spontaneity are easy with tungsten-halogen lighting.

harder light on the subject. The typical tungsten-halogen flood is also likely to be available with a greater array of light-modifying accessories, including four-way barn doors and snoots.

In addition to a standard flood, there are other designs that use tungsten-halogen bulbs to replace flood lights. Two very different ones are the Fresnel spotlight and the softlight. Both can be used to replace a standard flood light as the key in a portrait lighting setup. The spotlight produces a hard effect and an adjustable, but limited, beam. The softlight does just the opposite—it creates a softer effect on the subject and provides a wide, evenly dispersed beam.

If you replace a standard flood light with a spotlight, remember that a lower wattage rating can produce roughly the same illumina- tion on the subject from the same distance. Specifically, when a 1000-watt flood light is replaced by a 500- or 750-watt Fresnel spot, the amount of light on a subject six feet from the source will be about the same. To achieve the same illumination on a subject with a softlight as that created by a standard flood light, a higher wat- tage rating is needed.

Because the beam of a spotlight is focused, the light intensity does not strictly follow the inverse square law. Of course, the inten- sity does fall off as distance increases, but generally, you have to move it a greater distance than a standard flood light to get the same degree of fall-off. The opposite is true of a softlight because it is designed to spread the beam.

When applied to the standard portrait lighting arrangements, a tungsten-halogen Fresnel spot is particularly useful as a hair light and as a background light when you need an adjustable spot effect. A softlight is frequently used to re- place a standard flood light used as a fill source.

Unlike photofloods, the stan- dard tungsten-halogen flood light is quite adaptable for use with some kinds of light modifying accessories. You can easily create a soft source by using a standard tungsten-halogen flood light with an umbrella. The larger the umbrella, the softer the effect, as long as the subject distance remains the same.

Also, the size of the umbrella influences the amount of light it reflects. As the umbrella size increases, the distance from the light source to the umbrella sur- face must also be increased to illuminate the full surface of the

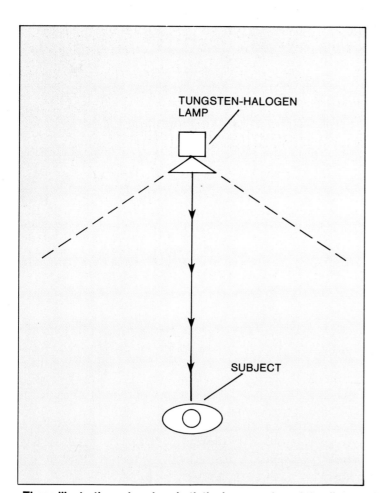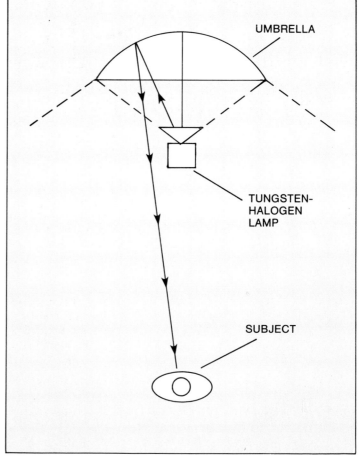

These illustrations show how both the beam angle and the distance light travels increase when an umbrella is used to reflect light. Softer light results. The tungsten-halogen lamp is the same distance away from the subject in both cases.

umbrella. This adds to the total distance the light must travel from the tungsten-halogen source to the umbrella and back to the subject. In addition, the umbrella surface diffuses and disperses the light at a greater angle than a standard flood reflector. You'll need more wattage in an umbrella light than you do when using the light directly to get the same light level at a specific distance.

For example, suppose you use a 72-inch umbrella with a standard silver cover and a 1500-watt light. A 500-watt flood light shining directly on the subject from the same distance as the umbrella would give the same intensity.

Besides umbrellas, you can use reflectors and diffusers effectively with tungsten-halogen sources. However, you should not use some softlight accessories, such as the Larson Soffbox and Starfish, with a tungsten-halogen light. These enclosed accessories trap heat inside the unit and could create a fire hazard.

The effects of modifying tungsten-halogen light sources with reflectors and diffusers are the same as described in the following section, which presents a variety of lighting methods using electronic flash.

USING ELECTRONIC FLASH

A contemporary studio flash system is the choice of most professional photographers for photographing people. Although the initial cost is more than incandescent lighting equipment, the advantages far outweigh the expense, provided sufficient use of the equipment is assured.

Some of its advantages affect the subject as much as the photographer. Compared to tungsten sources, electronic flash does not produce enough heat to make the subject uncomfortable. Nor is the intensity of the modeling light so great that it causes the subject to

The Broncolor IRS is a small infrared transmitter. It mounts in a camera accessory shoe and is connected to the camera's sync circuit through a hot shoe or with a short PC cord. When you trip the shutter, the Broncolor IRS sends an infrared pulse to the infrared receiver built into the power supply, which fires the flash. The transmitter gives you greater mobility and eliminates the often troublesome PC cord between camera and flash.

squint and blink, which is often the case with tungsten-halogen or photoflood lights.

The advantages for the photographer are several. First, the exposure duration of all but the most powerful electronic flash units is short enough to freeze most subject movement. This helps you get sharp images. The light output of electronic flash systems offers a broad range of exposure settings

to suit most subjects. The color temperature of electronic flash illumination is 5500K, or standard daylight, so you can choose from a wide selection of daylight-balanced color films.

All but the largest studio flash systems operate on household 110-volt AC power, and their amperage requirements are low enough not to overload a typical fuse or circuit breaker. Relative to

the light output, electronic flash units consume very little electricity.

Because they produce little heat compared to tungsten light sources, electronic flash equipment is usually constructed of lightweight metal, which results in efficient and compact designs. Even a medium sized, 1000- to 1500-watt-second power supply with four flash heads and four light stands is light and compact enough for you to handle and set up by yourself when working alone. In addition, the widespread use of electronic flash has led various manufacturers to offer a diverse selection of units with an array of accessories for the standard flash heads. Many special-purpose flash heads are also available.

What used to be shortcomings have been largely overcome by recent technological advances. These are either incorporated into the newest models or offered as accessories by the flash manufacturers and other companies.

Remote infrared transmitters and receivers, either incorporated in some electronic flash systems or available as separate accessories, have largely eliminated sync cords between camera and flash. The transmitter attaches to the camera's hot shoe or PC plug. When you trip the camera shutter, the transmitter sends an infrared signal to the receiver attached to the flash or power supply. Then the receiver fires the flash. All of this happens very quickly and eliminates the fragile and troublesome electrical connection between the camera and flash.

Older flash equipment and some of the least expensive current models use standard incandescent bulbs as modeling lights. These incandescent lamps provide rather weak modeling light which is unstable, decreasing in brightness as they are used. Most modern flash units now use tungsten-halogen modeling lamps. Their smaller size has permitted the design of more compact flash

MEASURING FLASH EXPOSURE

1. Because the flash duration is so short, light meters designed for continuous sources can't be used with flash. You may have to purchase a flash meter designed for electronic flash. However, with some flash units you can determine exposure settings for the flash by measuring the modeling light with a conventional light meter. These units use tungsten-halogen modeling lights that produce illumination proportional to the flash output.

To use the modeling light to determine flash output, conduct a test to find the difference between the modeling and flash level. Make this test for each film you'll expose with the flash. Begin by setting up the flash to give front lighting. The test subject should include a gray card and a person with normal skin tones.

2. Meter the scene lit by the modeling light and record the aperture corresponding to your camera's X-sync speed. Then make a series of bracketed exposures several steps above and below the exposure based on the flash manufacturer's recommendations. Use the X-sync shutter speed for each exposure and bracket in 1/2- or 1/3-step increments by changing the aperture setting. Make a record of the aperture setting for each bracketed exposure.

3. When the tests are complete, process each type of film exactly as you will in the future. Evaluate the processed film and identify the frame with the best exposure. If you shot negatives, a proof sheet should show this well. Slides are their own proofs.

4. Now find the recorded exposure that corresponds with the identified frame. Referring to the modeling-light meter reading, determine the number of exposure steps between the correct exposure and the meter reading. This is the correction. To apply it, adjust the film-speed setting on the meter so the modeling-light reading gives the same exposure setting as the correct exposure from the bracketed series.

For example, suppose the tested speed of the film you are using is E.I. 50. The modeling-light reading recommends an exposure of 1/60 second at f-5.6, and the correct exposure is 1/60 at f-11. The exposure difference is two steps. Increase the film-speed setting of your meter by two steps to E.I. 200. For future use with this flash, measure the modeling light level with the meter set at a film speed of 200. Then use the aperture setting the meter recommends.

When using flash lighting with people, base exposure on the incident level or the level of reflected light from an 18% gray card to get good skin-tone reproduction. Whether you use a flash meter or a conventional meter with modeling lights to determine exposure, the metering techniques already described for various lighting setups and sources apply to the same kinds of flash setups.

heads with the modeling source closer to the flash tube. This gives better correspondence between the qualities of the modeling and flash illumination.

With the increased use of motorized film advance, electronic flash manufacturers have quickened the recycling rate of power supplies. Rapid sequential firing is made possible by quick recycling. This also affects the

flash tube. With little time between flashes, the heat generated by each flash does not have an opportunity to dissipate. Therefore, many flash heads now contain blowers that provide air to cool the flash tube and modeling lamp. In addition, the tube's heat resistance has been significantly upgraded, making today's flash tube very durable and reliable in normal use.

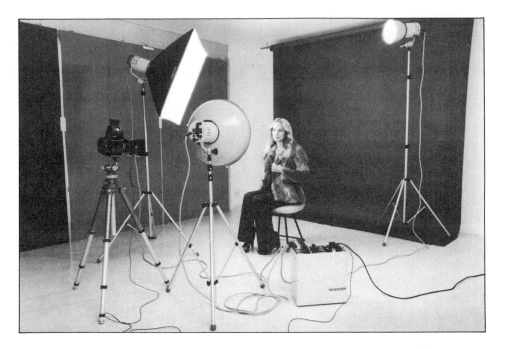

A standard portrait lighting setup using an electronic flash system can include three or four flash heads. In this arrangement a Quadraflex softlight accessory reflector is used for a key, a Softlight reflector for the fill, and a normal reflector as an accent light. The Broncolor 404 power supply is set on asymmetrical power distribution, with 70% of the power to the key and 15% each to the fill and accent lights. This gives a 1:3 ratio because the fill illuminates the subject directly and the output of the key is substantially reduced by two layers of diffusion material over the reflector.

STANDARD MULTIPLE-LIGHT SETUP

Studio flash systems, particularly those with separated power supplies and flash heads, are designed to work well with lighting techniques traditionally used in portraiture. Most medium to large power supplies provide outlets for four flash heads. Many of these units provide an asymmetrical distribution of power to the outlets. This gives more power to one or more flash heads and less to the remainder. Typically, the flash head used as the key emits more light than the flash heads used for fill, hair and background light. Accessory reflectors are also helpful with various lighting setups.

Setting Up—The procedure for setting up a multiple-light arrangement for portraiture involves essentially the same steps as lighting with multiple incandescent sources. However, there are some steps that differ because of the flash equipment's different features and functions.

I made a variation in the standard three-light setup shown by moving the accent light behind the subject's head to backlight the hair. Changing subject orientation and maintaining quarter lighting involves only switching the key and fill to opposite sides of the camera.

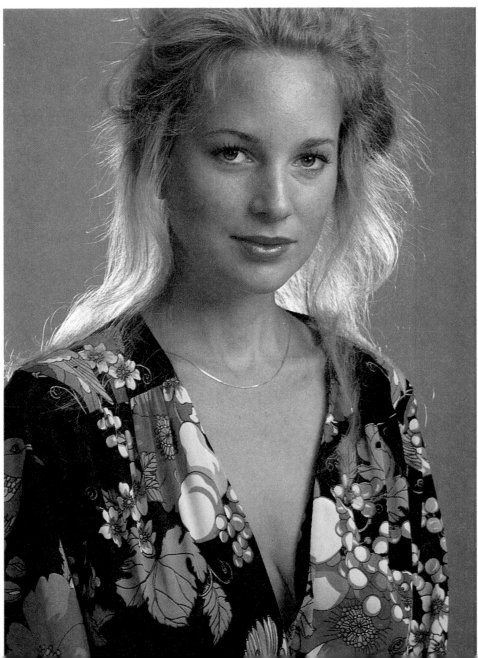

First, it's necessary to plug the power cables of the flash-heads into the power supply *before* turning the power supply on. If you plug in the cables of some flash equipment while the power is turned on, an electric arc between the plug and socket may occur. This can damage electrical contacts. When all the flash heads are plugged in, the power supply may be turned on.

With the key modeling light turned on and positioned to illuminate the subject, frame and focus the image in the camera viewfinder. If you can't turn off the modeling lights in the other flash heads you'll use, direct the lights away from the subject. This way you can see and adjust the key

light's effect on the subject. Then set the fill, hair and background lights. You can arrange the flash heads in the same configurations as the four basic lighting directions shown on pages 84 and 85.

Metering—If your flash system has a proportional modeling-light level, it will provide a visual approximation of the light ratio. If the modeling light is not proportional, you must measure the flash illumination from each source with a flash meter to see the effect.

Measuring the light ratio between the key and fill source and determining the overall exposure require the same technique described for each of the lighting setups in the incandescent lighting section of this chapter.

UMBRELLA LIGHTING

An electronic flash and an umbrella reflector naturally complement each other. Studio flash units produce the abundant light necessary to overcome the relative inefficiency of the umbrella. And the very broad, soft light produced by an umbrella combined with the short flash duration allows a greater range of subject movement and expression than is possible with traditional lighting arrangements.

Umbrellas became popular as color photography for portraits and commercial applications became more and more common. Low light ratios are easy to achieve with umbrellas, and the very smooth tonal gradations from

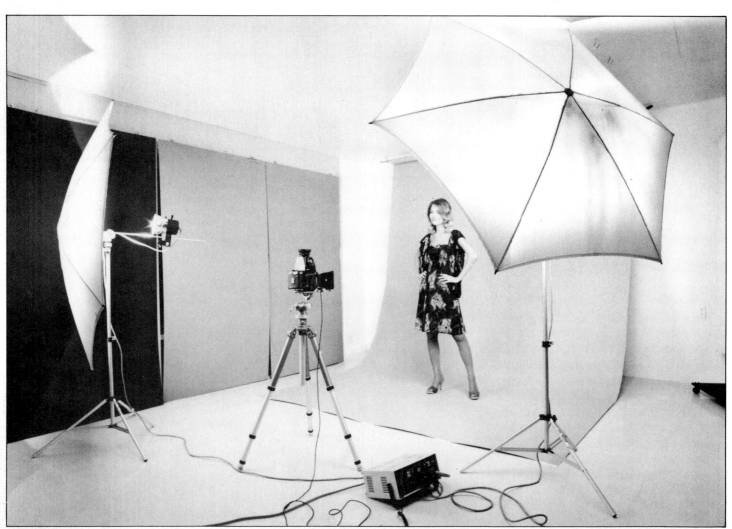

Two 72-inch Larson Hex umbrellas, each with one Ascor flash head, furnish soft, even and easily controlled light. The Ascor power supply provides symmetrical power distribution so I used two different covers on the umbrellas—a soft white for the fill and a bright silver for the key. This produced a light ratio between 1:2 and 1:3. Because of the large size of the umbrellas, the light wraps around the subject and completely illuminates the background.

The simplicity of umbrella lighting and its adaptability to various subjects not only provide a light quality that makes a subject and garment appear at their best, but also require minimal time to make minor lighting adjustments for different poses and attire.

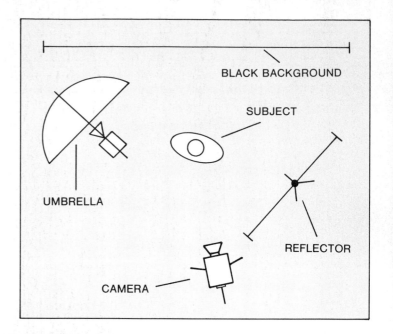

BLACK BACKGROUND

SUBJECT

UMBRELLA

REFLECTOR

CAMERA

The soft light produced by an umbrella is especially flattering for female subjects, but a single umbrella can also provide strong lighting suitable for masculine portraiture. By combining a black background and umbrella light from behind the subject, you can easily create a pleasing and effective low-key image.

Used in this arrangement, however, back lighting with an umbrella does not allow the same degree of subject movement within the scene that front umbrella light permits. The subject must be positioned carefully so you can adjust the light's position to get the best subject modeling. To preserve the low-key effect, the lens must be completely shielded from any direct light from the umbrella. Photo by Wah Lui; courtesy of Yuen Lui Studios, Seattle, Washington.

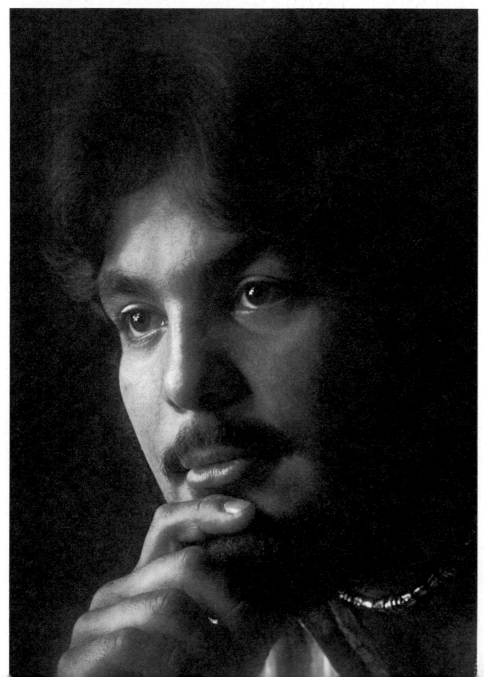

highlights to shadows minimize the need for retouching—a difficult and expensive technique in color.

Adjusting Light Ratios—Partly as a concession to traditional setups and partly to provide relatively even illumination for half- or full-figure pictures, two umbrellas are frequently used. The key is located on one side of the camera and positioned higher than the camera. The other umbrella is then placed as close to the camera as possible at camera height to act as a fill light.

With a single flash head providing light for each umbrella and symmetrical power distribution to the flash head, you can easily create light ratios from 1:1 to 1:2. You can get higher ratios with power supplies having asymmetrical power distribution by allotting more power to the key than the fill. If the power supply provides only symmetrical power distribution and a third flash head is available, a ratio higher than 1:2 can be arranged by using two flash heads with the key umbrella and only one with the fill umbrella.

Umbrella Size—If you are making a close-up of the subject, use a small umbrella placed near the subject to provide soft illumination. As more of the subject is included in the picture and the

umbrella is moved farther away to provide even illumination, the umbrella size must be increased proportionately. If both the distance from subject to umbrella and the size of the umbrella are increased, the power requirement to furnish the same light intensity incident to the subject increases several times.

Ways to Use Umbrellas—You can use one or more umbrellas to create different effects. They do not have to be used exclusively. In fact, if an integral studio flash is used with an umbrella, it is convenient and economical to use a reflector instead of another flash to fill shadows.

One of the main advantages of a relatively large umbrella is that there is a lot of spill light to use. This is excess direct light that doesn't illuminate the subject directly. You can light the background by directing part of this light with reflectors.

Although the characteristics of umbrella light favor simple lighting with as few sources as possible, this does not preclude using them with other flash heads using normal reflectors. One possibility is to light the subject with one or two umbrellas and then use a flash head with a normal reflector to light a white background. The advantage is that the white background will receive more light than the subject. This will reproduce it as paper-base white in the print.

An umbrella has several practical advantages as a source of soft light. An umbrella is very light, is simple to mount on a light stand, and easy to adjust. Because it collapses and is easy to pack and transport, it is an ideal accessory to take on location.

However, it is not faultless. An umbrella used close to camera position places the flash head close to the lens axis, shining toward the lens. Unless the camera lens is protected by a shade or hood, this extremely intense light can create severe flare problems.

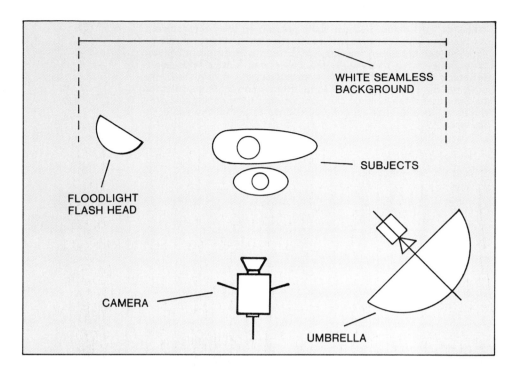

When a child is the subject or when more than one person is in the photograph, your ability to respond to spontaneous expressions is important. It's often difficult to predict how a subject's face will be turned when just the right expression occurs.

In this case, you can get optimal lighting with an umbrella set up between front and quarter lighting. To make this photo, the light was positioned close to the subjects, producing pleasant modeling of facial features. A white background lit separately created an open environment and also helped fill the shadows. Photo by Wah Lui; courtesy of Yuen Lui Studios, Seattle, Washington.

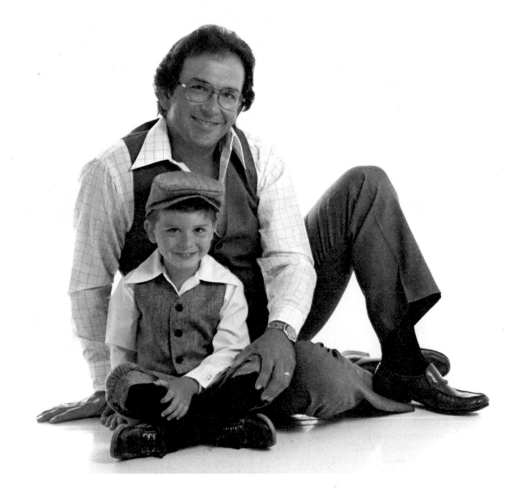

White or light-colored studio walls provide an ideal environment for bounce light. With just two flash heads and a choice of reflectors you can create a wide range of effects with different lighting arrangements. In this setup, one flash head with a wide-angle reflector is on the left behind the power supply. It furnishes very soft, flat light reflected from a large area. A normal flood reflector on the other flash head on the right points at the ceiling and produces a more intense, directional source to model the subject's features.

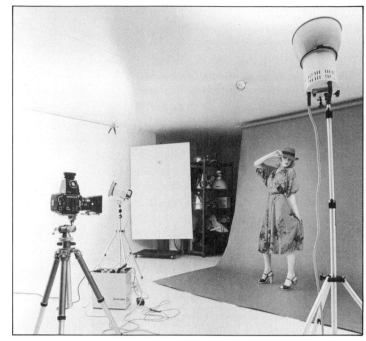

BOUNCE LIGHT

I've already mentioned that increasing the size of an umbrella at any subject-to-source distance softens the light on the subject. Obviously there is a practical limit to the size of an umbrella. However, white or light-colored walls and ceilings let you use a much larger bounce surface for directing light. With just two or three flash heads and a suitable environment you can create many different effects—from the simulation of a large window source to essentially directionless and shadowless light.

Bouncing light from walls or ceilings has been a favorite practice with photographers who use portable flash units attached to their cameras. The function is the same—to provide softer, more evenly distributed light. With studio flash units the technique gives much more predictable results because the modeling light allows you to see the effect.

Bounce light gives uniform illumination with seamless paper backgrounds. As long as the background's reflectivity is different from the subject's, the subject will attract all of the viewer's attention.

Because studio flash often involves more than one flash source, the illumination can be spread out over a larger area or directed to different areas to create a desired light ratio. Another advantage to bouncing studio flash is that most produce a lot of light to compensate for the loss at reflecting surfaces and the increased distance the light must travel.

Appropriate Subjects—One reason for bouncing light to create very soft, uniform illumination is evident if you photograph moving subjects. You can capture active poses and be assured of pleasant, flattering modeling of subject features. Bounce light also provides even, shadowless illumination of the background, preventing shadows. Therefore, the viewer's attention will concentrate on the subject.

Color Considerations—Even though bounced light off walls and ceilings can be seen with the modeling light, the effect of the reflecting surfaces is not always apparent. Shifts in color due to selective reflection of the bounce surfaces are not always predictable. Therefore, it's good insurance to make a color test of the films you'll use with a bounce-light setup.

The shadowless effect created by bounced flash also accentuates a monochromatic selection of colors if their shades are slightly different.

HIGH-KEY LIGHTING

Although a high-key effect is essentially derived from a subject and background made up of predominantly light tones, the lighting effect can either complement or detract from the results. With light ratios that are high and lighting directions that produce large shadow areas, too much of the image area is in dark tones and the high-key effect is lost. Usually, low light ratios produced by the uniform distribution of bounce light are used with a subject dressed in light-colored clothing against a similar background. This produces an image in which light tones predominate and the high-key effect is maximized.

When we think of a high-key photograph of a person, we usually picture a subject dressed in white standing in front of an even whiter background. If you use bounce light to illuminate such a subject and background, you'll definitely get an image with a high-key effect. However, because the reflectance of the clothes and the background are very similar, there are likely to be areas where the dress and background merge, eliminating the effect of separation.

To create a tonal separation between the two, you must apply more light to the background than to the subject. You want the background to record on film as a specular highlight and the white in the subject's garment as diffuse highlights. This way the back-ground will reproduce with no density in a print or color transparency. You can achieve this burned-out effect very effectively with multiple-source electronic flash.

Setting Up—Two flash heads are usually required to light the background. They should be equipped with standard flood reflectors. You may find that barn doors on these two flash heads are helpful to limit the light to the background and prevent spill onto the subject. Position the background lights so one is on each side. Adjust them to provide uniform illumination behind the subject.

Then light the subject with one or two other sources to create even overall illumination with a

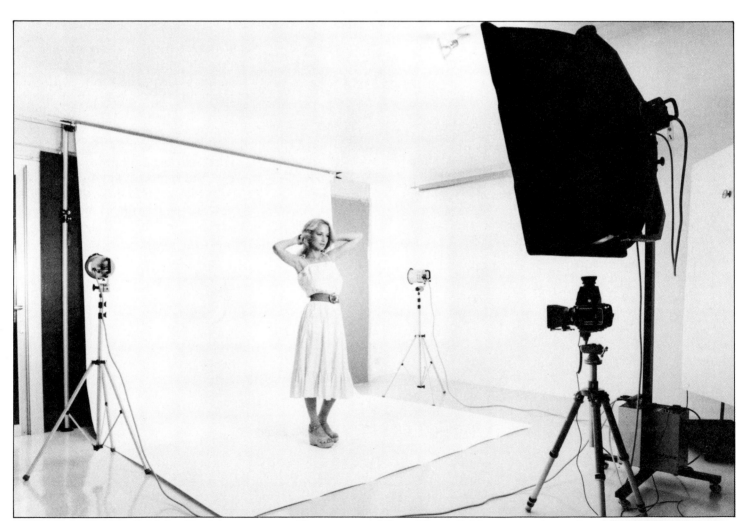

With a Broncolor Hazylight directly above camera position you can get the soft, even light necessary to create a delicate, high-key image. Two additional flash heads pointed directly at the white seamless background provide enough light to wash out the background, although each head receives only 15% of the power. Exposure is based on an incident flash-meter reading taken in front of the subject so the subject shields the meter from any background light.

When you use color reversal film to photograph low-contrast lighting of a high-key setup such as this, you must make exposure readings very carefully. If even slightly overexposed, highlights in the white garments will wash out. This makes the separation between clothing and background indistinguishable. In fact, slight underexposure ensures the strongest tonal separations in these critical areas. It also provides richer color saturation.

light ratio no greater than 1:3. If available, a large umbrella or softlight is an ideal source for this.

The incident light level on the subject should be about one exposure step lower than the level on the background. If there is less difference, there will not be sufficient tonal separation between the subject and a pure white background. If you apply too much light to the background, reflections from it can create specular highlights on the sides of the garment. This too can decrease the tonal separation between subject and background.

Metering—Once you've adjusted the lighting, determine the exposure. Base exposure on the light incident to the front of the subject. A flash meter is a great help in getting an accurate reading. If you have a flat light receptor available for the meter, use it to ensure that the meter won't be influenced by any of the light on or reflected from the background.

If you make a reflected reading with a gray card, be very sure that it's lit only by the source incident to the subject and not influenced by the light on the background. However, you *should not* turn off the background lights to make the exposure reading. The studio surroundings will reflect some of that light onto the subject.

Low-contrast lighting of a high-key subject preserves the light tones of the subject because no shadows are apparent. Because there are some dark tones in the eyes and nostrils, negative development for this image was normal. The negative was printed on a normal grade of printing paper. Developing the negative for a longer time would have produced more contrast between the skin tones and clothes.

SOFTLIGHT TECHNIQUES

A softlight furnishes much the same kind of soft, even light as an umbrella. However, it can often be used when an umbrella would not be effective. This is because the softlight is enclosed—square or rectangular in shape—and is more compact than an umbrella with an equal source area.

For example, when a camera is placed immediately next to an umbrella, the flash head is pointing almost directly into the camera lens. With a softlight used in the same way, the light source is enclosed within the reflector and all the light produced by the softlight is directed at the subject. This helps minimize the possibility of lens flare.

You can use a softlight on a standard light stand, but stands designed to support a softlight suspend it from the side. In addition to allowing many adjustments, it also lets you locate the camera directly under the center of the softlight.

Used in this manner for portraiture, a single softlight provides front light with gentle modeling of subject features. The quality of this front light from immediately above the camera has a number of advantages. The direct, rather flat light does not reveal irregularities in the skin, giving flattering reproduction of a subject's complexion. Therefore, minimal retouching of the image is necessary, which favors the use of small-format cameras and color reversal films.

Even if the subject changes position, facing one way then the other, modeling of features remains flattering. Because of the short flash duration, the subject is also free to move naturally while you shoot, helping you record spontaneous expressions.

The Broncolor Hazylight on a Vari-Stand lends itself to placement above the camera. This creates front light that is universally flattering for portraiture. A Larson 42-inch Square Reflectasol acts as a convenient fill source, further softening the effect of the Hazylight.

Low Light Ratios—When used alone as the only light source for a portrait, a softlight provides a relatively low light ratio. If the camera is at the edge of the softlight, there are virtually no shadows, as seen by the camera. With the center of the light well above the lens axis, however, more light strikes the subject from above camera position. This creates a gently gradated shadow effect under the eyebrows, nose, and chin. You can reduce this light ratio even more by placing a reflector under the light to redirect some spill illumination onto the subject.

Using a large softlight close to the camera lens is particularly effective for making portraits on color reversal films. A softlight above camera position produces a lighting effect that minimizes minor complexion imperfections. In addition, the lighting is even for all subject orientations, from straight on to profile, allowing the most freedom for expressive movement by the subject. The action-stopping flash makes it easier to hand-hold a medium-format camera without getting a blurred image during an active shooting session.

Background Considerations—
When you use a single softlight directly over camera position, illumination from the softlight also lights the background. This also helps hide any shadows cast by the subject that are visible from the camera's point of view. Because the background is farther from the light source, it is illuminated with a lower level due to the fall-off of light. You can lighten or darken a background by moving it closer to or farther from the light. Bear in mind when choosing backgrounds, that they will always reproduce somewhat darker than they appear to the eye because of light fall-off.

Don't assume that because of the light fall-off it would be easy to create a black background effect just by putting up a piece of black seamless paper three or four feet behind the subject. Because the light source is in line with the camera axis and paper backgrounds exhibit some sheen, reflection from the paper surface can reproduce as a gray tone instead of the expected black.

One way to solve this potential problem is to angle the background or move it even farther behind the subject. If you don't have enough room to ensure sufficient light fall-off, try using a piece of black Foamette from The BD Co. or a black velvet curtain for a background. Either will provide much greater absorption of the light falling on it.

You can achieve just the opposite effect by using reflective material as a background with the front softlight source positioned over the camera. Either plain silver plastic sheeting, such as Mylar mirror, or one of the colored foils available from Studio Specialties can help you get striking effects. Hang one of these highly reflective materials against a wall and then place the subject right in front of it. Be sure that the camera lens axis is perpendicular to the wall and background material. Then the softlight source will be reflected by the mirror-like material, creating a halo of highlight tones around the subject.

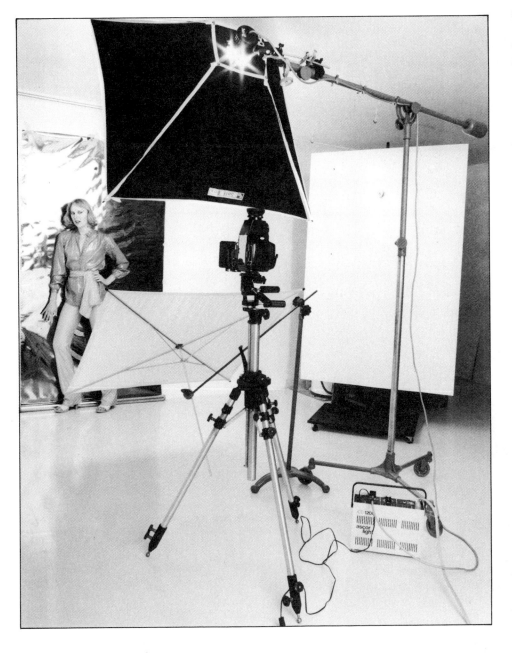

A Larson Soffbox accessory softlight and an Ascor flash head are well supported by a boom stand made for a 500-watt Fresnel spotlight. The square Soffbox can be raised close to the ceiling so you can position the camera underneath to photograph a standing figure. A 42x42 inch square Reflectasol redirects fill light onto the subject.

Variations—A softlight need not be restricted to front-lighting arrangements. Nor does the use of shiny background materials have to depend on front lighting over the camera. You can change the angle of the camera and background from a right angle to approximately 45° and then position the softlight about 45° from the background plane opposite the camera. The background will

A shiny foil background hung from a studio wall reflects the softlight and reflector source to create specular highlights behind the subject. The uneven surface of the foil creates an irregular area of dark gradual tones framing the image. Metallic threads in the subject's blouse also reflect the light source and provide a pattern of sparkling, specular highlights. The satin pant fabric is distinctly reproduced with strong tonal differences created by the diffuse highlight reflections of the light source.

The color of the foil background reflects colored light back onto the subject, creating an unusual backlit effect on the subject's hair.

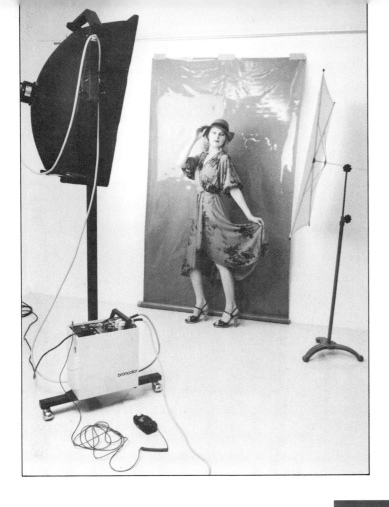

reflect the source onto the subject and create side lighting.

With such a side-lighting effect, much more of the subject is in shade compared to the front lighting setup. To keep the light ratio within normal limits it's imperative that you use a reflector to bounce spill light from the softlight back onto the subject to fill the shadows. One disadvantage, however, is that the side lighting restricts movement.

For this photo a Broncolor Hazylight was in quarter position and the subject seen from camera position was at a 45° angle to the background. In this arrangement the Reflectasol is positioned on the other side of the subject opposite the Hazylight. The greater the distance the light has to travel from the source to the reflector and then to the subject, the lower the level of fill light. Therefore, a much higher light ratio results than with the front-lighting setup.

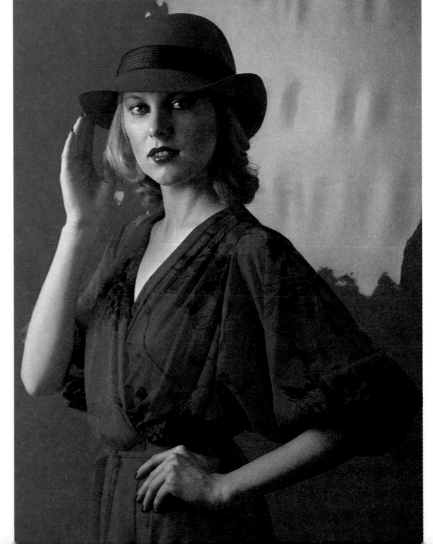

Instead of colored foil, a background of brightly colored, glossy vinyl was used. It creates rich color saturation accented by diffuse highlights in a pastel tint, representing the reflection of the Hazylight. By adjusting the position of the softlight and camera, you can place the reflection of the light source to make the contrast separating subject and background as strong as you like.

RINGLIGHT EFFECTS

The fundamental quality of illumination produced by a ringlight is very flat and even front light. Basically, the effect is like that of a small flash mounted on the camera above the lens. However, the light emanating from all around the camera lens adds some unique characteristics. These special qualities have caused many fashion photographers to adopt the ringlight for some of their work.

The effects of the ringlight that distinguish it from other sources are particularly evident with certain subject characteristics. For example, if the subject includes shiny material, areas of that material at right angles to the lens axis reflect the light source and create specular highlights. The effect is most pronounced in the center of the image area and falls off towards the outer edges of the picture. Shiny fabrics like satin reproduce with strong tonal differences between the areas of the garment directly facing the camera and those angled away.

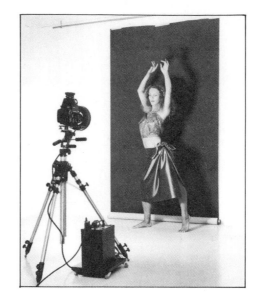

If a plain background is close to a subject lit by a ringlight, the edge of the shadow will surround the subject as seen through the camera lens. If the subject has small, bright surfaces at right angles to the lens axis, they will reflect the source and create strong specular highlights.

In the same way, a ringlight also creates strong specular reflections in the center of a shiny background material perpendicular to the lens axis. If the background material is not completely flat, distinct tonal differences are produced, even though the background material has uniform reflectivity. If you use such a background material directly behind the subject, some of the light reflected by the background will strike the subject and create a rim lighting effect.

The ringlight creates a shadow that surrounds the subject on a background close to the subject. It appears as a very thin line close to the subject as seen from camera position. Of course, reflective background materials can obliterate the subtle shadow line by filling it with light.

The flat, uniform light from a ringlight fully illuminates the subject and defines detail well. If the subject is in front of a shiny surface, distinct tonal gradations are produced, including specular highlights in the center of the image. Note the red-eye effect.

A minor side effect caused by the ringlight is a phenomenon called *red eye*, in which pupils of the eyes appear red. The light source is so close to the lens that light entering the subject's eyes is reflected from the blood vessels in the retina to the camera lens. This shows in a color photograph when the person is looking directly at the camera. Some photographers use this effect intentionally to create a startling effect in their portraits, but you can easily avoid it by making sure the subject's eyes are slightly turned away from the lens.

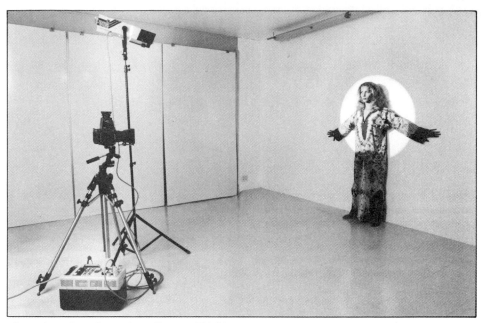

One of the functions of the Norman Tri-Lite is to produce a sharply defined circular beam of light. You can vary the size of the round pattern of light by three different methods, as described in the text.

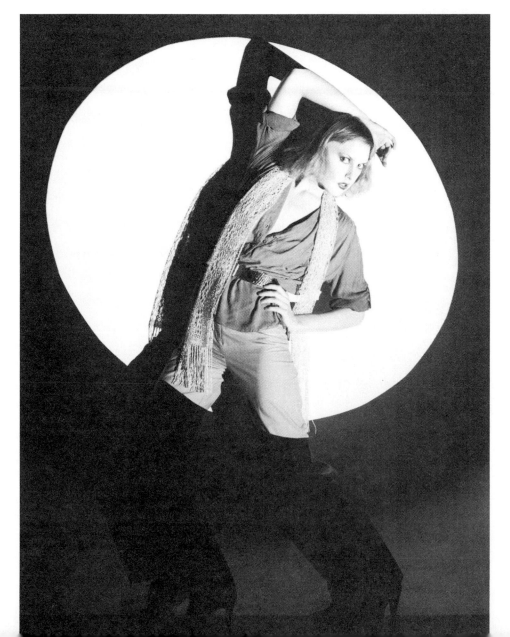

OPTICAL SPOTLIGHT EFFECTS

The basic light quality produced by an optical spotlight is the exact opposite of the softlight. The hard light of the optical spotlight makes very sharp distinctions between highlights and shadows. Unlike any other light source, the boundary of the light beam is also sharply defined. You can usually control the shape and size of the beam with an adjustable iris diaphragm. The light's projection lens also lets you focus the beam. By adjusting the angle of incidence of the beam, you can create elliptical or circular patterns.

In this fashion photo, the circle of light produced by an optical spotlight distinctly isolates a specific area of the image. The hard light sharply delineates fine detail in the subject. Without the aid of a fill source, the high light ratio produces strong image contrast. Details outside the spot of light are largely left to the viewer's imagination. The large dark border also furnishes an evenly toned area which can be used for type in an ad or poster.

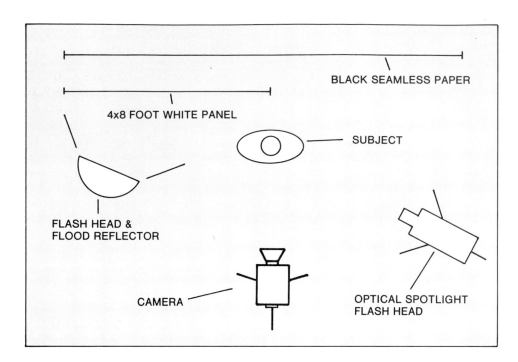

BLACK SEAMLESS PAPER

4x8 FOOT WHITE PANEL

SUBJECT

FLASH HEAD & FLOOD REFLECTOR

CAMERA

OPTICAL SPOTLIGHT FLASH HEAD

The simplest and most direct effect that you can produce with an optical spot is to illuminate a subject, or part of a subject, by focusing the spot on a certain area within the camera's field of view. This technique calls attention to the subject within the spot. When the spotlight is used alone, the rest of the picture frames the spot in very deep shade. If the area outside the spot requires illumination, a second source is needed.

An optical spotlight has many applications. In this photo, I projected a high-contrast, parallel-line screen used in the graphic arts. It was cut to size, put in a slide mount and projected on the model to create a high-contrast contour-line image. This same technique can be used with a variety of screens, patterns or grids for striking visual effects.

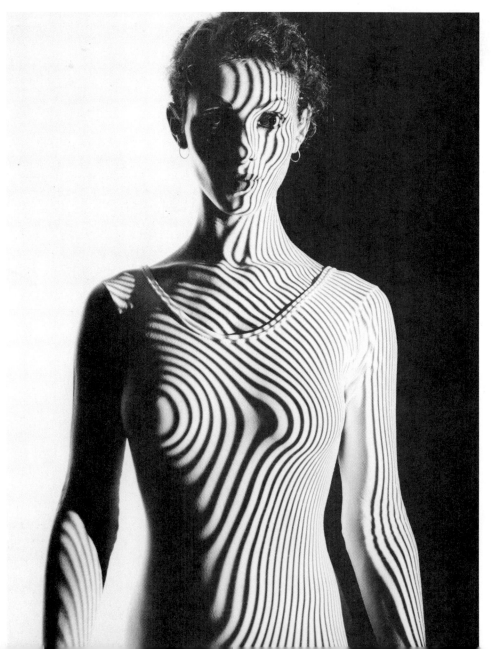

Projecting Images—Some optical spotlights resemble a slide projector and have a gate that can hold transparencies. You can use this feature in a number of ways. Probably the most popular use of a projected image from a transparency is to create artifical backgrounds. This is done in one of three ways: (1) Project the image onto a plain white screen behind the subject. (2) Project the image from behind the subject onto a translucent rear-projection screen also behind the subject. (3) Project a background image through a partially-silvered mirror and onto a special highly reflective front projection screen behind the subject.

You can also use an optical spotlight to project transparencies directly onto a subject. The effect is a unique kind of multiple image. The projected image does not have to be another photograph. You can use all kinds of grids, patterns and screens available from graphic-arts supply houses.

When you're projecting an image with an optical spotlight, and also using other sources to illuminate the subject or background, carefully shield the projected image from the other sources. Otherwise, the projected image will be washed out. Barndoors, honeycomb grids and flags are essential accessories for controlling these sources.

How do you create a photograph in a studio that appears to have been taken outdoors on location? Use a front-projection system like the Broncolor Front Projection Unit shown in the foreground. A front-projection system uses an optical spotlight to project an image that is reflected by a partially-silvered mirror in front of the camera lens. The reflected image falls on the subject and onto a special, high-efficiency screen behind the subject. Because the reflectivity of the screen is greater than the subject, the background image is visible only on the screen. The camera takes the photo "looking" through the partially silvered mirror. Photo courtesy of Broncolor.

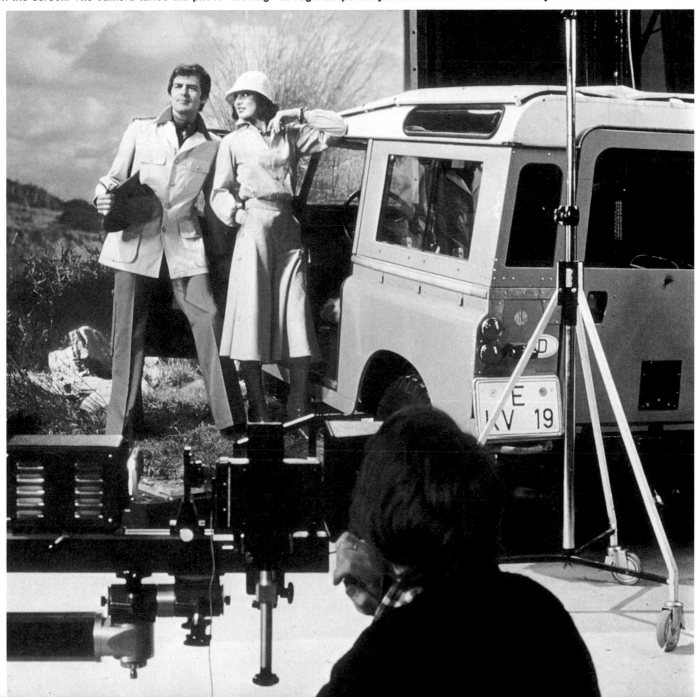

MIXED LIGHT SOURCES

Mixed light sources are mixed blessings. Not only do they provide exciting opportunities to create unique effects, they also present special problems. Because color films are balanced for only one color temperature, a subject lit by two or more sources with different color temperatures is reproduced with part of the subject colors shifted by the imbalanced source. There may also be a significant difference in the duration of the sources, such as when flash is combined with continuous light sources. Mixed sources may also have distinct differences in softness or hardness.

It's important to be aware of possible differences in the light qualities of mixed sources as they affect film. Then decide whether these differences will produce conflicting or adverse image qualities in the photograph. Sometimes, correcting a difference in color temperature results in images that look artificial.

You can correct differences between sources in several ways—by actively modifying the effect of one of the sources, or passively by changing how the exposure affects image formation. For example, if a room is partially lit by window light and partially by household tungsten lamps, you can replace the bulbs in the lamps with daylight photoflood bulbs to actively balance the mixture of sources to daylight quality.

Another situation may require electronic flash fill with a high level of tungsten room light. If you choose tungsten-balanced film, using an 85 series filter over the flash source will match it to the film's color temperature. This reduces the flash output and requires an exposure adjustment to balance the two intensities affecting film exposure.

Whenever a mixed source includes electronic flash, calculating an exposure setting that yields predictably exposed film always involves some guesswork—even with the most sophisticated meters available. The reason for this difficulty is that the two sources have an unpredictable cumulative effect.

This exposure effect is much like what is frequently experienced when you make exposure-test strips on photographic paper. A cumulative series of short exposures may not have the same exposure effect as a single exposure of equal duration. In mixed-light situations in which the flash and the continuous source are read and added together, an exposure setting based on the sum of the two may not affect film the same way as an equal level from just one light source.

Usually, each source affects subject areas differently. They cannot be simply added together to determine exposure. Even modern flash meters that can read both flash and ambient light together

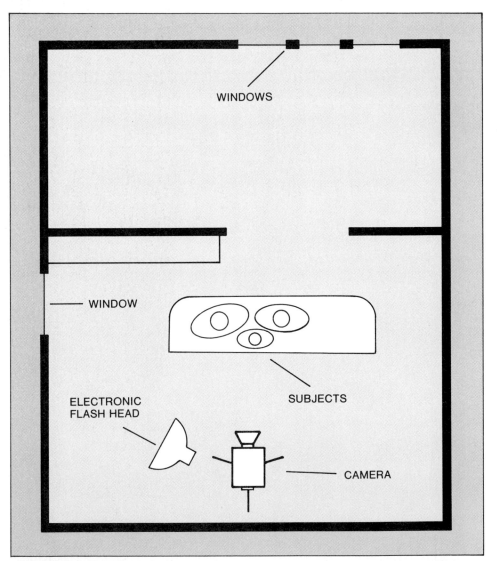

You should light a home portrait during the day so that both the environment and subject appear natural. In the photo at right, a 400 watt-second flash was bounced from the wall in front and to the left of the subjects. This produced both an ideal light ratio and pleasant modeling of facial features.

When balanced with the continuous window light, the bounced flash gives the impression that it also emanates from a large window source. The cooler light illuminating the room behind the subjects is primarily from the sky. This color-temperature difference does not require any correction because it has a natural appearance. Photo by Wah Lui; courtesy of Yuen Lui Studios, Seattle, Washington.

cannot be relied on to provide an ideal exposure, even though such a reading might be technically accurate. You always have to adjust the relative effect of each source by an evaluation of the overall result of placement and metering.

FLASH KEY AND WINDOW-LIGHT FILL

Home portraiture is a good example of situations likely to involve mixing daylight and electronic flash. A portrait done in a typical home during the day may provide some existing illumination for both subject and background. However, a supplementary flash source is always advantageous to get enough light to expose color film.

This supplementary source may be direct illumination from a flash or softer light bounced from a reflector or umbrella. If the color and tone of the walls and ceilings permit, you can get a very soft effect by bouncing an electronic flash from these surfaces onto the subject. A 50 to 100 watt-second power supply is adequate if used directly, while 200 to 400 watt-seconds, or more, may be necessary when you bounce the light.

Metering—With the electronic flash used as the key and daylight from windows acting as fill and illuminating the background, base exposure on the electronic flash incident to the subject. Then adjust the reading for the cumulative effect of any window light fall-

ing on the subject from the general direction of the flash.

Begin this procedure by measuring the flash striking the subject from the electronic flash source. This will roughly establish lens aperture. Next, measure the continuous light level on a background area where you want fidelity of tone reproduction. Use this reading to determine and set the shutter speed at the same aperture set with the flash reading. If the shutter speed is the same or slower than the flash-sync speed of your camera, continue with this procedure. If it isn't, set the aperture that corresponds to the flash-sync speed and readjust the position or output of the flash to give that aperture when you meter the flash again. Of course this is easiest to do if you use a camera with a leaf shutter.

Now read the continuous light incident to the subject and find the recommended aperture for the reading at the shutter speed you set for the background. This level must be lower than the background level if the electronic flash is to act as the key. Determine the light ratio between the continuous window light and the electronic flash on the subject.

If the ratio is high, then the cumulative effect of window light on the overall exposure level will be low. If the ratio is low, the cumulative effect will be greater. To estimate the final aperture setting, close the lens aperture 1/3 to 1/2 step if the light ratio is high, and 1/2 to one full step if the ratio is low.

Variation—A special-effects variation of the flash-key and window-fill situation can create a graphic effect of movement. Although it is a special effect, it has valuable applications for fashion and active subjects, such as dancers and gymnasts who work indoors.

The technique depends on using the daylight source as the background with the subject backlit by the continuous illumination. The

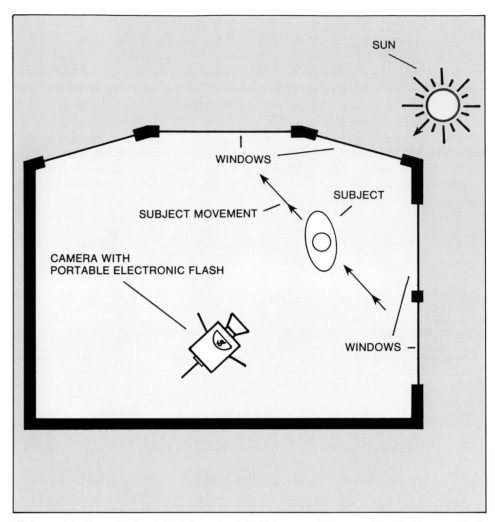

This combination of a front flash key, back light from a window, a slow shutter speed of 1/4 to 1/15 second, and a moving model creates an ethereal mix of blurred movement and sharply defined facial features. With this technique the camera must be mounted on a tripod or the slow shutter speed will cause the background and parts of the subject to blur.

The ghost-like appearance of background showing through parts of the subject is actually due to double exposure. The model's image is formed by the short-duration flash freezing motion at one position during her movement across the field of view.

electronic flash as key light is located either on or above the camera and gives front lighting.

A medium size portable flash pointed directly at the subject should provide enough light to balance with the window light at the desired shutter speed. Units with variable power settings allow a more precise selection of shutter speeds to balance the two light levels.

The continuous light level must be low enough to permit a shutter speed from 1/4 to 1/15 second. Use the slowest shutter speed with slow-moving subjects and the faster speeds with fast-moving models or dancers. In any case, the speed you select must be slower or equal to the camera's flash-sync speed.

The light provided by the flash, which lasts for 1/1000 second or

less, freezes the subject. Therefore, the effect of the mixed light is some blurring of the moving subject due to the long exposure with ambient lighting.

To set up for this special effect, your camera should be mounted on a tripod and set to frame the background. Place the subject in the frame where you want to record the action and focus on the subject. Have the subject rehearse the movement so you can view the action.

Metering—After selecting the shutter speed, meter the window light incident to the back of the subject. Based on this reading and the selected shutter speed, set the lens aperture. Then adjust the flash distance or output so an incident flash reading in front of the subject recommends the same aperture setting.

Next, check the amount of window light reflected from the room surfaces incident to the front of the subject. This level should be at least two steps below the initial shutter speed and aperture settings. If it is, stop down your estimated lens aperture another 1/2 to 1 step for the exposures.

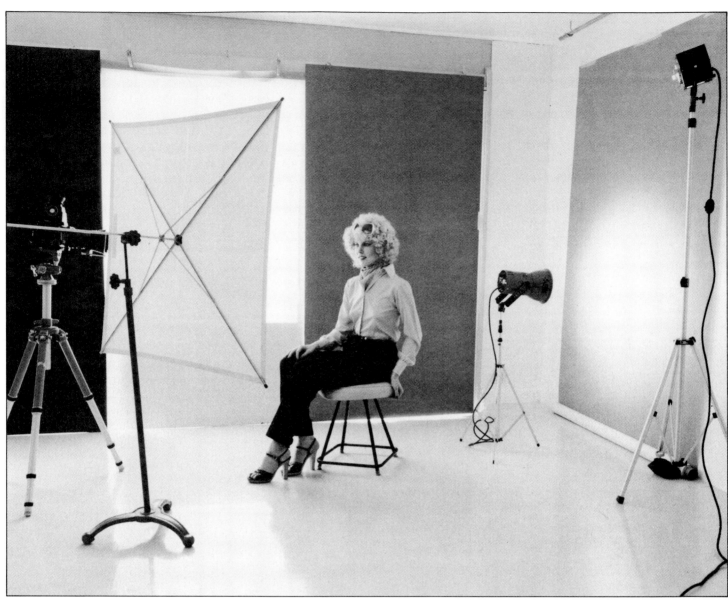

In this setup, key light is the diffused window source, which is also bounced with a Reflectasol to fill the shadows. The four-light effect is completed with a 200-watt Fresnel spot on the subject's hair and a 250-watt photoflood on the background.

WINDOW LIGHT AS KEY WITH TUNGSTEN SUPPLEMENT

It is not easy to duplicate a standard four-light portrait setup with window light and reflectors. For example, not even the most efficient reflector can adequately reflect window light to act as a hair or background light. However, you can combine window light and tungsten lights to get results similar to four lights. In most cases tungsten light used on the hair and background is all you'll need.

Though the difference in color quality between daylight and normal tungsten sources does not adversely affect image formation on b&w film, the visual appearance may be misleading. The apparent intensity of supplemental tungsten sources in a window-lit room may record differently on film than your visualization of the image suggests. Therefore, you should carefully measure the level of these supplemental sources on background and subject relative to the level of the window light incident to the subject. Adjust the feathering and distance of the tungsten lights from the subject according to this reading, rather than their appearence. Do it this way until you see some photographic results and are better able to judge the photographic effect of this setup.

Balancing Sources—Your selection of color films should be based on the color balance of the key source—the window light. Of course, the supplemental tungsten lights will be out of balance with the film. Whether or not you should do something about the resultant warm tones on daylight color film is a matter of personal taste. If the subject's hair is golden blond, warm brown or red, a tungsten hair light that creates warm accent highlights may be flattering. If you're using a tungsten source to provide extra light on seamless paper background, the background color may be enchanced if the paper is a warm goldenrod or rust.

A warm tungsten light on a cool-colored subject or background can produce an unpleasant shift or an inappropriate effect. For example, in a portrait of a matron with silver hair, a warm highlight accent would look incongruous.

When using a tungsten-halogen Fresnel spot for a supplemental hair light, the most effective method of balancing it with daylight-balanced film is to fit the light with a dichroic daylight conversion filter.

Balancing the background light is different. For example, if you're using an aqua-colored background and you want the supplemental light from a photoflood to illuminate the background without distortion, use a blue daylight-type photoflood.

Window light supplemented by tungsten preserves the best characteristics and eliminates the shortcomings of each source. The soft effect of the window key is kind to the subject's complexion and gently models her features. The accent on the hair is easy to adjust to the ideal intensity and area, creating plenty of sparkle from specular reflections. The soft-edged photoflood light pattern aids in producing a gentle gradation from a very light tone immediately behind the subject's shoulders to a darker tone separating the highlights in the hair from the background.

Blond hair, warm-colored attire and a deep orange background all lend themselves to using supplementary tungsten sources without corrective filtration. Notice how well it enhances the natural warmth of the image.

STROBOSCOPIC FLASH AND CONTINUOUS SOURCES

The image produced by the pulsing series of flashes from an electronic stroboscopic flash is itself a special effect. It is frequently used to illustrate the path travelled by a moving subject. Some of the practical applications include a study of dance movements, a golfer, or baseball pitcher. The even and closely-spaced pulses of flash within one exposure period freeze pieces of the action within the field of view, recording them in the time encompassed by the exposure. The result is an interesting photographic record of time and movement.

Lighting Considerations— Stroboscopic flash presents a set of special factors requiring careful planning of the lighting arrangement and exposure calculation. Because a strobe unit produces a series of individual flashes, stationary things struck by these bursts of light receive the cumulative effect of the light. Anything moving within the picture frame receives the effect of one flash at each location.

Obviously, there will be a great difference between the total exposure of a stationary object and that received by a moving object. This difference can be extreme when there are many flashes during one exposure. Therefore, it's best to isolate the effect of the strobe light to only the moving subject. This way it won't light stationary elements.

The easiest way to do this is to place the light to the side of the subject or slightly behind the subject plane. When using one stroboscopic source, you should put it on the side of the setup the subject will be moving toward.

If the subject is moving in place, such as a golfer swinging a club, the strobe should backlight the subject from a more acute angle, but with the light still outside the field of view. This position will prevent the cumulative effect of

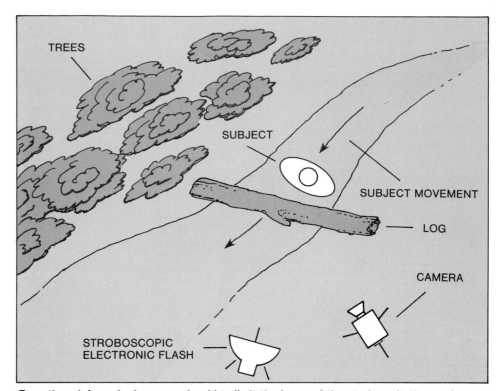

Even though I used a honeycomb grid to limit the beam of the strobe unit, the stationary foreground and log across the runner's path received a cumulative exposure much greater than the rest of the image. Because I used color negative film, I could burn in the foreground and log to create sufficient image detail when I made the print.

Always be careful when selecting a natural setting for stroboscopic effects. A dark background is essential for minimal visibility through the images formed by the strobe's flashes. Using the Balcar Monobloc outdoors required a portable generator to provide AC power.

the flashes from grossly overexposing the relatively static portions of the subject facing the camera.

If the stroboscopic lighting setup is indoors, you should limit reflections from the flashes. They should not illuminate the background or other stationary objects. Cover white or light-colored walls with non-reflective material such as black seamless paper.

If you want to show the environment, light the stationary elements with a low level of continuous light. Protect them from any direct or reflected strobe light. The level of continuous light should give good exposure with the long total exposure time.

Metering— Determining exposure is similar to the procedure used for other mixed sources that use a flash as key. The key light determines the initial aperture setting. With stroboscopic effects, the duration of the movement to be recorded determines the exposure

time. If there is no other source but the stroboscopic flash, then the final aperture adjustment depends on how much of the subject's movements lit by each flash overlap each other. If there is little overlap, close the lens 1/2 to 1 full step to compensate for the cumulative effect of the overlapping exposures. If there is much overlap, close the lens aperture even more.

Only trial and error will let you establish the exact adjustment. If your camera accepts Polaroid film, you can test the lighting, its effect on exposure, and the relationship between the flash rate and subject movement.

If you use a low level of continuous illumination on the subject, setting exposure becomes even more complex. The span of subject movement dictates the exposure time, and in this case the incident level of continuous light determines the initial aperture set-

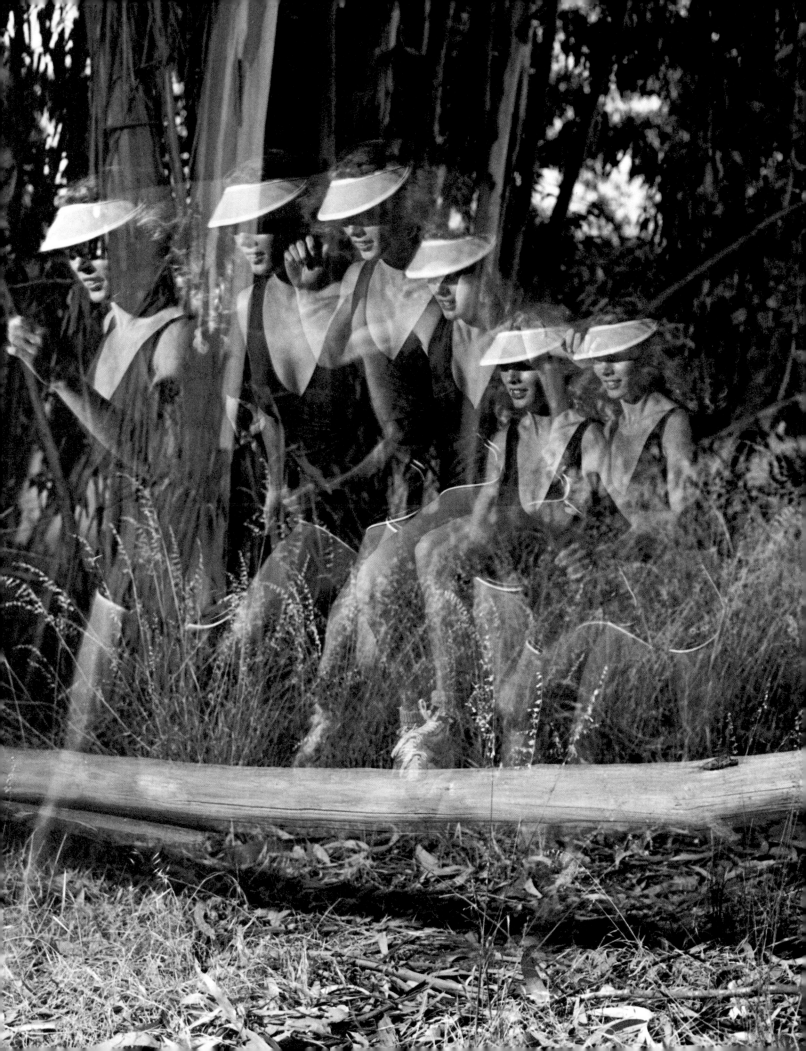

ting. Then you must adjust the effect of an individual flash of the strobe incident to the subject to equal the continuous background level.

Do this by modifying the flash output or the distance from the flash to the subject. With mixed continuous and strobe sources, the cumulative effect on both subject and background usually requires closing the lens aperture at least one step from the initial setting. Exactly how both kinds of light mix to expose film is beyond precise measurement and prediction. I recommend testing and record keeping for best results.

Variation—A variation on this theme uses a tungsten source to illuminate the subject from a position opposite the stroboscopic source. The continuous source will create a blurred line tracing subject movement between the flash-frozen images.

On daylight-balanced color film the tungsten source records as a warm streak. If you do not desire this color shift, use a daylight dichroic filter on the source or a blue photoflood bulb in a photoflood housing.

Determining exposure for this variation is essentially the same as just described for the previous setup. The cumulative effect will be less, though, if you use a black background. Therefore, the initial aperture setting will require less adjustment.

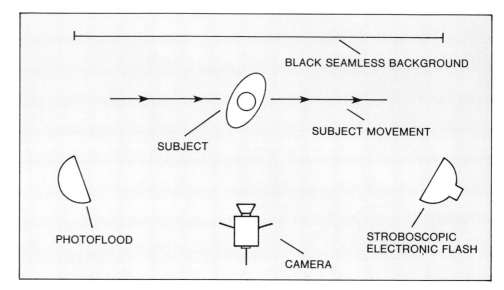

In the photo below, the illusion of subject movement photographed with a strobe is enhanced by the addition of tungsten light. The lights were placed on opposite sides of the subject and as close to the subject plane as possible. This prevented any light from striking the background.

The farther both lights are from the subject, the less effect light fall-off has on exposure of a moving subject. If the light sources are too close to the subject, the exposure difference as the subject moves closer to one and farther from the other produces significant tonal differences.

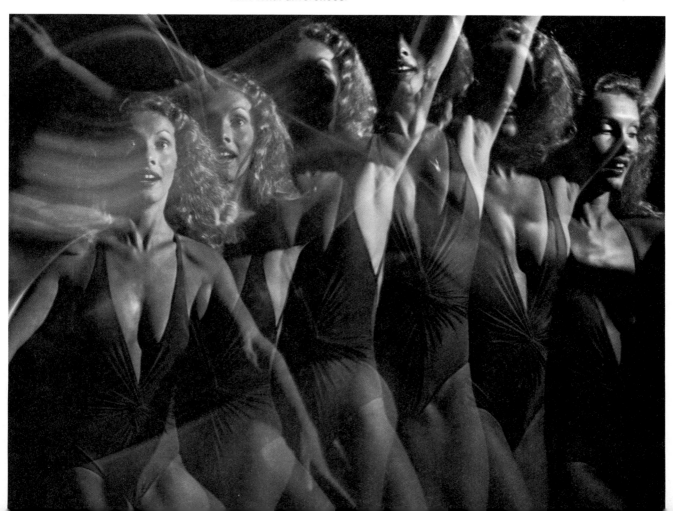

MIXED STROBOSCOPIC AND SINGLE FLASH

You can easily simulate movement of a static subject by using a stroboscopic flash. The illusion is created by either moving the camera so the position of the subject changes within the field of view, by changing the focal length of a zoom lens during the exposure, or both.

Each case includes a number of strobe flashes. Again, to avoid the cumulative effect of the flash series on the background, use back lighting for the strobe. To illuminate the front of the subject, use a regular, single-flash unit opposite the strobe source. Put it in either a front or quarter lighting position.

Metering—These two light sources must be balanced to have the same exposure effect on the subject. Therefore, the single-flash unit illuminating the front of the subject is the key. Make the initial aperture setting on the basis of its light level incident to the subject.

Because the strobe source is in a back-lighting position, creating an accent and forming specular highlights on the subject, its intensity incident to the front of the subject should be lower than the front light. Just how much less light should strike the subject from each flash of the strobe depends on both the reflectivity of the subject and the amount of overlap created by the strobe lighting. The

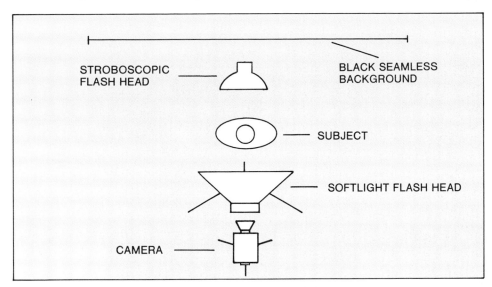

I created this striking visual effect by using a stroboscopic flash, a single-flash unit, and a Minolta zoom lens with an XD-11 camera. The strobe is hidden behind the subject. It's filtered with a colored gel over the reflector to create rim lighting on the expanding hair. A single softlight flash over camera position creates front lighting on the subject's face.

I put the camera on a tripod and composed to include the subject's hair with the zoom lens at its longest focal length. A one-second shutter speed was used for zooming from 75mm to 200mm. I controlled the stroboscopic light source manually and connected the softlight unit to the camera's X-sync terminal.

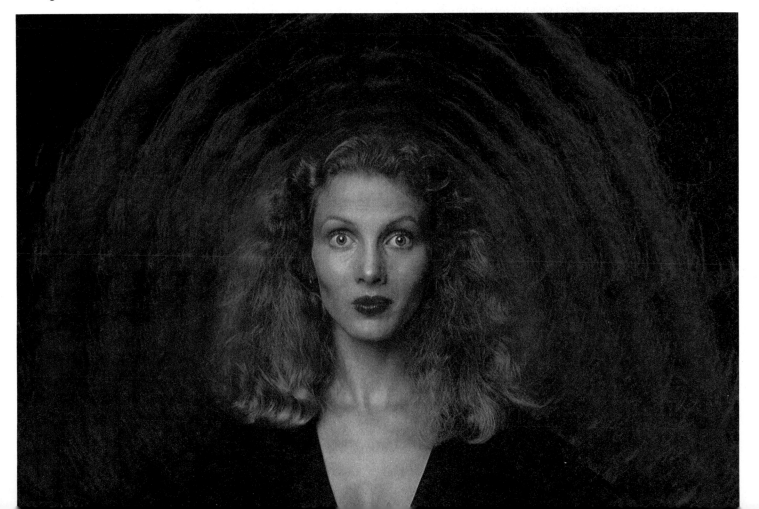

overlap is a function of both the pulse rate of the strobe unit and the speed of camera motion or zooming.

Determine exposure time by the amount of motion you want to induce with the camera or lens. Do this by rehearsing the actions a few times before shooting film.

With some practice you can establish the final adjustments of the flash rate and intensity and speed of the camera or lens movement to fix exposure time. Based on these factors, estimate the final adjustment necessary to compensate for any cumulative effect of the multiple exposures.

Controlling the Flashes—First decide where in the field of view the front flash should occur. For example, if you want the subject to appear to be moving toward the camera, then the stroboscopic effect should trail behind the subject. Connect the single-flash unit to the camera's X-sync terminal and control the flashes of the strobe unit manually with a remote switch.

Proceed by composing the scene so the subject is in the position where apparent movement is to start. Turn on the strobe unit, immediately open the camera shutter, and simultaneously begin the camera or lens movement. The single flash fires when the shutter is completely open at X-sync or slower, and the strobe flashes during the exposure as long as the manual switch is closed.

Do not connect the strobe to the camera's X-sync terminal and fire the single-flash unit with a slave cell. If you do, the single-flash unit will fire again as soon as it recycles, creating more than one front-lit image of the subject. A slave cell will not effectively control the strobe flash because it only closes its sync circuit for a fraction of a second when activated by a flash of light. The strobe unit's sync circuit must remain closed for the duration of the exposure to provide flash pulses for the entire period.

SINGLE FLASH AND TUNGSTEN

A simple method using movement in space and time in a single-exposure photograph combines the effects of electronic flash and tungsten light. By using a comparatively weak tungsten source and a slow shutter speed, you can record subject movement as a streak of light against a dark background. When you fire the flash during this long exposure, movement is frozen. You can use this

Capturing a dancer in midair is easy to do with an electronic flash. But if the subject is isolated in space, the viewer has no reference as to how that instant happened. By adding light from a continuous tungsten source and using a slow shutter speed with the electronic flash, you can also record the path of action with streaks of light.

In this photo a single electronic flash lit the subject through a violet gel over the reflector. The flash was on the right side of the subject. A 500-watt photoflood with barn doors to the left of the subject provided illumination to trace the subject's motion during the one-second exposure.

same technique to create the illusion of movement of a stationary subject either by moving the camera or zooming during the long exposure.

Arrange the two light sources opposite each other and put the subject between them. Control both sources with barn doors or flags so cumulative illumination does not reach the background.

Metering—Once you've established the lighting setup and subject movement, practice the technique carefully. Time it to determine the shutter speed you'll use. Next, measure the tungsten light incident to the subject to get the initial aperture setting for the chosen shutter speed.

If the subject will move swiftly across the field of view, less continuous light—between one and three steps—will be reflected by the subject relative to a stationary subject. If the subject will move toward or away from the camera or you're going to create the effect by zooming, there will be a greater cumulative exposure on the subject in one area of the image. This will require a smaller adjustment of the initial aperture setting.

When you've judged the effect of movement on the continuous light reflected by the subject, use that secondary aperture setting as a target for adjusting flash distance. Then make a test exposure with the aperture closed another half step. Bracket for best results.

Other Considerations—With either variation of this technique the flash can be triggered by the camera. In this case, the flash will occur as soon as the shutter is completely open, which is soon after the beginning of the exposure. Therefore, to create a streak of light trailing the subject, the subject should move *in the opposite direction* the image will imply.

For example, if you want the subject to appear to be moving from left to right, the subject should actually move from the right side of the setup to the left, but should face the right side.

To create streaks with a zoom lens and give the impression the subject is moving away from the camera, start the exposure period with the subject framed for the flash exposure. Set the lens at the shortest focal length. When you open the shutter, smoothly adjust the focal length towards its longest setting, reaching the limit when the shutter closes.

In this photo a Larson Super Soffbox powered by an Ascor flash gives front light on the subject. A 500-watt Fresnel spotlight behind the subject produces rim lighting, which partially silhouettes the subject and creates the bright streaking highlights. A very rigid tripod supported the camera during the one-second exposure to guarantee straight streaks of light created by zooming.

Using one tungsten and one flash source opposite each other is the simplest way of producing a sure-fire zoom effect. The front flash provides a sharp rendering of the subject areas facing the camera. The hidden tungsten source behind the subject is almost completely isolated, producing the zoom streaks leading your eye to the subject.

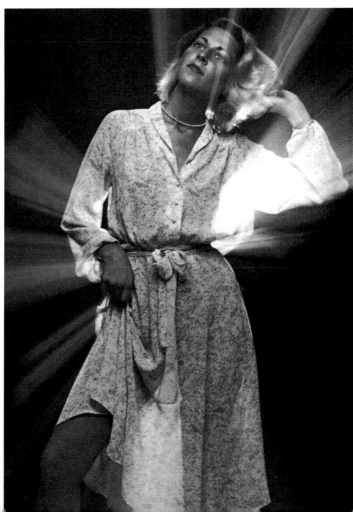

5
Lighting for Things

I've separated lighting techniques for inanimate objects from lighting techniques for people because of the basic differences between the subjects themselves, *not* because of any lack of common methods. In fact, essentially the same cameras, lenses, films and lighting equipment may be used. Of course, the qualities of light incident to both kinds of subjects may also be the same.

Because people present a limited range of reflectivities when compared to inanimate objects, there is a fundamental difference between controlling light for these two categories. Lighting techniques applied to photographing people are also limited in another way. The purposes for which people are photographed are different. The preconceived expectations of both the subjects and the audience

This product photo of a Nikon F-3 camera shows the extreme reflectivity range of an SLR. The camera was carefully lit so all of its features are distinct.

for whom the photograph is made play an important role.

It might seem that you could exercise greater creative freedom in using light to photograph things. Freedom without disciplined control, however, means a greater chance for error and brings with it unpredictable image qualities. In fact, the broad range of subject shapes and surfaces narrows the choices you have. This is due to the inability of the photographic process to reproduce all the values you see in the subject.

The range of reflective values in human subjects rarely pushes the subject brightness range beyond the limits of the film, so lighting control is safely reduced to manipulating the light ratio. However, the reflective qualities of inanimate objects may vary so much or so little within one subject that each of the characteristics of the incident light requires precise control.

One Example—Let's take a look at how the reflective qualities of one inanimate object influences lighting choices. Consider an object familiar to all of us, a 35mm SLR camera. Many contemporary cameras contain the broadest range of reflectance values possible—shiny, convex lens surfaces, polished chrome surfaces, brightly colored markings, areas of textured, lustrous black, and dull matte black finishes. An SLR camera is definitely a challenge to light and photograph effectively.

The lens surface will reflect anything within a broad area, including the light sources. This limits the direction from which you can light a camera if you want to avoid strong specular highlights on the lens surface. Flat, polished chrome also mirrors the environment and may further limit the lighting positions. Conversely, the camera's black surfaces often include shadow areas requiring a high level of fill light, or a low light ratio, to provide image detail.

In addition, the only distinction between some black parts of the subject may be their shape. To separate the shapes you must control both the direction and contrast of the light. Such extremes of reflectivity displayed by a typical camera limit the qualities of light incident to the subject.

This discussion of lighting things begins with common subjects that do not have unusual characteristics and require only simple lighting techniques. More complex subjects requiring more complicated lighting methods follow. The discussion is concluded by an examination of unusual subjects that require special lighting techniques. Within each of these groups, I've selected typical subjects of a very broad range.

SINGLE-SOURCE LIGHTING

Much photography of things involves still-life product photography as seen in catalogs, ads and magazine illustrations. In today's commercial world, time is money, so efficiency is an important influence on lighting methods. Just as important as the economical use of time is the requirement that the lighting create an image that represents the subject well.

Professional photographers have found that one large soft source is highly effective and broadly applicable to all but a few special subjects. This has encouraged the development of flash equipment that produces easily controlled soft light for photographing small to medium size objects.

Whether your purpose is commercial or not, using a single source to photograph a variety of still-life subjects provides the easiest way to begin learning to control the effects of light on things. Although the high-powered, electronic flash softlight is the most popular and efficient tool currently used commercially, you can easily simulate this technique and get good results.

This Broncolor Hazylight on a Vari-Stand typifies the way a softlight can be positioned over the subject. With the center of the source slightly in front of the subject, the vertical surfaces of the subject are fully lit, although at a lower intensity than the top surfaces.

This position also creates a fall-off of light on the area behind the subject. You can darken the background behind the subject to create even greater contrast and separation from the subject by using a flag. In this setup a Larson Reflectasol next to the rear edge of the Hazylight and extending below it cuts off much of the light falling behind the subject.

We often view small objects from above, so the camera is positioned to frame the subject from a 45° angle above the table surface. With the light source parallel to the work surface, the light striking the subject relative to the camera angle is from a quarter position. Because much of the subject is in a vertical plane, the light skims across the surface, defining the textures of the yarn and basket.

SOFTLIGHT TECHNIQUE

The softlight has become popular because of the many advantages it offers. When it is mounted on an arm or boom supported by a stand, you can position the source over the subject placed on a table or on background material laid out on a studio floor. With the light's support on one side, it won't be in the field of view or interfere with the tripod. The large size of the source relative to the subject usually provides complete illumination of the subject and background. Its wrap-around effect can create gentle gradation of highlights that merge into open shadows.

Softlight Size—When shooting subjects that vary considerably in size, you can keep the soft effect and wrap-around quality of the light uniform by using an appropriate size softlight. The most common softlight is three to four feet across the diffusing surface.

Accessory softlight reflectors for use with standard flash heads are available in sizes from one to two feet. The smaller softlights are most adaptable to photographing jewelry and other small products. At the other extreme, there are large commercial units supported by heavy counter-weighted boom stands that measure up to eight feet across. These large units are best for photographing large products with many irregular shiny surfaces, such as motorcycles.

As the size of a softlight increases, the power requirement also increases somewhat. The necessary amount of light incident to

Light from a large, soft source above these melons defines their shapes by creating a smooth tonal gradation from semi-specular highlights on the upper surfaces to detailed shading along the sides and darker tones underneath. In addition, the sliced melons facing the camera receive light skimming over the cut surface, which accentuates the texture and detail in an otherwise monochromatic area. Photo by Richard Y. Fukuhara.

In this food photo, the appearance of crisp freshness is an essential element. The diffusion sheet of the softlight source screens much of the heat created by the tungsten-halogen modeling light. This helps keep the vegetables moist and minimizes wilting. A full range of tonal values is created by a black slate background against reflections of the source in water. Photo by Richard Y. Fukuhara.

the subject depends on the distance the light should be from the subject for the best lighting effect and on the speed of the film being used. Still-life subjects photographed with large-format cameras require very small lens apertures for sufficient depth of field to keep the whole subject in focus. When combined with relatively slow color films, a medium size softlight will need at least 1000 to 1500 watt-seconds of power.

Setup—The most common placement of a softlight is above the subject. In this position it provides a back-lighting effect with the top of the subject highlighted by its relative proximity to the source. The subject's front receives angled illumination with slightly less intensity. The light fall-off on the background reproduces as a darker tone, creating a strong separation with the highlight tone and defining the subject's top.

Variation—If the subject or background contains a shiny surface, you can adjust the softlight's position so the source is reflected in that surface. This helps create strong, uniform highlight areas in the image. This variation on the overhead technique requires an unobstructed and uniform source. An umbrella and some non-rigid softlight reflectors have ribs and cross-bars that can break up the highlight area on the subject.

LARGE DIFFUSER TECHNIQUES

A large sheet of diffusion material suspended above the subject and background will increase the effective area of the source. This method is an efficient substitute for an overhead softlight. It's not easy, however, to adjust the height of the diffuser relative to the subject. You're also limited to one lighting position once it's set up. To compensate for these limitations, you can adjust the flash head in relation to the diffusion material to increase or decrease the size of the source incident to the subject.

When the flash is close to the diffusion material, the edges of the lit area are feathered. So when the light source is reflected by a shiny background, you can create an area of softly graduated highlights that halo the subject. You can't do this with a softlight.

There are at least three good reasons to consider using this diffusion technique. Working with a large piece of diffusion material to create a soft, single source may be economical if occasional use does not justify having a softlight. Because diffusion materials come in long rolls that are considerably wider than the size of a standard softlight, you can inexpensively create very large source sizes for photographing very large objects.

There are many ways to stretch and frame a large piece of diffusion material above a subject. In this setup, two Bogen Auto Poles in the back provide the primary support for the diffusion frame made of electrical conduit. In the front, two Century stands support the frame vertically. Masking tape holds the diffusion material to the frame.

By moving the flash head up or down or changing to a narrower reflector, you can vary the size of the illuminated area on the diffusion material and the degree of feathering.

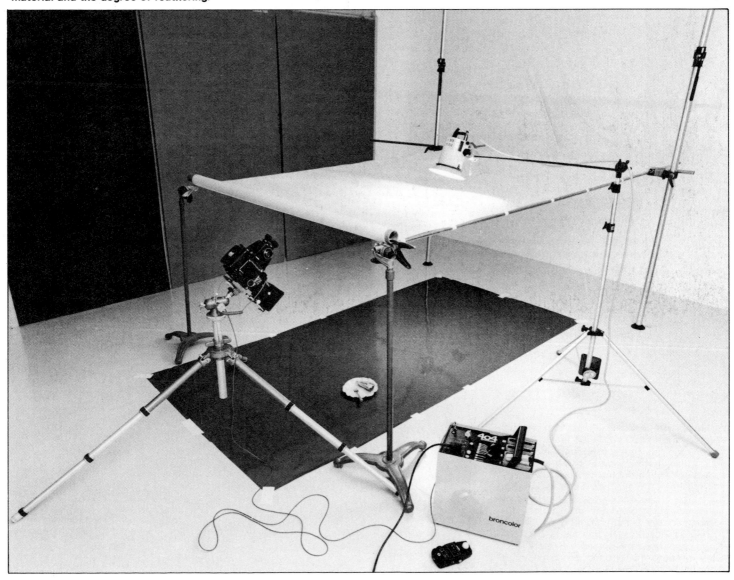

Finally, if you use tungsten rather than electronic flash, this method of producing soft light is relatively safe as long as the light is far enough from the diffusion material to prevent melting or burning. The diffusion material also blocks much of the heat radiated by the light source, protecting perishable subjects from the effects of a tungsten source. However, it cannot be a complete substitute for the much cooler electronic flash. Ice cream, frozen desserts and frosted drinks simply do not remain stable under any form of incandescent lighting. It's within the natural realm of electronic flash to capture their fleeting character.

FRAMED DIFFUSER TECHNIQUE

You can avoid some of the disadvantages of setting up and using a large diffuser, yet still have some of the versatility and flexibility of a softlight by constructing a simple framed diffuser. This method also lets you use tungsten light. The heat generated by the source is dissipated in the large air space between the light and the diffuser.

Setups—The range of positions possible with these diffusers on light stands is limited. Overhead back lighting, which is easily created with a flash softlight, cannot be set up without using some kind of boom stand for both the framed diffuser and the light source. Even so, this limitation does not make a simple framed diffuser less valuable as an inexpensive and easy-to-use softlight.

A homemade diffuser is an inexpensive lighting tool that produces soft light. I assembled this frame from eight pieces of 1x2 pine lumber and screwed them together. The diffusion material is sandwiched between the two 1x2s making up each side of the frame. A pair of gate-latch bolts on the frame act as anchors for attachment to a light stand with Larson Reflectasol clamps. In this setup a 1000-watt photoflood in a Smith-Victor Ultra Cool reflector with barn doors provides even illumination for the diffuser.

You can take advantage of shiny subject and background surfaces to reflect the light. With the camera angle about 45° from the background surface, put the light source slightly behind the subject so it's reflected in those shiny surfaces parallel to the floor. In this way the apparent low contrast of the subject is increased by specular reflections of the source and strong shadows cast in front of it. Subject surfaces not parallel to the floor are reproduced in midtones, contrasting with the highlights and defining subject shapes and textures.

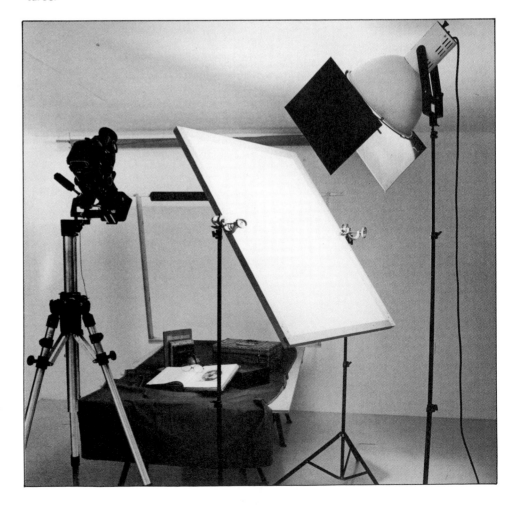

The setup produced soft, even light that's easy to control, yet is adaptable to many still-life subjects. This kind of economical, single-source lighting may be ideal for you if you do small-object photography infrequently. You don't have to tie up a substantial amount of money in equipment. The simplicity of the technique and the pleasing effect of the light assures success with only a little practice.

With a framed diffuser you can convincingly produce a lighting effect that simulates diffused window light. Catch-lights, specular reflections of the source in shiny surfaces in the subject, will reflect the shape and character of the source. Shadows will be softly defined, while textured surfaces angled away from the same plane as the diffuser will be prominent. If the relatively large source is close to the camera position, it will virtually illuminate the subject completely. Quarter and side lighting positions, which create large areas of shadow in the subject, can be filled by using an efficient reflector to bounce fill light from either the diffuser or the original source.

Making Fill Light—For example, suppose you place a framed diffuser close to the subject in a side lighting position and the primary light source is far enough away so its light pattern covers more than the entire frame. Some light will go past the sides of the diffuser frame. You can use barn doors on the light source or flags to prevent that direct light from striking the subject or any part of the area in the field of view.

However, you can also position the diffuser frame so the subject and foreground are shielded from direct light from the primary source. Feather the light source to provide substantial spill past the side of the diffuser nearest the camera. By placing a reflector on the side of the subject opposite the diffuser and light source you can bounce fairly strong fill light to create a lower light ratio.

Similarly, you can redirect spill light over the top of the diffuser frame from the far side of the subject by using a small mirror. This creates a back lighting effect. With a few basic, inexpensive accessories, such as reflectors, mirrors and flags, you can create secondary sources to enhance the versatility and sophistication of what is essentially a single light source.

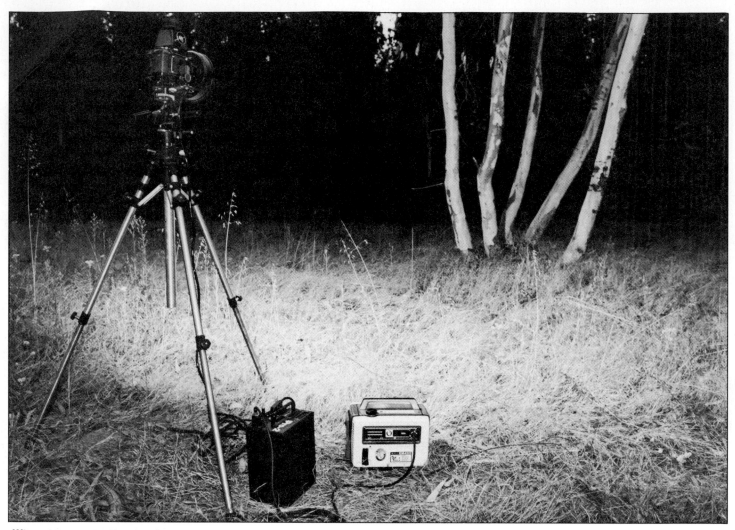

When you use the Hershey Profoto Ringlight on location, you'll need a portable generator to supply power for the flash power supply.

RINGLIGHT TECHNIQUE

Until recently, ringlights have been chiefly associated with technical illustration, such as close-up photography in medicine and dentistry. Now with a large ringlight flash head available for use with power supplies rated to 1800 watt-seconds, ringlight applications have been extended significantly.

From a purely practical standpoint, the ringlight is a unique single source, as discussed in the preceding section. Because it's attached to the camera and surrounds the lens, its light is both hard and flat. The uniform quality of the illumination leaves only one variable requiring control—the distance from the light to the subject. Because that distance is the same as the camera-to-subject distance, focusing provides an exact measure of distance and light fall-off. For example, areas twice as far away as the main subject will receive two steps less light.

Determining Exposure—To determine exposure with a ringlight, simply divide the distance at which the lens is focused into a predeterminded guide number to obtain the proper aperture setting. This method produces predictable results if the subject has a normal range of reflectivity. Very light or very dark subjects may require some exposure compensation if you want them to appear either lighter or darker than normal in the image.

The Ringlight at Night—The constant light quality, the high intensity from an 1800 watt-second unit, the simplicity and relative compactness of the equipment, and the low power requirements of electronic flash make the ringlight an ideal source for photographing all kinds of large subjects on location at night. The large ringlight provides a very predictable, high-intensity light which allows small lens apertures. The flat, even illumination means that detail in the object will be recorded sharply with nothing important lost in shadow.

Just because a large ringlight provides the right kind of light for practical and technical purposes, this does not preclude using it for creative photography. The unique characteristics of ringlight illumination, particularly as they affect shiny subject surfaces, offer

By using a large ringlight to illuminate subjects not commonly photographed at night, you can create unusual images. The light fall-off lends a distinct sense of depth.

many possibilities. The nature of the ringlight's shadowless, high-intensity illumination should fill your imagination with ideas about working with subjects seldom photographed at night.

MULTIPLE-SOURCE LIGHTING

Considering the advantages of using a single light source, it would be the best choice if it served all subjects and conditions equally well. However, some subjects are simply too large to be illuminated effectively by a single softlight. Others are too complex, requiring a number of sources to bring out the character of the sub-

ject. When you photograph extremely small subjects with close-up techniques, multiple sources provide the best lighting and are also easier to use than a single, soft source.

There is another consideration besides a subject's special characteristics. Some key light sources, such as spotlights, require supplementary sources to fill shadows or create highlight accents. You may want to use such a key source simply to use a lighting style different from what is commonly seen. Often, subjects are so lacking in visual interest that the only way to create an interesting photograph is to use dramatic lighting effects with several individual sources.

Control multiple-source lighting of inanimate subjects using the

same principles outlined in the opening chapters and described in the discussion of people photography. You should pay particular attention to the reflectivity of the subject. The effect of the light ratio should produce a subject brightness range compatible with the reproduction capabilities of the film and process you're using.

The following descriptions of subjects and multiple-source techniques represent some problems and solutions in creating an effective image. Because there are many other subjects and techniques in multiple-source lighting, you should not consider these examples as comprehensive. Rather, look at them as suggestive of a wider scope of practical problems and solutions.

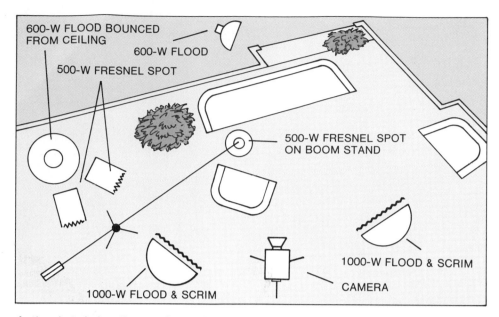

In the photo below the two pieces of furniture facing the camera are keyed from above by a spotlight supported on a boom stand. Overall fill light is supplied by two diffused floods shining directly on the subject area and a third bounced from the studio ceiling.

Accent light and illumination to define the chair in the foreground are furnished by two spots to the left of the camera. The window in this studio setup is illuminated from behind with a flood light to simulate sunlight coming through the shutters. Photo by Francis A. Wironen.

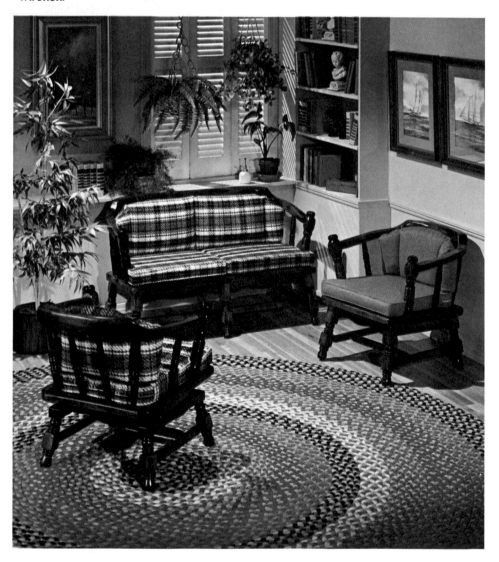

LIGHTING FOR INTERIORS

Lighting the interior of a room or building differs from lighting objects inside a studio. A photograph of an interior may be used to show the way space and materials are arranged, such as how the details of walls, ceilings, floors, windows, doors and other structural features appear. Or an interior space in a photograph may merely furnish a setting for the objects contained within, with the details of the enclosure only serving as an environment or reference. In other situations the inclusion of interior elements may be only incidental, but a practical necessity.

Regardless of their purpose, all photographs of interiors involve both a complexity of surfaces to be illuminated and a variety of subjects that may require separate lighting consideration. An interior may require not just one, but several, key sources. Of course, fill and accent sources are needed too.

To successfully photograph an interior you must keep the purpose of the picture in mind so you can decide what elements will determine the key lighting. This way you can place the key sources to light these elements most effectively.

You must assess the light produced by each key source in terms of how it will model each portion of the interior and subjects within that area. Whether a soft, broad source or a narrow-beamed, hard source is used as a key, you need to consider more than just what shows off that portion of the subject.

You must ask yourself how the lighting effect will blend with the overall appearance of the interior, and whether there is a possibility it will adversely affect other important areas and subjects.

Setting Up—Follow a step-by-step procedure. Add one light source at a time and evaluate its effects on the whole subject. For example, a catalog illustration of a furniture grouping is often made in an interior that supports the character of the furniture. The main subject, however, is the furniture. The reflective characteristics of each piece, its position in the setting, and the practical limits of the space should dictate your choice and placement of the key sources.

First, light the main elements one at a time so the relationships are complementary. Then examine the overall effect to assess the need for supplementary fill and accent sources. Add these one at a time also, while carefully studying both their specific and overall effects.

Final Adjustments—Once you've completed the arrangement of light sources, measure the overall light ratio from the strongest key to the weakest shadow fill. With a number of sources, what frequently begins as a high-ratio setup ends up with a much lower ratio because of overlapping spill from various sources and reflections from interior surfaces. Correct this by reducing the intensity of the fill sources, increasing the intensity of the key sources, or both.

Consider the range of reflectance values in the scene. Very reflective light surfaces intermingled with highly absorbent dark surfaces may demand a low light ratio to prevent an excessively high overall brightness range. A low reflectivity range allows using a higher ratio.

Shiny areas often mirror one or more light sources and create distracting specular highlights in the image. Solving this problem is difficult if the lighting must be adjusted to eliminate the reflections. It's much easier and more effective to change the reflectivity of the offending areas themselves by using dulling spray.

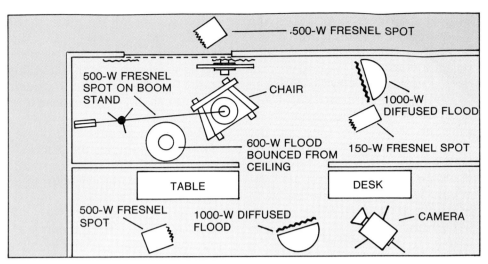

A doorway is an effective framing device in a setting showing furniture. The feeling of depth is accentuated here by less illumination on the walls closest to the camera, drawing attention to the primary subject.

The rocking chair is keyed from overhead with a spotlight on a boom stand. Fill illumination is provided by two diffused floodlights, one on the doorway in the foreground and another from the right inside. A third flood is bounced from the ceiling inside and to the left of the doorway. Supplemental light for the pieces in the foreground is supplied by a spot on the desk at the far left and a spot that back lights the table from the interior. Another spotlight behind the set simulates the effect of daylight coming through the draped window. Photo by Francis A. Wironen.

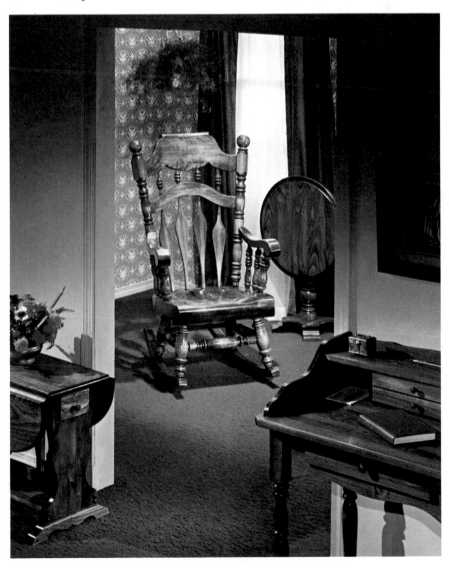

Mixing Sources—Sources having different color temperatures can be to your advantage or even purposefully created. You can produce a noticeable color contrast to symbolize an indoors/outdoors juxtaposition or to suggest a night-time environment. One of the most common situations occurs with interiors that have both windows and electric lamps in view. When lighting the interior with multiple tungsten sources, the light from the lamps will closely match the color temperature of the lighting. If there is a large window area artificially lit to provide simu-lated daylight, that source should be filtered to have the blue appearance of daylight. Some of the light on subjects that are close to the window may also require filtration so they will appear to be lit by the window.

In commercial furniture photography, for example, the interior is usually a set—a room within a studio. The windows can be lit from behind with the intensity adjusted to balance with the interior light. Frequently, the source providing the artificial window light is made cooler for color photography. A blue gel is used over the light source to simulate daylight.

When real or simulated daylight is entering through windows and illuminating part of the interior, there will be a color-temperature difference from the warm light of interior tungsten lamps. The artificial lighting used to illuminate the interior should match daylight in the area close to the window. When using photofloods, use the blue daylight variety. Or, use dichroic daylight filters with tungsten-halogen lights.

If you use electronic flash to illuminate the interior, the color

The effect of two color temperatures of light is used very effectively in this inside/outside illustration. The warm light associated with an interior is at a higher level, adding to the overall image contrast. The lower level of the cool light illuminating the aircraft and exterior of the container produces darker tones, accentuating the effect of nighttime and intensifying the color-temperature difference with strong color saturation. Photo by Richard Y. Fukuhara.

temperature of the flash will be close to that of natural window light. Use filter gels, such as those from the 85 series, over the flash heads illuminating those areas that should have the appearance of warmer light.

I do not recommend using electronic flash to light interiors and to balance daylight from window sources. The modeling light level of a studio flash unit does not match the output of the flash, so it's impossible to see the balance of the window light with the flash. **Location Lighting**—Location interiors often present other kinds of color-temperature problems. The most difficult existing illumination you can encounter on location is fluorescent lighting. As the sole source of illumination, fluorescent lights found in most buildings can be completely unpredictable. Often, there is a mixture of different tubes, with each type producing a different color as reproduced on film. Nor can they be readily matched by photographic light sources. Also, fluorescent lights are usually in the ceiling so they provide an excessively high light direction requiring fill lighting.

Supplementing fluorescent lighting in an interior location involves compromise. The compromise includes the choice of the supplemental source and the way it's used, and how the overall effect of the light is filtered to expose color film. If the fluorescent source provides the primary light for subject areas requiring fidelity of color reproduction, first decide on film type and lens filtration. Then add supplemental lighting in such a way that it does not change the color temperature of those areas. Make sure the supplemental source matches the film's color sensitivity.

For example, if an interior location has fluorescent ceiling lights with predominantly warm-white tubes providing key light, use a tungsten-balanced color film. It will most closely match the

nominal color temperature of the fluorescent tubes.

The supplementary sources used to fill and accent the interior image area should be either photofloods or tungsten-halogen lights. Usually, a warm-white fluorescent source has a cooler color than a

standard photographic tungsten source and may also exhibit a shift towards the green portion of the spectrum. Therefore your filtration over the camera lens should consist of the 81 or 85 warming series with some added magenta filtration.

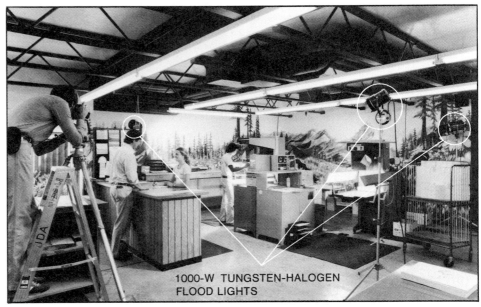

1000-W TUNGSTEN-HALOGEN FLOOD LIGHTS

The overhead fluorescent lighting in this location inadequately illuminates many of the vertical planes in the subject area. Tungsten-halogen flood lights are positioned to fill the shadow areas and illuminate the significant vertical planes. Daylight film was chosen as the closest match for the cool-white fluorescent lighting at this location. Dichroic daylight filters were used over the tungsten-halogen lights to balance their illumination with the film.

Some magenta and yellow filtration over the camera lens was also needed to compensate for the excess green and blue light produced by the fluorescent tubes. The exact amount was determined by tests. This filtration caused the tungsten-lit areas to be rendered with a slight magenta cast. Because this color shift does not affect the primary subject much, the overall fidelity of color appears natural. Photos by Frank Bez; courtesy of Poor Richard's Press, San Luis Obispo, California.

STILL-LIFE LIGHTING

The great advantage of lighting still-lifes with multiple sources rather than a single softlight lies in the ability to selectively illuminate portions of the subject. Many complex subjects require light on certain areas to bring out detail and accent features. Or, the setup may require fill light. There are also subjects having such a limited range of tones that they can't be attractively represented without increasing the tonal differences. This can only be done with more than one light source.

You should approach every still-life subject by analysis of what the subject needs. Then proceed to build the lighting step-by-step like a house, starting with the foundation and ending with the fine details and finishing touches.

A Typical Still-Life—Typical of such still-life problems is a scene with several objects, each having different characteristics. The solution begins with determining the important characteristics of each object. For example, let's consider a situation in which some of the important elements are in different planes.

It may be best to arrange the objects in the setup so you can use the minimum number of key sources in positions that accentuate the characteristics in these different planes. However, there may be a limit to this approach. More than one key light can cast conflicting shadows of each object in the arrangement. An alternative might be to use a single, relatively soft key to define the basic shapes

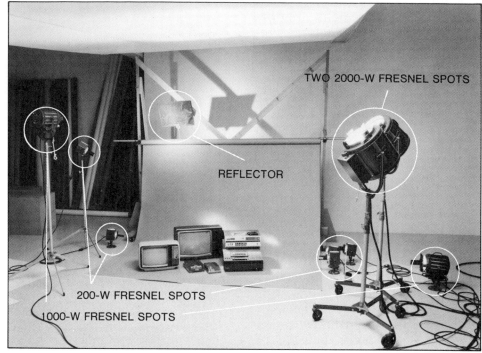

TWO 2000-W FRESNEL SPOTS

REFLECTOR

200-W FRESNEL SPOTS

1000-W FRESNEL SPOTS

Multiple objects such as these can have different planes containing significant subject detail. In addition, they have subtle tonal variations, precluding a simple, single-light solution. The basic lighting effect was established with a single key by bouncing two large Fresnel spots from a large reflector suspended over the subject area. Other lights highlight detail.

Although the objects in the left-hand photo are adequately illuminated by a soft, single source bounced from above the subject, the tops of the video recorders lack definition of detail. The units are not distinctly separated from one another or the background, and the overall effect is flat and dull. In the photo at right, reflected back light opens up the top areas of the video recorders, revealing important detail. Spots of light on the background both separate and define the shapes of the units, besides adding to the overall image contrast. Gels placed over some of the smaller spotlights fitted with narrow snoots provide colored accents that highlight significant image detail. **Photos by Frank Bez; courtesy of Warehouse Sound Company, Fresno, California.**

of the objects and to define detail in those areas in the same plane. Then you can illuminate areas in another plane with additional accent sources.

With this technique, the key is usually positioned so an overall fill is not needed. However, if you do use more than one key, such as spotlights, to bring out detail in different planes, your next step is to provide fill light for the shadows. A soft, broad source for a fill is usually used next to camera position to avoid creating multiple shadows on the subject and background.

Once you establish the key and fill sources, you have defined the still-life's basic shapes. Then study the effect to see if there are small details that should be emphasized. Is there adequate tonal separation between objects? Is there sufficient contrast to separate objects from the background?

You can then add small sources one at a time to fill specific needs. Review them carefully to assure that each new source you introduce doesn't create unwanted or distracting illumination in adjacent areas of the composition.

Problem Still-Lifes—When objects are both uninterestingly shaped and poorly differentiated in

Above: When used as a key light, the Norman Tri-Lite produces a round, precisely defined beam of very hard light. Without a supplementary fill source, shadows would be dark and reproduce black. The fill source can be a second, conventional flash head plugged into the power supply. Adjust the light ratio by selecting different output levels for each source.

This arrangement of objects, which are distinguished by only slight differences in reflectivity and contour, benefits from the added image contrast and the contrasting shape of a spot of light. Spot lighting a selected area of the subject draws attention to the significant elements in the composition and adds to its graphic interest.

tone, uniform lighting is not appropriate. The result would be an image lacking contrast even though the full scale of tones is used.

One possible solution to these problems is to light the setup with different levels of illumination. This creates a scale of tones apart from the subject that will isolate the subject shapes.

To do this you need a light source with a narrow beam that you can direct and adjust to cover a selected portion of the image area. A Fresnel spotlight provides such a pattern of light with soft feathered edges. You can also create a sharply defined light area with an optical spotlight.

When you use a spotlight to illuminate only a portion of the subject, the remaining areas will be in very deep shadow. You can bring out some detail in these shaded image areas with a fill light. The fill should be a broad, soft source positioned close to the camera to avoid creating multiple shadows and conflicting highlights.

An optical spotlight used to project an image in the subject area also requires fill sources. The most common use of a projected image is as a background. For example, a studio setup of a kitchen is likely to include a window. Producing a typical scene at the window is done one of two ways. You can place a screen well behind the window and project the background image on it. Or, use a piece of rear-projection screen in place of the window glass and project the background image onto it from behind. Filter the light source projecting the background image to provide a cooler daylight color temperature.

In either case, you must control the light so no illumination spills onto the screen. Otherwise, the projected image will be washed out. Also, the average brightness of the projected image must match the light level in the interior but not necessarily the keyed objects.

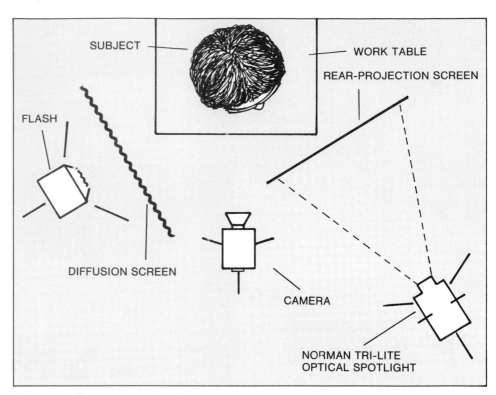

A projected image can be used in other ways than as a background or a window scene in a studio set. Here a 35mm slide image projected onto a rear projection screen was reflected in the lenses of mirrored sunglasses. The screen was located so the entire surface of each sunglass lens reflected the slide image.

A lower level of soft light subtly defines the shape of the mannequin head. For this effect I used a small portable flash directed through a large diffusion screen. I based exposure on the light level reflected by the sunglasses from the projected image.

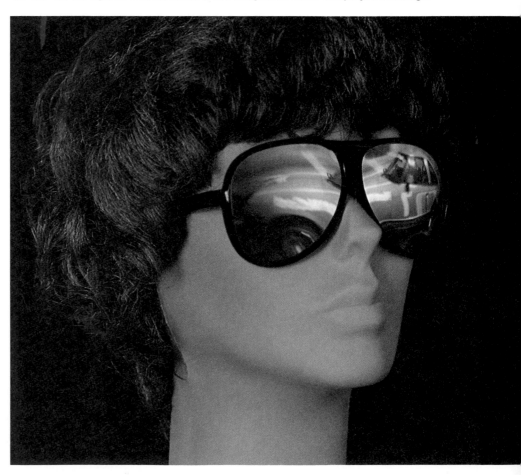

CLOSE-UP LIGHTING

Essentially the same considerations of the effect of light on large subjects apply to close-up subjects. Because the camera lens is close to the subject, front lighting is virtually impossible without a shadow of the lens itself falling on the subject area. One exception to this rule is when you use a ringlight. For technical applications requiring only documentation of a subject, the ringlight is an ideal close-up source because it gives even, flat light.

To create a more esthetic image, revealing shape and surface texture, use angled light from a relatively small source with a second source to fill shadows. In other words, the same reasons for using multiple sources apply to small subjects as to large. However, the tools and methods to create the light and control its effects differ because of the subject's size.

Using Natural Light—The technique you use to light a close-up subject will also depend on the light source. Many close-up subjects that occur in nature force you to use the available natural light or a light source that's both compact and portable. Existing illumination outdoors must be bright enough to permit the small lens apertures usually needed to get all of the subject in focus. This usually requires direct sunlight.

If you are fortunate enough to have an ideal angle of sunlight falling on the subject, you will need only a small reflector to bounce light into the shadows and control the light ratio. When the relationship of the subject and sun are not to your advantage, you must modify it.

One way is to use a reflector to redirect the sunlight to produce the desired angle of key light. The other method is to use a diffusion screen in the dual role of screening direct sunlight from the subject and filling the shadows.

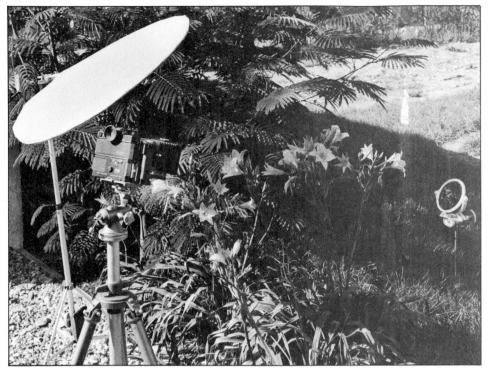

An inexpensive set of tools is all you need to modify sunlight to control natural illumination of close-up subjects. I made the circular diffuser on the left of the camera by bending a piece of 3/8-inch aluminum rod into a circular shape with an extension. Then I covered the framed area with Flexiglass secured by clear tape. The diffuser is supported on a light-weight stand that was counter-weighted for stability. To the right of the camera a make-up mirror is attached to a steel rod with a Larson Reflectasol clamp. The rod was stuck in the ground.

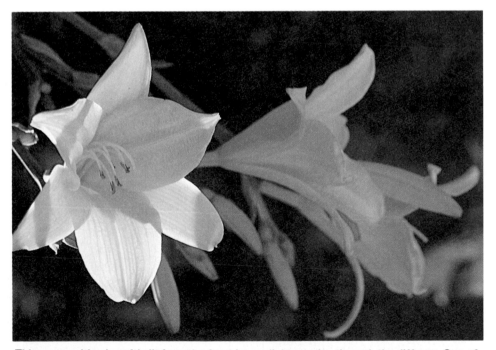

This composition is softly lit from the front by sunlight passing through the diffuser. One of the day lilies is selectively backlit by the make-up mirror reflecting a narrow beam of sunlight from behind. A dark background, which makes the flowers prominent, is created by the shadow of the diffuser.

141

Using Flash—One excellent way to control close-up lighting is to use two small portable flash units on an adjustable bracket mounted on the camera. The short flash duration assures that almost any subject or camera movement will not affect image sharpness. With the flash units relatively close to the subject, the light fall-off causes the background to be dark so it doesn't conflict with the subject.

Small flash units suitable for multiple use on a Macro Bracket for close-up photography are used with manual control, providing a fixed light output. When you use flash close to the subject, the standard guide numbers don't apply because the window of the flash is relatively large when compared to subject distance. Therefore, you must determine a close-up guide number by testing. In addition, close-up shooting may require exposure compensation due to increased image magnification.

Bracket a series of exposures at 1/3- or 1/2-step intervals on each side of an estimated setting. Establish this setting by dividing the distance between the closest flash unit and the subject into the guide number for the film speed. Then determine an aperture adjustment based on magnification. When using a macro lens or extension tubes, determine magnification and refer to the accompanying table and find how much more you should open the aperture. If you are using supplementary close-up lenses, skip this step. Then close the lens 1/2 step to adjust for the effect of the second flash unit.

Choose the test image that gave the best results and use that aperture setting for subsequent shooting with the flash setup. Of course, a change in image magnification may change exposure compensation. Refer to the accompanying table and find the difference between the aperture adjustments that correspond to the old and new magnification. If magnification increases, open the aperture the indicated amount, if it decreases,

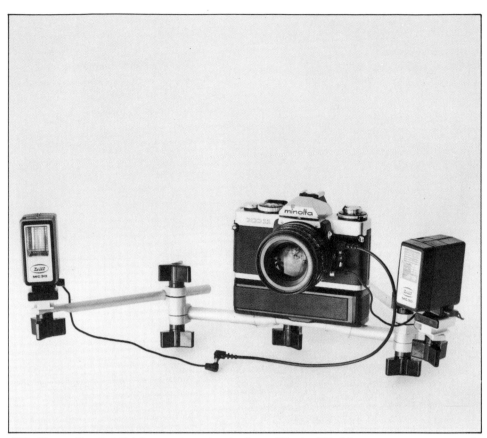

This Macro Bracket lighting system attached to a Minolta XD-11 camera uses two small manual flash units to light close-up subjects. The adjustable arms that hold and extend the flash units are securely mounted to the camera tripod socket, making hand-held close-up photography easy. Also included as part of the Macro Bracket system is a pair of diffusers for the flash units.

close the aperture that amount.

For example, suppose you change image magnification from 0.5 to 1.0. The difference in the aperture adjustments is one step, so you *open* the aperture one step and use the same flash setup.

Small, portable flash units bracketed to the camera have limitations. The range of positions is restricted, so some light directions are not possible. Although diffusers can be used over each flash unit to slightly disperse and reduce the output, the hardness and the coverage of the light is relatively constant. Going beyond the limits offered by two flash units and the range of positions provided by the bracket would be difficult in any case. Without modeling lights you can't see the lighting effect.

APERTURE ADJUSTMENT DUE TO MAGNIFICATION	
M	**Open Aperture (steps)**
0.1	1/3
0.2	1/2
0.3	2/3
0.4	1
0.5	1
0.6	1-1/3
0.7	1-1/2
0.8	1-2/3
0.9	2
1.0	2
1.1	2
1.2	2-1/3
1.3	2-1/3
1.4	2-1/2
1.5	2-2/3
M	$(\log (1+M)^2)/0.3$

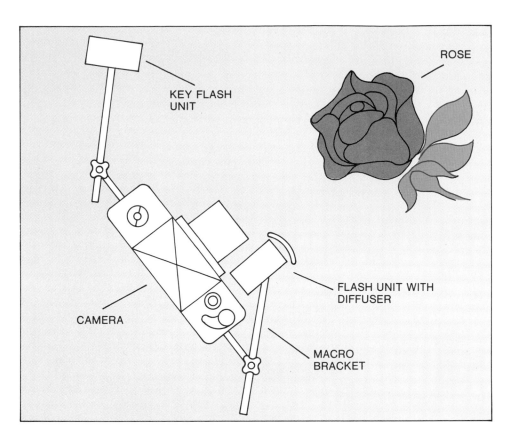

KEY FLASH UNIT

ROSE

FLASH UNIT WITH DIFFUSER

CAMERA

MACRO BRACKET

The two flash units on a Macro Bracket were positioned to create an unequal light ratio. The key flash was in quarter position and the other in a fill position close to the lens. Even though both flash units produce the same intensity, by putting a diffuser over the fill unit I could reduce its output. The undiffused key light skims across the surfaces of the rose blossom, accentuating the shape of the petals.

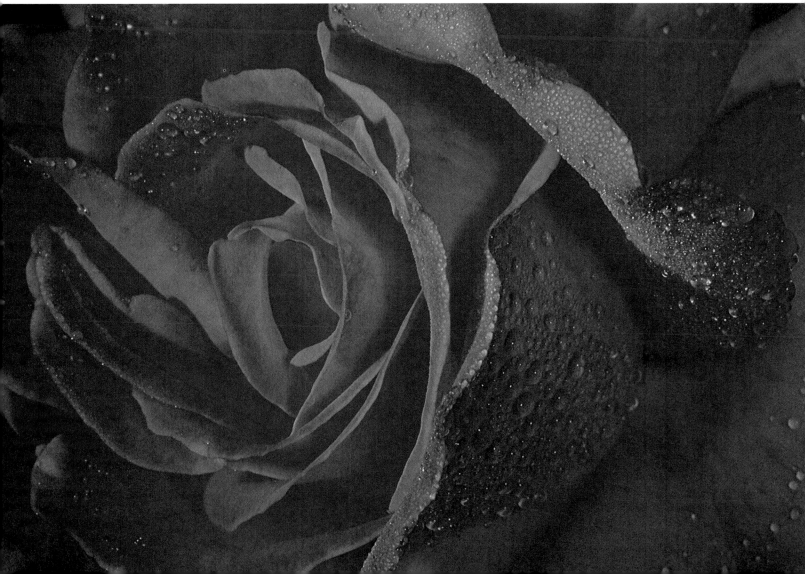

Using Tungsten Lights—When working indoors with a close-up subject, you can use tungsten lighting. You can see and control the lighting effect. Essentially the same lighting effects possible with larger subjects can be applied to close-up work. However, because the subject is smaller, the light sources must also be smaller and closer to the subject to have the same relative degree of hardness or softness. Small tungsten sources are usually limited to several brands of 100- to 200-watt Fresnel spotlights. Sources with higher wattage ratings used close to the subject and camera position may radiate too much heat on both you and the subject.

Softlight tungsten sources for close-up subjects are not offered commercially. However, you can use a 250-watt photoflood light in a large reflector and cover it with a diffuser. This will provide soft light that matches the intensity of the small spots when positioned close to the subject.

A little ingenuity will go a long way. You can fashion reflectors, flags, diffusers and scrims from poster board, aluminum foil, tracing paper and window screening. Clothespins, small welder's clamps and gaffer's tape will hold and support devices for modifying and controlling the effects of light on close-up subjects.

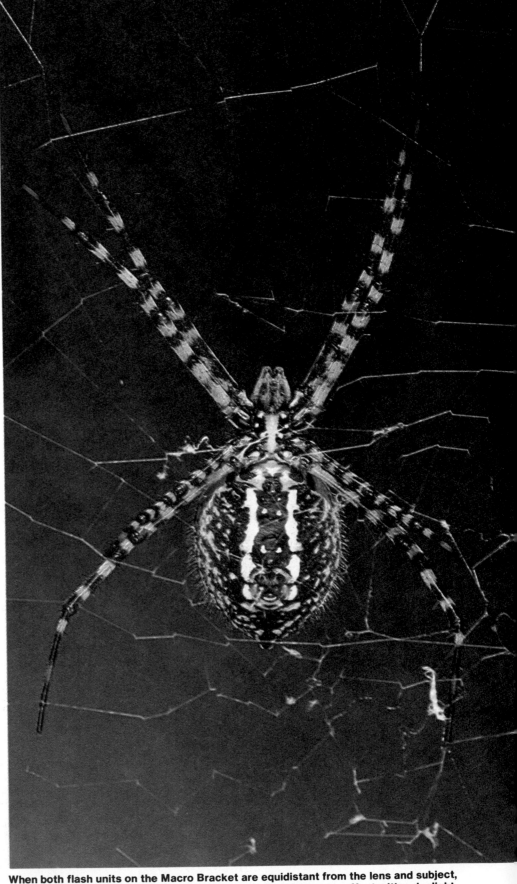

When both flash units on the Macro Bracket are equidistant from the lens and subject, uniform illumination is created. You can get essentially the same effect with a ringlight. This kind of flat, shadowless light is appropriate for documenting small subjects for technical illustration.

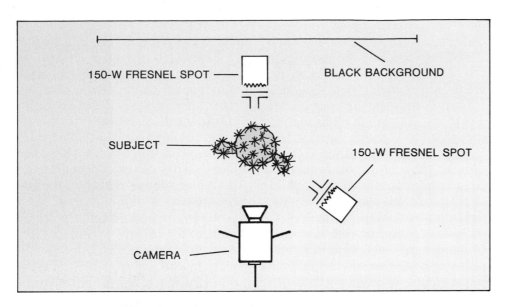

150-W FRESNEL SPOT

BLACK BACKGROUND

SUBJECT

150-W FRESNEL SPOT

CAMERA

Studio lighting gives you freedom to create exciting effects with close-up subjects. This photo of a common thistle is dramatized by the use of a 150-watt Fresnel spot with a small snoot and a red gel to back light the subject. Another 150-watt spot with a small snoot provides front light to selected areas of the thistle. Photo by H. R. Kuntz.

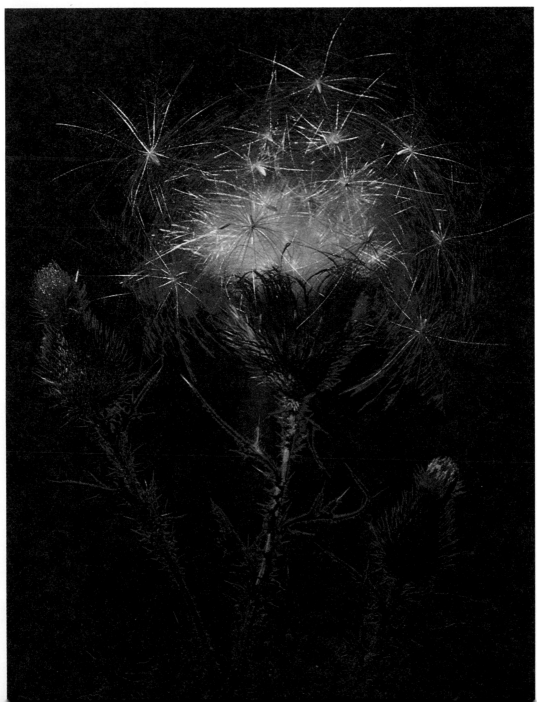

LIGHTING FOR SPECIAL SUBJECTS

Photographing glassware, unusually shaped objects with glossy surfaces, and copying photographs and flat art, such as paintings and posters, are tasks that most photographers encounter. These subjects require special lighting techniques.

The basic techniques I'll cover for lighting these special subjects take into consideration their individual qualitites. As long as you understand them, you can alter the methods to produce different effects based on your own needs and imagination. There is not just one way to photograph transparent or shiny subjects, nor are all copy subjects best served by standard lighting arrangements. There is as much latitude for ingenuity in lighting special subjects as there is in other kinds of photography. However, you must first understand the peculiar character of the subject's effect on light and use it appropriately.

Besides requiring different ways of using light, each kind of subject requires a certain metering technique to obtain predictable results. I suggest metering methods for each technique.

LIGHTING FOR TRANSPARENT SUBJECTS

The inherent beauty of glassware lies in its unusual combination of transparent and reflective properties. Besides being transparent, glassware is usually formed in rounded, complex shapes with mirror-like, shiny surfaces. This gives photographers both a challenge and the potential for creating striking images.

When applied directly in a conventional setup, artificial light does not adequately define the shape and character of glass objects. Much of the illumination just passes through the glass, while the light source is usually

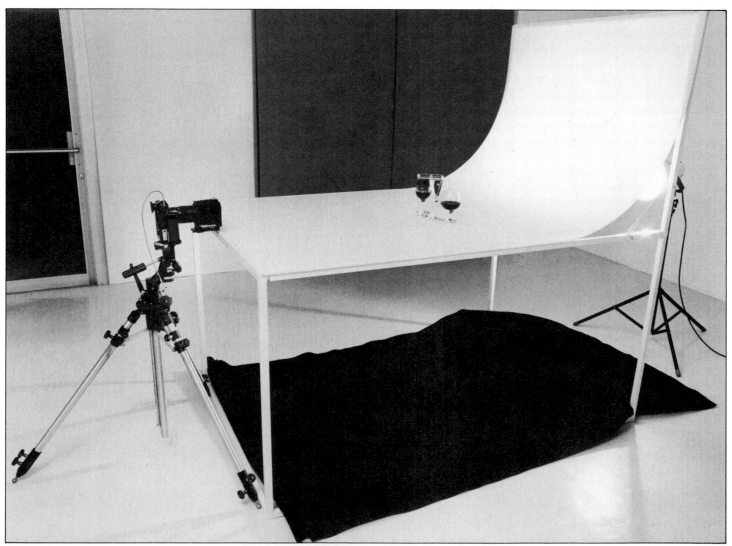

A light table, such as this Studio Specialties model, serves many purposes at the same time. It supports the subject, supplies a continuous, seamless foreground and background, and acts as the source of incident light.

You can create an evenly lit area behind glass objects to silhouette their contours by placing a light in back of the light table. Create a gradual tonal transition by raising or lowering the height of the light. A piece of black BD Foam-ett under the light table prevents light from being reflected onto the bottom of the table by the floor.

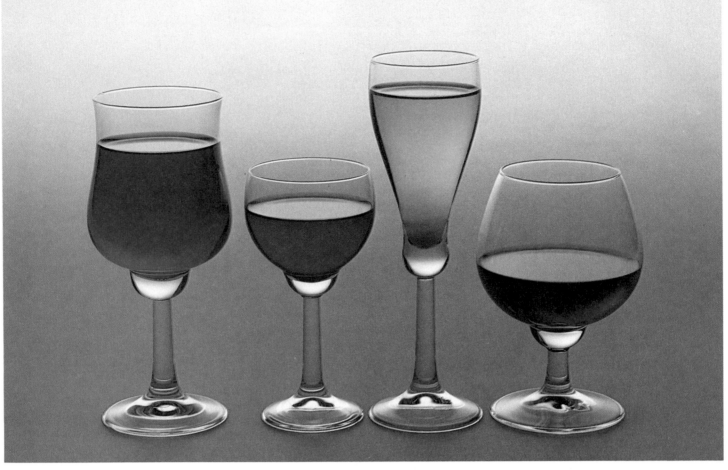

When you put several pieces of glassware in front of an illuminated background, you must carefully arrange each object to minimize reflections. By raising the camera angle several degrees above horizontal, I could include the gradual shift in tone from the darker base of the table's surface to the lighter tone of the table's vertical area. The center of the glass objects and their liquid contents then filter the brighter light from the upper part of the table, creating a strong contrast with the background.

reflected as strong specular high-lights from its surfaces. Additionally, conventional lighting may illuminate areas of the foreground, which are also likely to be reflected in the glass. Portions of a glass object will also tend to disappear and merge with the background.

Background Lighting—The standard approach to lighting glassware is to light the objects indirectly. Basic illumination is not applied to the glass pieces themselves but to what is *behind* them. With this method you avoid reflections of the light source and illuminated foreground areas. The contours of the glassware are then defined by differences in light transmission through various portions of the subject. The glass refracts the rays at various angles depending on the shapes and angles of its surfaces.

This causes those portions of the glass object that are parallel to the film plane to appear transparent. Surfaces at right angles to the film plane appear opaque. Parts of the glass between these angles exhibit varying degrees of opaqueness. The effect of this is that the outline of a glass goblet, for example, is opaque, creating a strong definition of its shape.

Setting Up—You can use this effect by carefully choosing and lighting the background. If the glassware is part of a larger arrangement, then place the pieces so they are shaded from direct light from the front of the subject plane and so there is a light, reflective area behind them.

It's not always easy to arrange glassware to create ideal lighting when glassware is combined with other kinds of objects. With some situations you may need a small flag to cast a local shadow on the glass and eliminate reflection of the light source. Then if the area behind the glass is not light enough to emphasize the glassware's contours, a supplemental source directed on that area will be necessary. This is easy

For this photo, a Broncolor Hazylight was used as a combined background and light source. A dark piece of cloth placed under the bottle has been draped to create an irregular horizon line. Base exposure for liquid in a glass bottle such as this on the density of the liquid. In this case, the light golden color of the perfume should reproduce with less density than a midtone. Therefore, an exposure reading of the light transmitted by the liquid should be adjusted for slightly more exposure to reproduce the tone accurately. Photo courtesy of Broncolor.

to do if you use a multiple tungsten light arrangement with a small Fresnel spot fitted with a snoot. Use the spot to illuminate the area behind the glass.

Glassware photographed by itself requires a relatively simple setup. Usually, a uniform white background just large enough to cover the field of view is used. Light the background with a source originating from behind the subject plane. If the background is white reflective material, such as seamless paper, position it far enough behind the subject so you can light it evenly by the source. If the background is translucent, you can light it from behind and position it very close to the glassware arrangement.

To keep the background as small as possible while still covering the exact field of view, use a long-focal-length lens on your camera. This is so shiny outer sides of a glass piece won't reflect the outer edges of the background

and create highlights that merge with the background. If the background material you use is not just the right size, use pieces of black paper to frame the background area to the exact field of view.

Metering—As with normal subjects, glassware should be exposed for an average midtone gray representing the light transmitted from the background through the glass itself. However, it's not simple. There may not be a tone in the subject that corresponds to an 18% reflectance value. A meter reading of light incident to the background roughly approximates this value *if* there is no light fall-off between the background *and* the subject and the background reflects or transmits most of the light. Obviously, an average reflected reading of the subject would be misled by the intensity of the background area.

The most effective method is to use a spot meter with a narrow acceptance angle to measure the

brightest and darkest tones in the glass objects. Average the readings to get a setting that will expose for the midtone between the two readings.

The next-best exposure method is to determine the incident light level cast by the background on the subject plane. Use an incident meter and take the measurement by placing the meter at the subject plane with the integrating sphere pointed toward the background.

Another way to get the same result is to place a gray card at the subject plane and face it toward the background. Measure the light on the gray card with an averaging reflected meter from a position adjacent to the background. With either of these readings based on the light incident to the rear of the subject, you must adjust the final setting for the light transmission of the glass. A subject made of clear glass can be exposed on the basis of the incident reading. With colored or smoked glass more exposure may be required.

In this setup, barn doors on a Smith-Victor Ultra Cool photoflood restrict the lit area on the table. Black BD Foam-ett on the floor and the back of the light table and a Reflectasol flag keep stray light off the vertical background. The shiny glass surfaces facing the camera lens reflect the foreground light source, creating areas of diffuse highlight that partially obscure the jars' contents. A polarizing filter over the camera lens could be used to limit these reflections, but they shouldn't be eliminated completely. Otherwise, there will be no visual indication of the shapes or reflective quality of the glass.

LIGHTING FOR SHINY SUBJECTS

Objects that are shiny *and* opaque present a different set of problems and require a slightly different lighting approach. With shiny, opaque objects a more conventional lighting arrangement is necessary to define substance, shape and surface characteristics.

Shiny objects range considerably in size. Smaller objects can be photographed using the same equipment as glassware. However, subjects too large to light with a softlight or light table require a sufficiently large, even source of bounce light.

The remaining areas in the studio must not have objects that would be reflected in the subject and create distracting forms. You can easily provide this environment by hanging large pieces of white seamless background paper to act as a bounce source and to cover surfaces in the room that could be reflected by the subject.

However, because the smooth, glossy surface of opaque subjects can mirror light sources and the surrounding environment just like glassware, these light sources and the surrounding surfaces require special consideration.

The qualities of the light source you need for shiny objects are the same as for illuminating glassware, but for different reasons. A broad light source is required, but you must put it where it will project light directly on the areas of the subject seen by the camera. When positioned this way, the source will

The automobile is probably the most commonly photographed large, shiny subject. Although there are large commercial studios that create indoor environments to capture the smooth highlights in a car's complex surfaces, it is most likely that you will choose an outdoor location. An appropriate location for photographing a car should include open spaces without features that would reflect distracting images in the shiny surfaces. A uniformly overcast sky or the softly lit sky just before sunrise or immediately after sunset produces ideal illumination. Photo by Richard Y. Fukuhara.

It's easy and relatively inexpensive to construct a frame for a medium-size light tent from 3/4-inch PVC water pipe and fittings. Cut the pieces of pipe to length with a hack saw and join them with standard PVC elbows. The joints fit so tightly that they don't have to be cemented. When the tent is not in use, you can easily disassemble the frame for storage. BD Dif-fuse, Studio Specialties Flexiglass, or other diffusion material can be stretched over the completed frame and secured with clear plastic package tape.

be reflected by at least part of the shiny surfaces in the subject to create smooth highlights.

Because the broad light source is of uniform intensity and is relatively large compared to the subject, reflections of the source should not be distracting or conflict with nearby tones. The rest of the surroundings should be equally uniform but of a much darker tone. The result is that portions of the subject displaying diffuse highlights suggest the shiny quality of the object's surfaces, while those areas also lit but not reflecting the source will reveal the object's color and tone.

The Light Tent—One popular solution for simultaneously lighting and creating an environment to photograph curved, glossy subjects is to make a *light tent.* A light tent surrounds the subject, eliminating the possibility of

reflections of the studio interior.

This room-within-a-room usually consists of white translucent diffusion material. Both Flexiglass or BD Dif-fuse are excellent materials for covering small to medium size tent frames. Larger subjects can be enclosed with translucent cotton or nylon sheeting supported from the ceiling.

By lighting the top and each side of the tent with equal intensities of even illumination, you can achieve a flat, shadowless effect. However, the major advantage of a light tent is that you can create an unequal light ratio by illuminating the tent from different angles with various light intensities. If you use a stronger source from one direction, it will key the subject. Lower light levels on the other sides can fill the shadows. If you bring the key source close enough to the tent to create a feathered spot of

light, it will be reflected in the subject with distinct, well defined highlights.

Metering—Shiny objects in a light tent reflect most of the incident light when in a light tent. This tends to make an incident reading give underexposure.

The most accurate exposure setting is based on a reflected reading limited to the subject area. However, an *averaged* reflected reading can include too much of the background, which may not be relevant to a correct exposure. The best way is to use a spot meter with a narrow acceptance angle so you can measure the subject brightness range. Average the readings to determine exposure. However, even the most accurate measurement of the reflected light may require some adjustment based on how the subject tones should appear in the photograph.

This light tent is held in position on the light table with plastic-tipped welder's clamps. I made a front panel of diffusion material and attached it to the tent frame with small welder's clamps. A hole cut in the front panel of the tent lets the camera lens into the tent. The tent and light table provide a diffuse light source that completely surrounds the subject.

Polished metal objects with compound shapes reflect virtually everything in the environment. The smooth, even tones of a light table and light tent provide both illumination and surface reflections that do not distract from the subject shapes. Without some differences in light intensity from different sides of the tent, there would be little tonal distinction in the shiny subjects to define their shapes. An unequal light ratio is necessary to establish highlight and shadow relationships.

LIGHTING FOR COPYING

Photographs, documents and flat art are often photographed. *Copying* usually refers to making a photograph of a flat, opaque image, while *duplicating* refers to photographing a transparent image. These two techniques require different lighting methods. Copying requires two identical light sources, and duplicating requires only one source. By using appropriate films, you can copy and duplicate images with either tungsten or flash sources.

The single most important characteristic of light sources for copying and duplicating is even illumination. A light source that produces uneven intensity levels on the subject area always causes density differences in the final image. This kind of copy does not truly represent the original.

Copying—The purpose of copying is to reproduce the original with maximum fidelity of tone and detail. Photographs, printed material and flat art do not have a reflectivity range as long as the subject brightness range of an average three-dimensional subject. It is extremely important that the light reflected from the subject maximize the reflectivity range of the subject but not the surface texture of the material supporting that image.

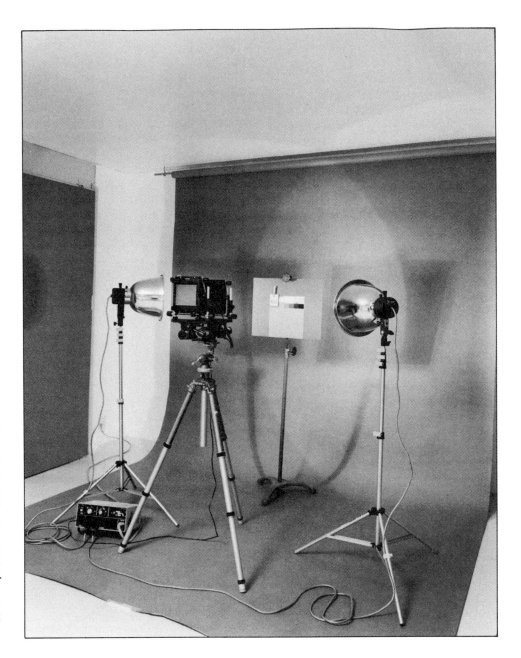

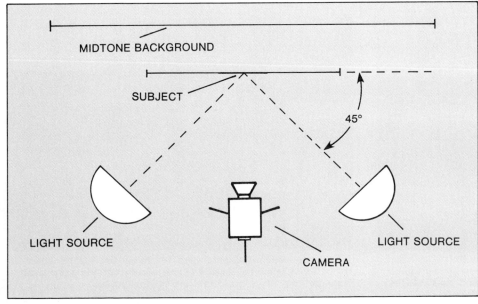

This typical copy setup includes an Ascor power supply with two flash heads and normal reflectors on stands. The copy material is at a 90° angle to the lens axis. The light sources are equidistant from the subject at a 45° angle to the subject plane. The center of the camera lens, light sources and copy subject should be about the same height. For best results, use a level, tape measure and protractor to make sure the setup is aligned properly.

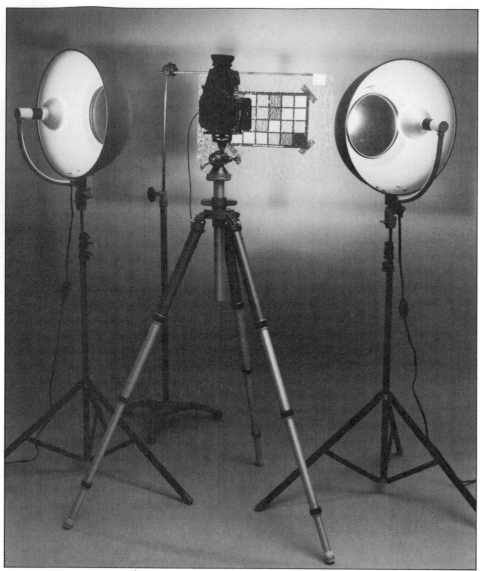

By using two identical light sources, one on each side of the copy material, you can distribute flat, uniform light across the entire area. Position the lights at a 45° angle between the subject plane and the lens axis. This minimizes surface texture and direct reflections of the light sources.

There is special lighting equipment available for copying that enhances the fidelity of reproduction of the range of tones in the original. Polarized light sources used with a polarizing filter over the camera lens can eliminate reflections from the surface of the copy material.

When using the Kodak Pola-Lights, you set the polarizing filters over the light sources with their "plane marks" set in a horizontal position. Look through the viewfinder and adjust the polarizing filter on the camera lens until reflections are minimized.

This helps reproduce copy materials with great clarity and contrast. Images with irregular surfaces and lustrous finishes, such as oil paintings, require this setup to obtain an acceptable copy.

This setup with two Kodak Pola-Lights is a standard copying arrangement. However, if space limitations or subject size require different lighting angles, the polarizing action of the lights and the lens filter will still eliminate reflections from the copy surface. The test subject in this setup is a Macbeth Color Checker with a piece of textured glass hung in front.

Without any filtration on the light sources or over the camera lens, a standard copy arrangement produces much specular highlighting in shiny, irregular copy surfaces. The contrast and color intensity of the subject is obscured by the reflective surface.

When you adjust the polarizers for maximum effect, specular reflections disappear. Also, the image contrast and color saturation more closely approximate the original subject.

A small tungsten-halogen spotlight is a good source for duplicating color slides onto tungsten-balanced films. A small electronic flash is appropriate for duplicating color transparencies on daylight-balanced film. Whatever light source you use, it should be in line with the camera lens axis. Once you find the right distance and light level to illuminate the transparency, measure and record the distance from the source to the subject. This way you can repeat the setup in the future and use the same exposure settings.

Duplicating—The only light qualities you need to be concerned with when duplicating are color temperature and evenness. In duplicating, the light behind the transparency is actually provided by a plastic diffusing screen between the transparency and light source. This diffusion screen is usually part of the slide-duplicating attachment for 35mm SLR cameras. For duplicating larger transparencies, a piece of flashed opal glass slightly larger than the original is usually used. It is supported between the camera lens and the light source. The transparency is mounted on the glass surface facing the camera.

Align the light source with the lens axis behind the diffusion material. You should place the light source at least twice the distance behind the subject plane that's needed to cover the area of the diffusion screen. Move the light even farther if heat from a tungsten source affects the transparency material, or if the light intensity is too great to make an exposure within an ideal range of lens apertures and available shutter speeds.

Index to Manufacturers

Following is a list of manufacturers and distributors of some of the equipment shown and mentioned in this book.

AMBICO SHADE +
Ambico, Inc.
101 Horton Ave.
Lynbrook, NY 11563

ASCOR FLASH
Berkey Marketing Co., Inc.
Ascor Photo-Lighting Div.
25-20 Brooklyn-Queens Expressway West
Woodside, NY 11377

BALCAR FLASH
Tekno, Inc.
221 W. Erie St.
Chicago, IL 60601

B-D STUDIO PRODUCTS
The B-D Company
2011 West 12th St.
Erie, PA 16512

BRONCOLOR FLASH
Sinar Bron, Inc.
166 Glen Cove Rd.
Carle Place, NY 11514

HERSHEY/PROFOTO FLASH
Leedal Inc.
1918 S. Prairie Ave.
Chicago, IL 60616

HONDA GENERATORS
American Honda Motor Company, Inc.
100 W. Alondra Blvd.
Gardena, CA 90247

KODAK PRODUCTS
Eastman Kodak Co.
343 State St.
Rochester, NY 14650

LOWEL-LIGHTS
Lowel-Light Mfg.
475 10th Ave.
New York, NY 10018

MACBETH COLOR CHECKER
Macbeth Div. of Kollmorgen
Drawer 950
Newburgh, NY 12550

MACRO BRACKET
Lepp and Associates
P.O. Box 6224
Los Osos, CA 93402

NORMAN FLASH
Norman Ent.
2601 Empire Ave.
Burbank, CA 91504

OLESEN GELS
Olesen Inc.
1535 Ivar Ave.
Hollywood, CA 90028

PROLIGHT ADAPTER
Photo Prod. by Accessories Unltd.
16631 Bellflower Blvd.
Bellflower, CA 90706

REFLECTASOL LIGHT MODIFIERS
Larson Enterprises, Inc.
18170 Euclid Ave.
Fountain Valley, CA 92708

SINAR PRODUCTS
Sinar Bron, Inc.
166 Glen Cove Rd.
Carle Place, NY 11514

SMITH-VICTOR LIGHTING EQUIPMENT
Smith-Victor Sales Corp.
301 N. Colfax St.
Griffith, IN 46319

STUDIO SPECIALTIES BACKGROUNDS
Studio Specialties Inc.
409 W. Huron
Chicago, IL 60610
 or
249 N. Reno St.
Los Angeles, CA 90026
 or
721 Walker St.
Montreal, Canada H4C 2H5

TOPCON CAMERAS
Photo America Corp.
7491-93 N.W. 8th St.
Miami, FL 33126

VIVITAR PRODUCTS
Vivitar Corp.
1630 Stewart St.
Santa Monica, CA 90406

Index

A

AC power supply, 64
Active control, 3
Additive primaries, 12
Angle of incidence, 8
Arranging lights, 85
Ascor portable flash, 55
Ascor studio flash, 51
Atmosphere, 29
Automatic flash, 49
Average scene, 13, 75
Averaging meters, 66

B

B&W, 14
BCPS, 50
Back light, 8
Backlighting, 23, 75
Balcar Monobloc, 50
Barn doors, 57
Bounce light, 98-99
Bracketing, 17
Brightness, 10
Brightness range, 10
Broncolor Studio Flash, 52
Butterfly modeling, 86

C

Camera meter, 65
CC filters, 34
Close-up flash, 142-143
Close-up lighting, 141-146
Color, 5, 16
Color Checker, 34, 154
Color-Compensating filters, 34
Color-correction filters, 33
Color filters for B&W film, 39
Color temperature, 6
Compendium lens shade, 64
Complementary colors, 12
Contrast, 40
Contrast effects, 20
Controlling strobe flashes, 122
Copying Techniques, 153-154
Cross light, 8

D

Daylight studio, 31, 68, 70-81
Diffuse reflections, 10
Diffuser techniques, 129-131
Diffusion materials, 62
Direction of light, 8, 21
Distance, 29
Duplicating technique, 155

E

E.I., 14
Electronic flash, 49
Electronic flash lighting, 91-123
Energy-saving flash, 49
Environmental effects, 28
Exposure, 13
Exposure index, 14
Exposure range, 13

F

Feathering, 86
Fill light, 131
Film speed, 13
Filters, 33-39
Flags, 60
Flash and tungsten, 122-123
Flash exposure, 92
Flash-exposure metering, 92
Flash fill, 82
Flash key and window fill, 113-115
Flash meters, 67
Fluorescent lighting, 137
Fluorescent lights, 35
Fog, 30
Four-light portrait setups, 84-85
Framed diffuser, 130-131
Fresnel spotlight, 47
Front light, 8
Front light modeling, 86
Front lighting, 21, 80

G

Gel frames, 58
Gels, 63
Gray card, 14
Gray scale, 11
Guide numbers (GN), 51

H

Hair light, 32
Hand-held meters, 66
Hard light, 6, 18
Hershey Profoto ringlight, 56
High key, 11
High-key lighting, 100-102
High light ratio, 73
Honda AC power supply, 64
Honeycomb grids, 58

I

Incandescent lighting, 84-91
Incident light, 5
Incident light meters, 66
Indirect light, 5
Infrared transmitter, 91,92
Integral flash units, 51
Intensity, 5
Interior lighting, 134-137
Inverse square law, 26

K

Kelvin (K) scale, 6
Key, 11
Key light, 32
Kicker, 32

L

Large diffuser, 129-130
Larson reflectors, 58-59
Light
 active control, 3
 direction, 8,21
 hard, 6,18
 incident, 4,5,
 indirect, 5
 mixed, 34
 passive control, 3
 photographic concepts of, 4
 ratio, 9
 reflected, 5, 10
 rim, 23
 soft, 7
Light table, 62, 146-149
Light tent, 151-152
Light meters, 65-67
Light ratio, 9, 86
Light-balancing filters, 33
Lighting accessories, 57-64
Lighting setups, four basic, 84-85
Lighting things, 124-155
Local contrast, 10
Location lighting, 137
Lowel-Lights, 48
Low key, 11
Low light ratio, 72

M

Macbeth Color Checker, 34, 154
Main light, 32
Metering
 average scenes, 75
 backlit scenes, 75
 flash exposure, 92
 nonaverage scenes, 75
 rimlit scenes, 75
Metering, 75
Midtone, 14
Mixed light, 34
Mixed light sources, 112-123
Modeling light, 50
Monostrobes, 51
Multiple light setups, 93-94
Multiple source lighting, 133
Multiple sources, 33

N

Nonaverage scene, 14, 75
Norman Tri-Lite, 55
North light, 31

O

On-camera flash, 49
Open effect, 40
Optical spotlight, 54
Optical spotlight effects, 109-111
Outdoor applications, 82

P

Paramount lighting, 86
Passive control, 3
People photography, 68-123
Photoflood lighting, 84-88
Photoflood reflector housings, 43
Photofloods, 43
Pigments, 12
Polarizing filters, 37
Projecting images, 110-111
Prolight adapter, 42, 46

Q

Quarter light, 8
Quarter lighting, 22
Quartz lamps, 47
Quartz-halogen lamps, 47

R

Reciprocity failure, 36-37
Reflectance, 10
Reflected light, 5, 11
Reflection, effects of, 25
Reflections, 10
Reflectivity, 10
Reflectivity range, 10
Reflector photoflood, 46
Reflectors, 60, 62
Rim lighting, 23, 75
Ringlight, 55
Ringlight effects, 108-109, 133

S

Scrims, 57
Seamless backgrounds, 63
Selective reflection, 12
Separated flash units, 51
Shade, 8
Shade +, 64
Shadow effects, 19
Shiny subjects, 150-152
Side light, 8
Side lighting, 22
Single flash and tungsten, 122-123
Single-source lighting, 125-132
Skylight filter, 39
Slave cells, 51
Snoots, 57
Soft light, 7, 18
Softlight techniques, 103-107, 127-128
Softlights, 54, 60, 90
Source size, 6
South light, 31
Space, 28
Special lighting techniques, 146-155
Spectrum, 6, 9
Specular reflections, 10
Spot meters, 66
Spotlights, 54, 90
Stands, 61
Step vs. stop, 3
Still-life lighting, 138-140
Strobe and continuous sources, 118-120
Strobe and single flash, 121-122
Studio flash, 50
Subject brightness range, 10
Subject color, 12
Subject contrast, 10, 40
Subject key, 11
Subject reflectivity range, 10
Subtractive primaries, 12

T

Textural effects, 19
Transparent subjects, 146-149
Tripods, 61
Tungsten-halogen lamps, 47
Tungsten-halogen lighting, 88-91

U

UV filter, 39
Ultra-Cool studio lights, 44
Ultraviolet (UV) radiation, 38
Umbrella lighting, 94-97
Umbrella reflector, 58, 90

W

Window light and tungsten, 116-117

A-8.271459710